TIMELESS LEGACY

His Holiness the Dalai Lama

BLOOMSBURY PUBLISHING INDIA PVT. LTD.
New Delhi London Oxford New York Sydney

ISBN: 978-93-84898-80-9

10 9 8 7 6 5 4 3 2 1

Published by Bloomsbury Publishing India Pvt. Ltd.
DDA Complex LSC, Building No. 4, 2nd Floor
Pocket 6 & 7, Sector – C, Vasant Kunj
New Delhi 110070

Printed at REPLIKA PRESS, India

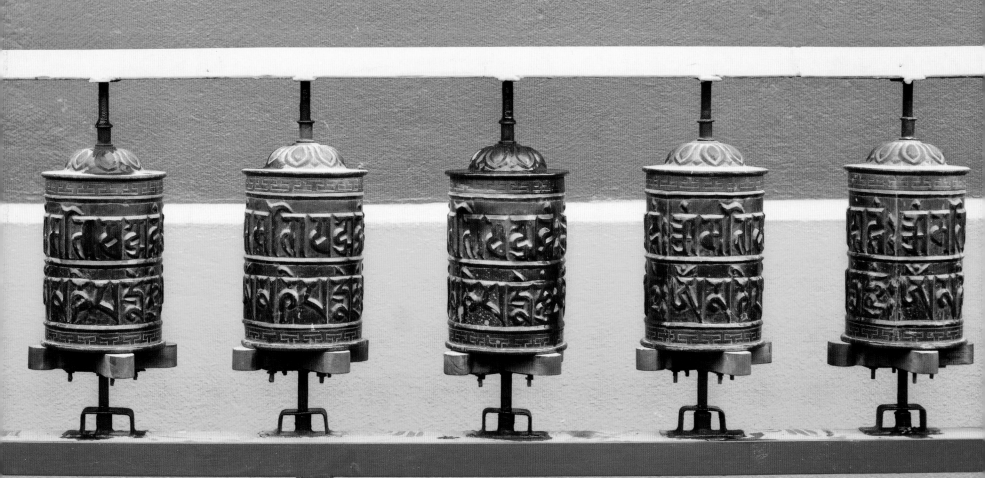

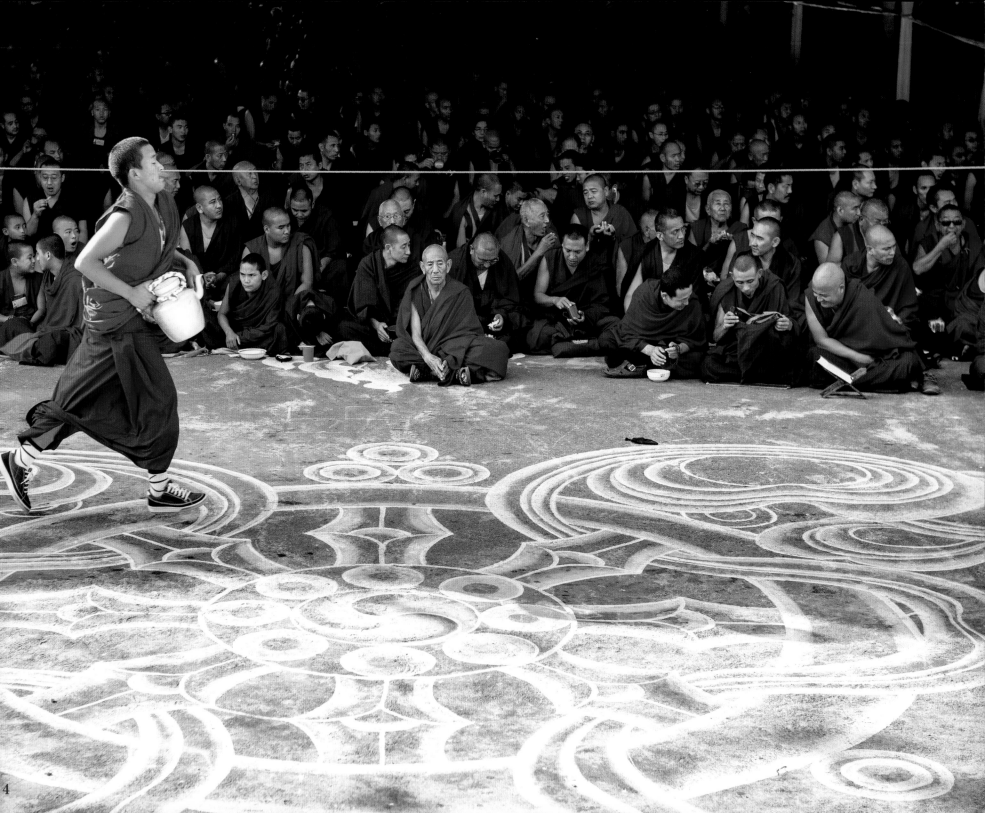

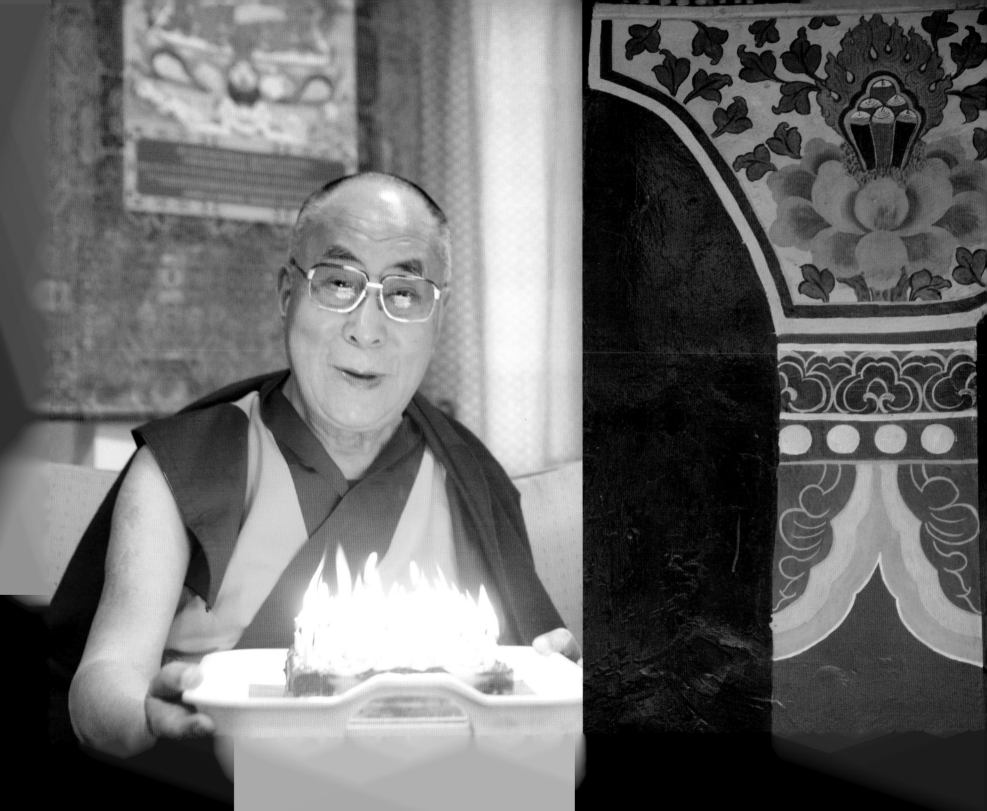

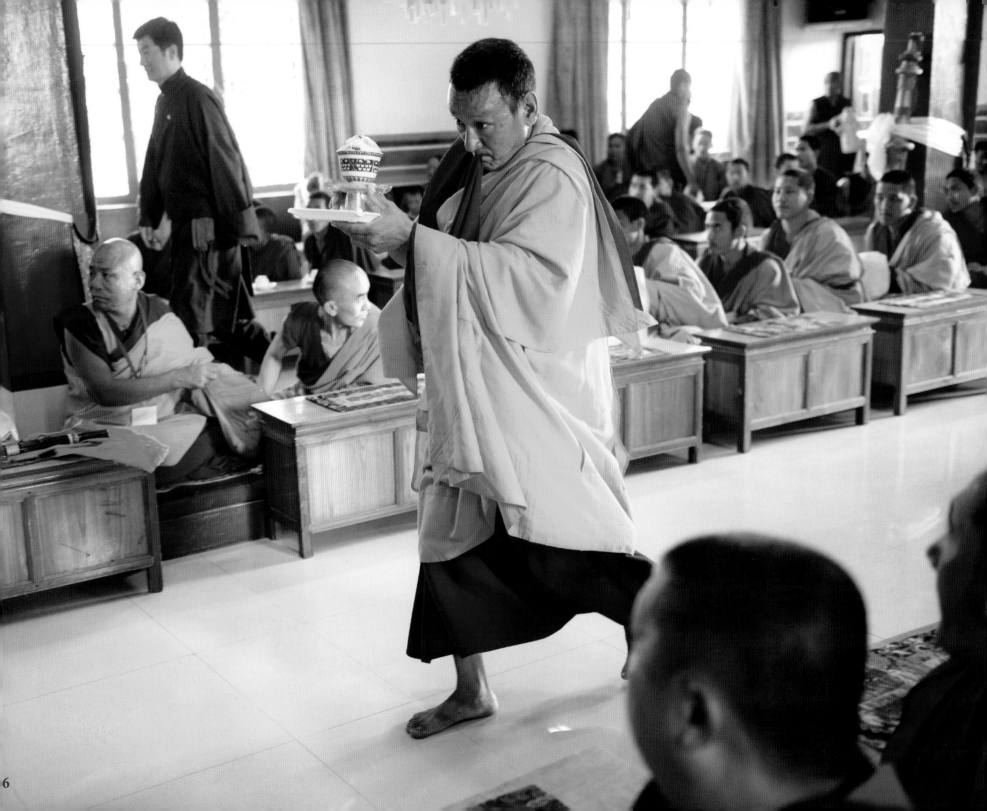

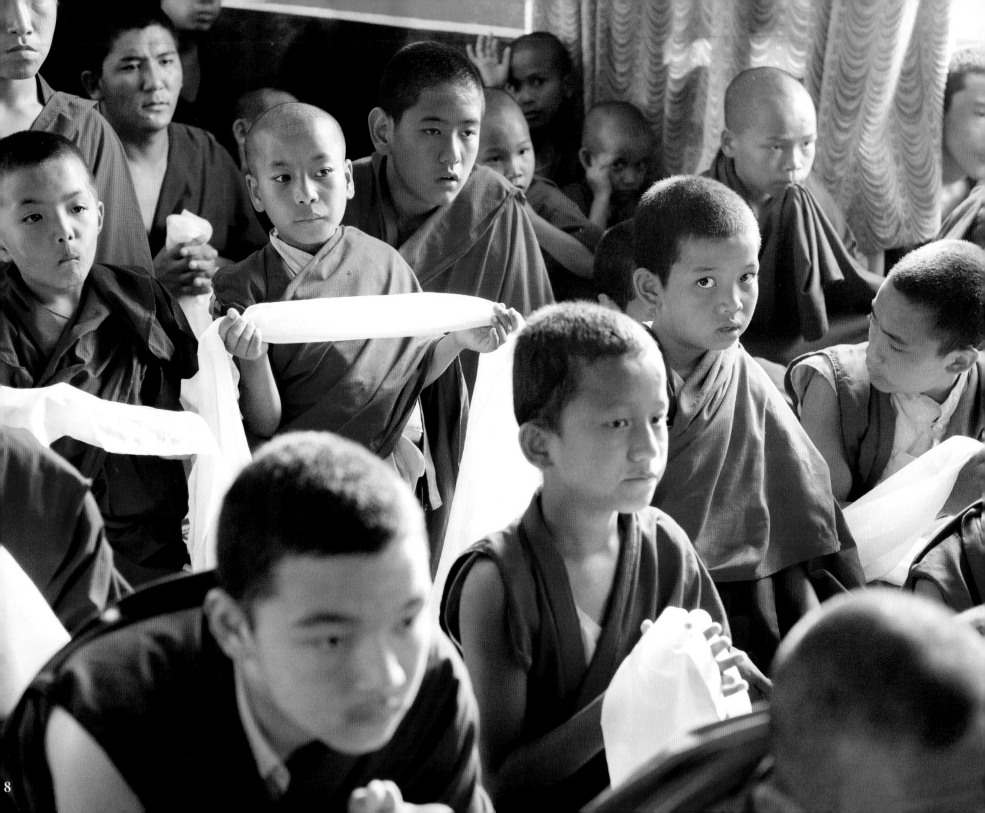

TIMELESS LEGACY
His Holiness the Dalai Lama

In conversation with

Vikas Khanna

Photographs by Tenzin Choejor

BLOOMSBURY
NEW DELHI · LONDON · OXFORD · NEW YORK · SYDNEY

Contents

Introduction 15

Words of Truth 25

Buddhism 31

The Dalai Lamas 53

His Holiness The 14th Dalai Lama of Tibet

• *Biography* 71

• *Three Main Commitments* 81

• *Birth to Exile* 85

• *Routine Day* 101

• *Training the Mind* 107

• *In Conversation – 80 Questions for His Holiness* 129

• *Quotations* 199

Acknowledgements and Dedication 229

Index 233

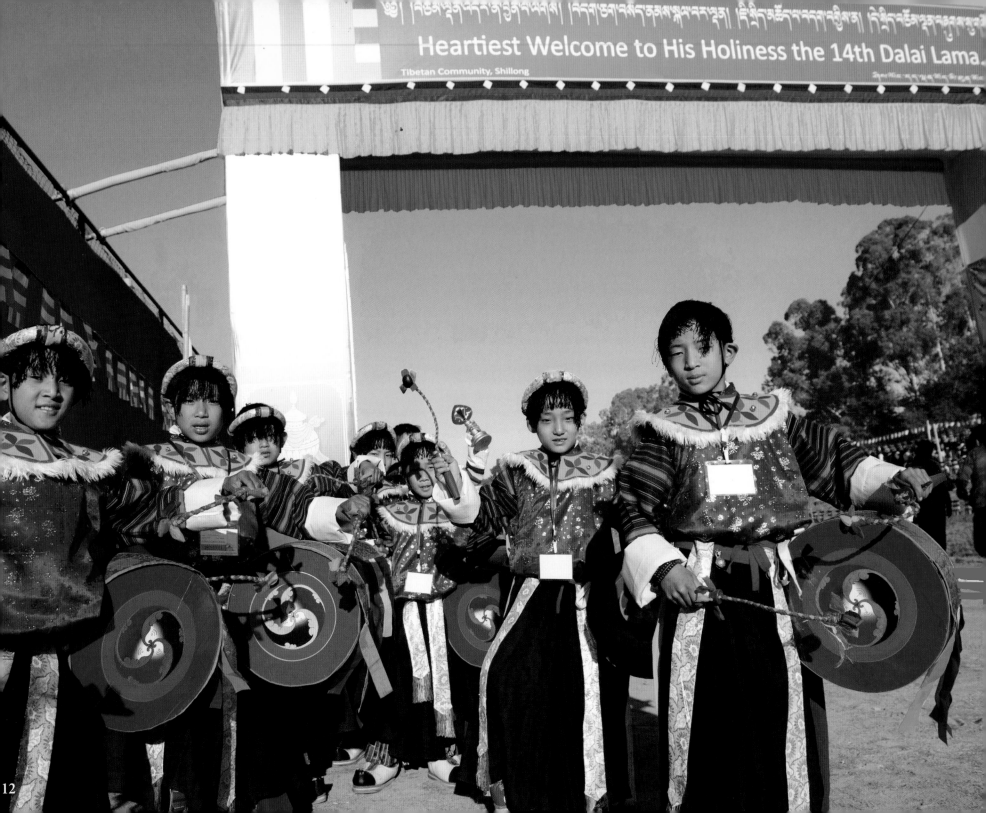

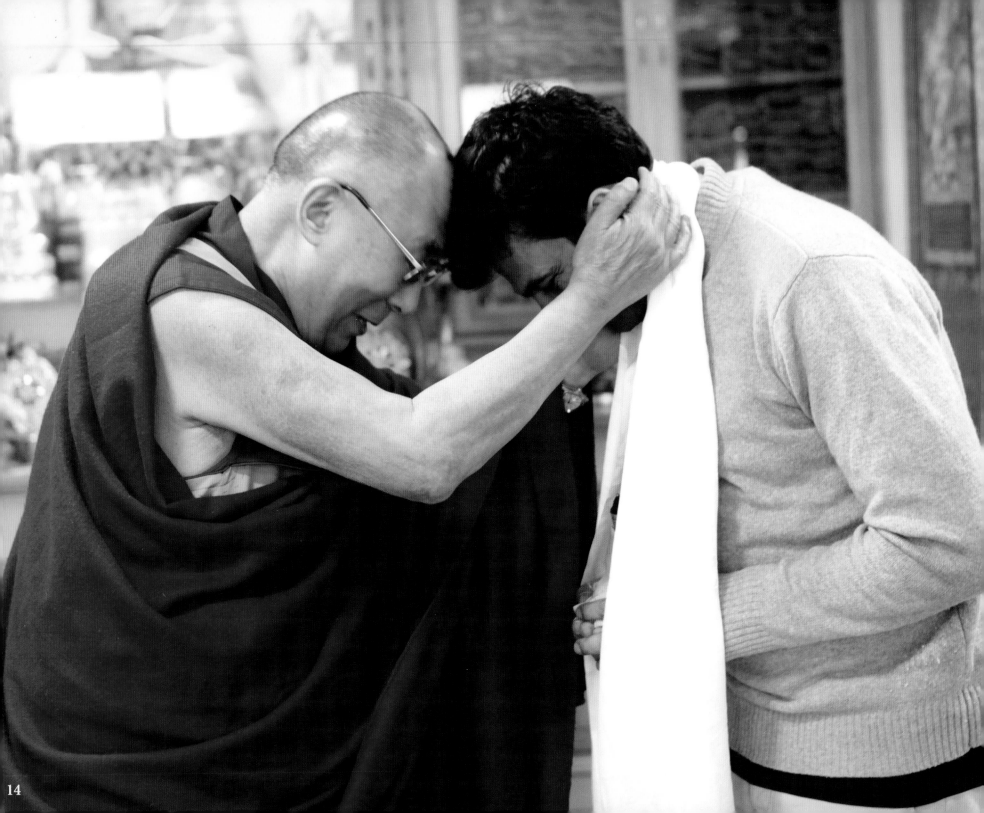

Introduction

My Journey

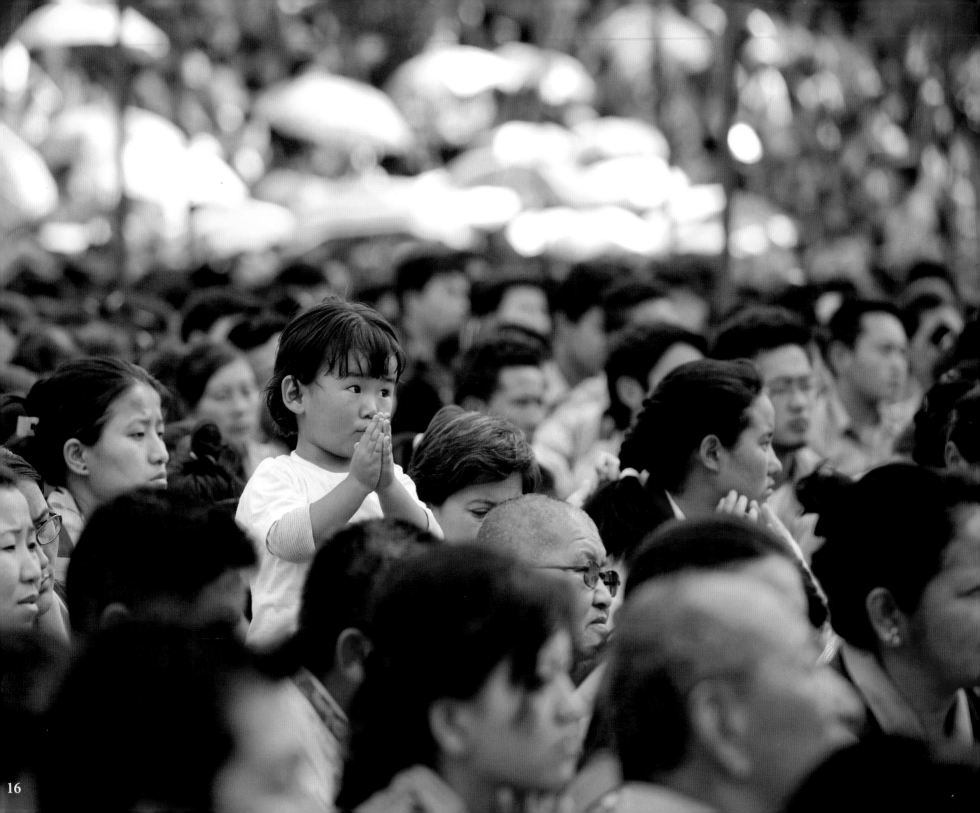

Not long ago, as I sat outside Purnima, with my head buried in my palms, I postponed the moment I would have to hand over the keys and say goodbye to my beloved restaurant forever. It was a long day!

We had already auctioned all the dishes, furniture, kitchen appliances, equipment and the lot that goes into setting up a restaurant. Well, almost everything … because much later I would realize that a restaurant is built on Hope and that day I had none. All I had were huge issues with property leases and several other problems.

The night before, I had worked with my team to organize all the articles so that they could be auctioned easily. I had no idea that all my favourite pans (and I can be very emotional about them) would be arranged perfectly so that someone else could buy and in turn resell them to an unknown restaurant.

Well, if you have ever attended an auction of a business that was about to shut its doors, you possibly would be able to relate to the emotions I was experiencing that day. People come on time, and many actually arrive earlier so that they can get the best things. They throw everything around as if they don't want to miss a single item that could be hidden under some pile or the other. Within a few minutes everything was a mess including the works of art, which had been hanging on the walls, were now scattered on the floor. It was truly a dream breaker. I could clearly see the moment when Gordon Ramsay brought me to the restaurant for the first time on a cold afternoon in April 2007.

The entire restaurant had to be redone for his show *Kitchen Nightmares*. It was an exciting start to something new, a fresh beginning for my career and life. We changed the name of the restaurant from Dillon's to Purnima, which means a full moon, in Hindi. However, on the fateful night that the restaurant shut down, it was to be a moonless night with absolutely no light. I was standing in the middle of all the scattered odds and ends from the auction, while everyone screamed for more discounts, "240 plates for 240 dollars!" I suddenly remembered that there were only 235 plates in the set, as five plates had been broken during a busy dinner service on New Year's Eve. Nevertheless, before I could correct the auctioneer about the number, he yelled, "Sold!"

It was an hour of shame, of humiliation of our work and the agony of loss. I wish we had done things differently to keep the restaurant alive. Within a few moments, everything was gone, and I was left with a feeling of emptiness and utter silence. And then my cell phone rang. I was in no mood to take any calls that day, but it was my dear friend, Tashi Chodron. Also known as the "Momo Queen" in chefs' circles, she has always been a great supporter of my work.

"Do you want to meet His Holiness the Dalai Lama?" she asked.

I was too broken to meet the man I had come to admire the most in my life. At the same time I also wanted to hear someone who would tell me that everything was going to be alright. So, I decided to visit the Beacon Theatre on Broadway. Tashi and I stood in what seemed like an endless queue, and I was almost at the end of it, feeling defeated and humiliated.

It was at this point that my life began to brighten up again. As His Holiness passed by, of all the hundreds of people waiting to catch a glimpse of him, he stopped in front of me, and looked at me with compassion. He touched my forehead, blessed me, and placed a khata, the white Tibetan Buddhist prayer scarf, around my neck.

I was numbed and humbled as I listened to his teachings that day. He explained that the Universe is ever changing, that nothing actually ends, it only changes form.

I met His Holiness again on the following day, at the Waldorf Astoria in New York for the "Thank You India" event.

I had the honour of speaking with him; I told him that I was a chef and had just closed my second restaurant, a couple of days ago. He looked at me and said, "Food is the most essential part of our being; it also helps in understanding the culture." I felt that he was silently referring to Tibet. I somehow just sensed it. His words were to become the most important part of my life and would go on to redefine my entire career.

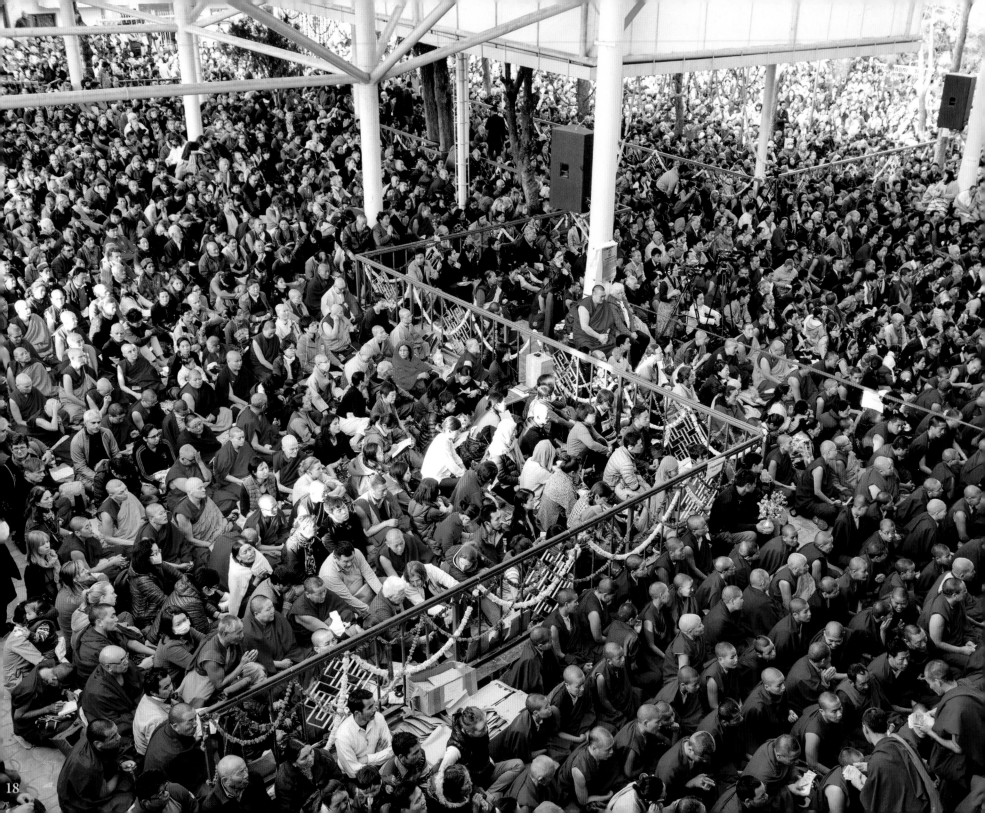

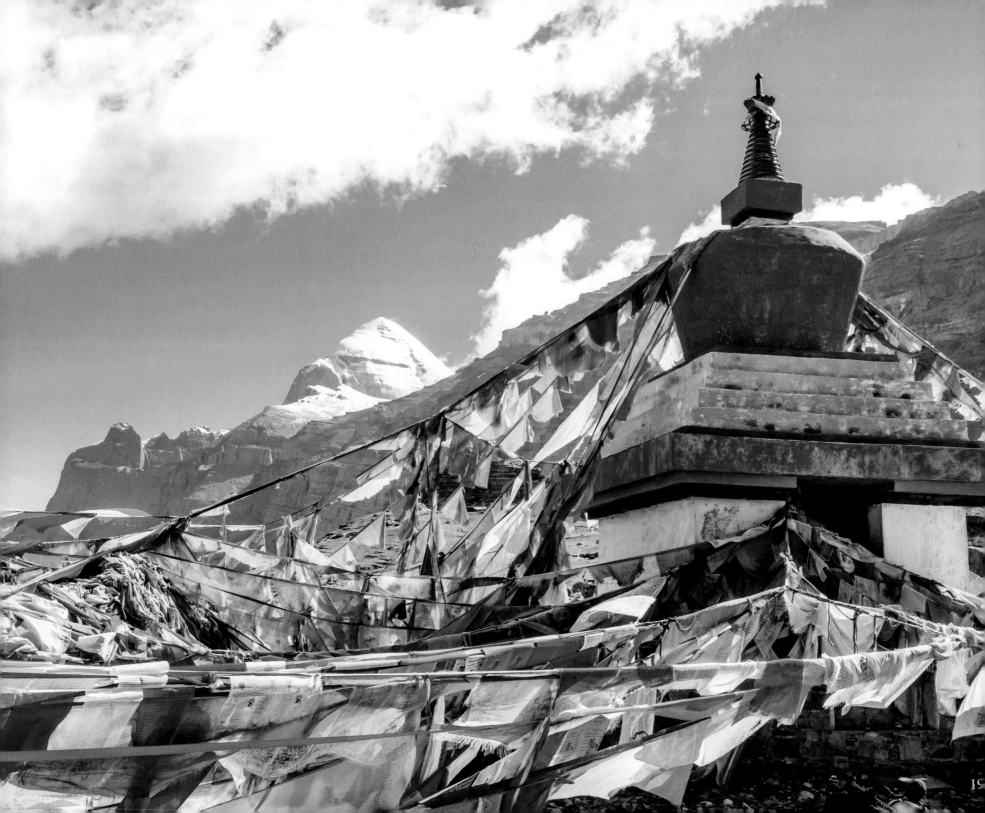

I called my mother and asked her if she could get me a ticket for a trip to Bhutan and Tibet. I said, "I want to write a book on their foods." She affectionately asked, "Viku, where do you want to go? Come to India instead. Life will be easier for you." She meant well as I had no means to support my dreams. Absolutely none.

She booked my tickets anyway, and that's when I started my most soulful book project ever, and a journey into the heart of the Himalayas. In time, *Return to the Rivers* was published by Lake Isle Press, my favourite publishing house (founded by the dynamic visionary Hiroko Kiiffner), and went on to win several accolades and was eventually nominated for the prestigious James Beard Award as well as the IACP award. However, the biggest reward was the *Foreword* sent by HH the Dalai Lama's Office. It was priceless. In the years that followed, every time I have been in doubt or pain, I look up to him. In 2011, I went to Bodh Gaya to attend the Kalachakra and had the privilege of interviewing His Holiness for my documentary series *Holy Kitchens*. I remember every time he spoke about food and its power, the air filled up with an amazing energy and gratitude.

When I presented a copy of the book to His Holiness, he hugged it warmly and blessed it. I had kept my promise, to the best of my ability and power, to preserve the culture and tradition through food stories. I had many more opportunities to meet His Holiness, in America and other countries. He was my shelter when I felt low and lost; his presence worked like a light that was pushing out the darkness for me. Once I asked him, 'What if one dreams the most impossible dream?' He replied, "That person has to trust himself or herself, and also trust in the power of time." My impossible dream was to receive a Michelin Star in my lifetime. It was awarded to my restaurant Junoon in October 2011. When I look at the sequence of events in my life, I always think about the moment when I had lost everything and the biggest loss of all was Hope. If I had left America after Purnima closed down, a lot would never have happened in my world. A new revolution happens when a new sun rises, and new thoughts arise, with trust in time. I will always be thankful to the

hand that stayed connected with me during my journey, which I now call a pilgrimage.

Timeless Legacy is a reflection of His Holiness the Dalai Lama's marvelous thoughts and is my humble gift to him. You were, you are and you will always be my inspiration and my Hero. Thank you! Or as they say in Tibetan, tujay shita-chay!

An Anthem of Harmony

He preaches compassion and peace
Lives as the simplest man with ease
Highest values of tolerance he gives
Without judgement, easily he forgives
First time he heartened my forehead
I realized the power of simple bread
I was a lost man without any hope
Felt that my life was a burning rope
When I thought life was a sad ending
He made me see a brilliant beginning
Swiftly I changed with a new vitality
Reshaping the meaning of prosperity
Lessons he has taught the world
He is the emblem of truth, unfurled
The greatest of it all is his life itself
Taught me to walk tall to success
A modest monk whose smile is lit
When even one soul refuses to quit

Vikas Khanne

Words of Truth

A Prayer Composed by
His Holiness Tenzin Gyatso
The 14th Dalai Lama of Tibet

Honouring and Invoking the Great Compassion
of the Three Jewels; the Buddha, the Teachings,
and the Spiritual Community

O Buddhas, Bodhisattvas, and disciples
of the past, present, and future:
Having remarkable qualities
Immeasurably vast as the ocean,
Who regard all helpless sentient beings
as your only child;
Please consider the truth of my anguished pleas.

Buddha's full teachings dispel the pain of worldly
existence and self-oriented peace;
May they flourish, spreading prosperity and happiness
through-out this spacious world.
O holders of the Dharma: scholars
and realized practitioners;
May your ten-fold virtuous practice prevail.

Humble sentient beings, tormented
by sufferings without cease,
Completely suppressed by seemingly endless
and terribly intense, negative deeds,
May all their fears from unbearable war, famine,
and disease be pacified,
To freely breathe an ocean of happiness and well-being.
And, particularly, the pious people
of the Land of Snows who, through various means,
Are mercilessly destroyed by barbaric hordes
on the side of darkness,
Kindly let the power of your compassion arise,
To quickly stem the flow of blood and tears.

Those unrelentingly cruel ones, objects of compassion,
Maddened by delusion's evils,
wantonly destroy themselves and others;
May they achieve the eye of wisdom,
knowing what must be done and undone,
And abide in the glory of friendship and love.

May this be heartfelt wish of total freedom for all Tibet,
Which has been awaited for a long time,
be spontaneously fulfilled;
Please grant soon the good fortune to enjoy
The happy celebration of spiritual with temporal rule.

O protector Chenrezig, compassionately care for
those who have undergone myriad hardships,
Completely sacrificing their most cherished lives,
bodies, and wealth,
For the sake of the teachings, practitioners,
people, and nation.

Thus, the protector Chenrezig made vast prayers
Before the Buddhas and Bodhisattvas
To fully embrace the Land of Snows;
May the good results of these prayers now quickly appear.
By the profound interdependence of emptiness
and relative forms,
Together with the force of great compassion
in the Three Jewels and their Words of Truth,
And through the power
of the infallible law of actions and their fruits,
May this truthful prayer be unhindered
and quickly fulfilled.

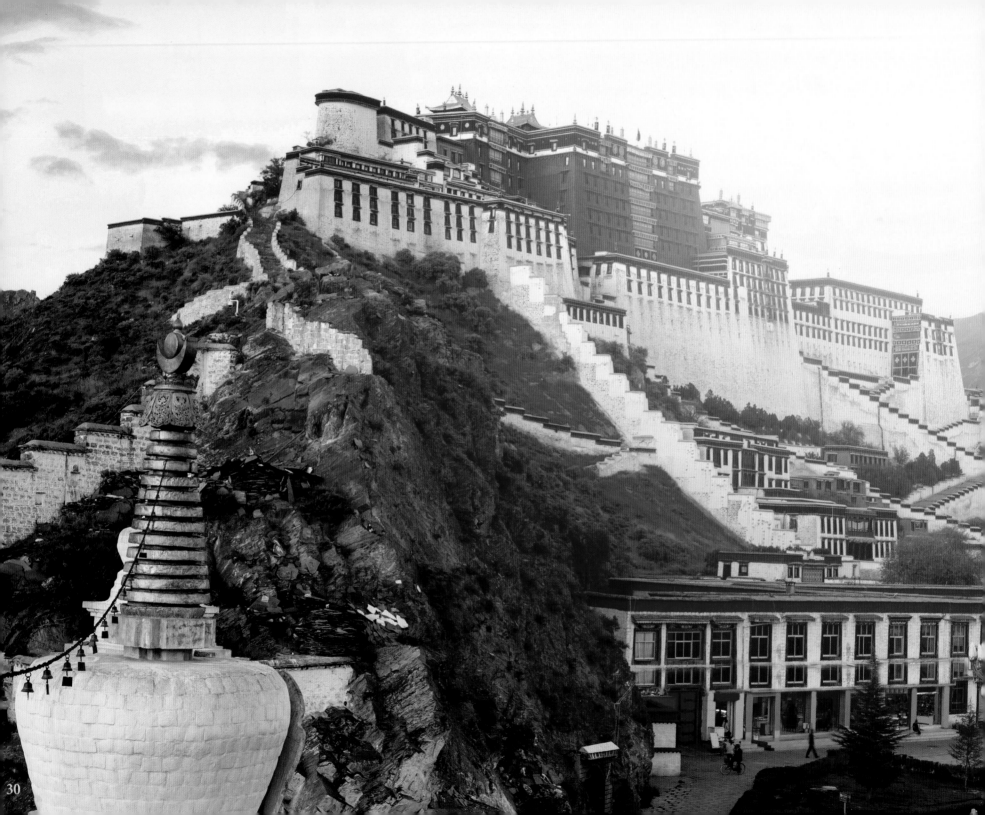

Buddhism

His Holiness the Dalai Lama's
Messages on Buddhism

THE IMPORTANCE OF EMPHASIZING THE EQUALITY OF EVERYONE AS PART OF HUMANITY

While I'm a Buddhist; but at a further, deeper level, I'm a human being, one of the now nearly seven billion human beings. I'm one of them. Humanity, I believe, is a social animal, and each individual's future entirely depends on the rest of humanity. Therefore, for my own self-interest, I have to think seriously about humanity.

Every human being wants a happy life; none of them wants suffering; and each one has every right to achieve that. There's no difference. Whatever religious faith we may have, or as a nonbeliever, or whatever social background we may come from – rich or poor, educated or uneducated, from a royal family or a beggar – we're the same human beings at that level. We are the same. We all have the same rights.

I think, with the many problems that we, i.e. humanity as a whole are facing, we place too much emphasis on the secondary level differences. If we think at a fundamental level, that we are all the same human brothers and sisters, then there's no basis to quarrel, no basis to cheat each other, or to look down at each other. We are the same. So we really need to clearly realize that we are the same.

A future happier humanity is in everybody's interest and is everybody's responsibility. But we Buddhists – I think maybe nearly a thousand million Buddhists – we also have a responsibility to serve humanity. I think Buddha Shakyamuni's motivation for gaining enlightenment was meant for all sentient beings. His whole life and his whole teachings were meant for sentient beings, not only for Buddhists.

The Necessity for Inner Peace at an Individual Level

In order to make this twenty-first century a peaceful century, we have to think about inner peace. Peace is never achieved through declarations, through resolutions, through slogans. Peace must come through inner peace. That's the only way. So in order to create a happier world, ultimately you have to look at the motivation of each individual. Through a world body like the United Nations, you cannot build peace. Peace must come through people's inner peace, at the individual level.

– From the Closing Address by His Holiness the Dalai Lama to the Global Buddhist Congregation 2011

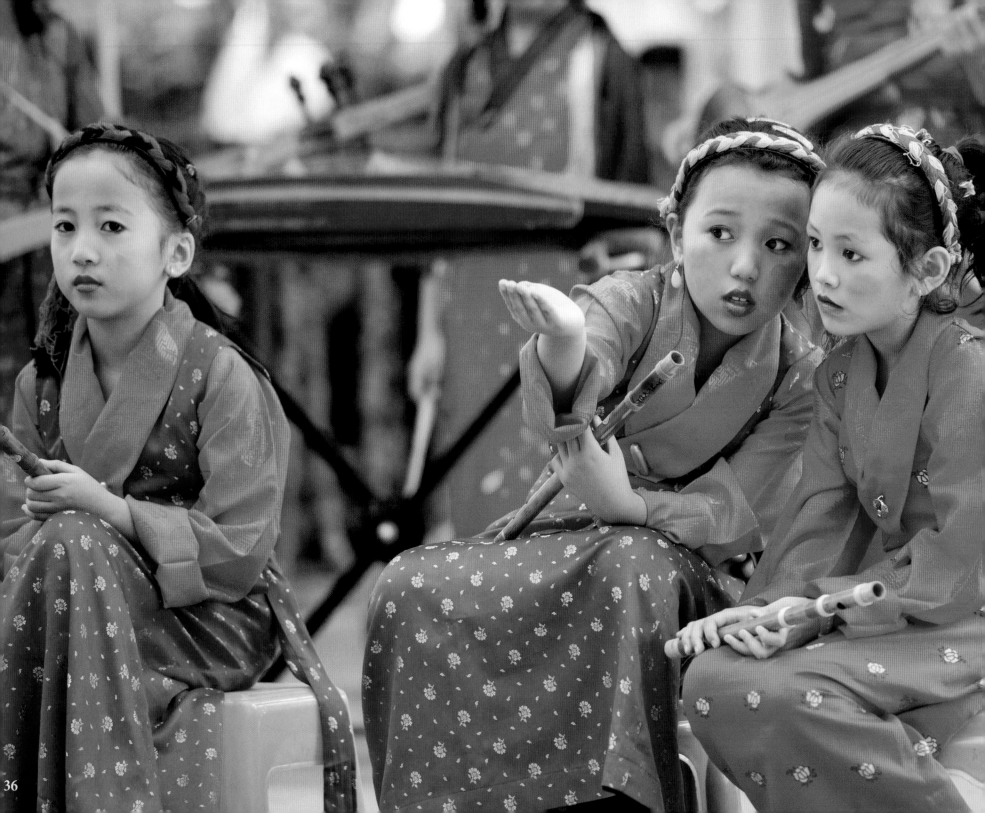

COMPASSION AND THE INDIVIDUAL

The Purpose of Life

ONE GREAT QUESTION underlies our experience, whether we think about it consciously or not: What is the purpose of life? I have considered this question and would like to share my thoughts in the hope that they may be of direct, practical benefit to those who read them.

I believe that the purpose of life is to be happy. From the moment of birth, every human being wants happiness and does not want suffering. Neither social conditioning nor education nor ideology affect this. From the very core of our being, we simply desire contentment. I don't know whether the universe, with its countless galaxies, stars and planets, has a deeper meaning or not, but at the very least, it is clear that we humans who live on this earth, face the task of making a happy life for ourselves. Therefore, it is important to discover what will bring about the greatest degree of happiness.

How to Achieve Happiness

For a start, it is possible to divide every kind of happiness and suffering into two main categories: mental and physical. Of the two, it is the mind that exerts the greatest influence on most of us. Unless we are either gravely ill or deprived of basic necessities, our physical condition plays a secondary role in life. If the body is content, we virtually ignore it. The mind, however, registers every event, no matter how small. Hence we should devote our most serious efforts to bringing about mental peace.

From my own limited experience I have found that the greatest degree of inner tranquility comes from the development of love and compassion.

The more we care for the happiness of others, the greater our own sense of well-being becomes. Cultivating a close, warm-hearted feeling for others automatically puts the mind at ease. This helps remove whatever fears or insecurities we may have and gives us the strength to cope with any obstacles we encounter. It is the ultimate source of success in life.

As long as we live in this world we are bound to encounter problems. If, at such times, we lose hope and become discouraged, we diminish our ability to face difficulties. If, on the other hand, we remember that it is not just ourselves but every one who has to undergo suffering, this more realistic perspective will increase our determination and capacity to overcome troubles. Indeed, with this attitude, each new obstacle can be seen as yet another valuable opportunity to improve our mind!

Thus, we can strive gradually to become more compassionate, that is, we can develop both genuine sympathy for others' suffering and the will to help remove their pain. As a result, our own serenity and inner strength will increase.

Our Need for Love

Ultimately, the reason why love and compassion bring the greatest happiness is simply that our nature cherishes them above all else. The need for love lies at the very foundation of human existence. It results from the profound interdependence we all share with one another. However capable and skillful an individual may be, left alone, he or she will not survive. However vigorous and independent one may feel during the most prosperous periods of life, when one is sick or very young or very old, one must depend on the support of others.

Inter-dependence, of course, is a fundamental law of nature. Not only higher forms of life, but also many of the smallest insects are social beings who, without any religion, law or education, survive by mutual cooperation based on an innate recognition of their interconnectedness. The most subtle level of material phenomena is also governed by interdependence. All phenomena from the planet we inhabit to the oceans, clouds, forests and flowers that surround us, arise in dependence upon subtle patterns of energy. Without their proper interaction, they dissolve and decay.

It is because our own human existence is so dependent on the help of others that our need for love lies at the very foundation of our existence. Therefore, we need a genuine sense of responsibility and a sincere concern for the welfare of others.

We have to consider what we human beings really are. We are not like machine-made objects. If we are merely mechanical entities, then machines themselves could alleviate all of our sufferings and fulfill our needs.

However, since we are not solely material creatures, it is a mistake to place all our hopes for happiness on external development alone. Instead, we should consider our origins and nature to discover what we require.

Leaving aside the complex question of the creation and evolution of our universe, we can at least agree that each of us is the product of our own parents. In general, our conception took place not just in the context of sexual desire, but from our parents' decision to have a child. Such decisions are founded on responsibility and altruism – the parents compassionate commitment to care for their child until it is able to take care of itself. Thus, from the very moment of our conception, our parents' love is directly in our creation.

Moreover, we are completely dependent upon our mothers' care from the earliest stages of our growth. According to some scientists, a pregnant woman's mental state, be it calm or agitated, has a direct physical effect on her unborn child.

The expression of love is also very important at the time of birth. Since the very first thing we do is suck milk from our mothers' breast, we naturally feel close to her, and she must feel love for us in order to feed us properly; if she feels anger or resentment her milk may not flow freely.

Then there is the critical period of brain development from the time of birth up to at least the age of three or four, during which time loving physical contact is the single-most important factor for the normal growth of the child. If the child is not held, hugged, cuddled, or loved, its development will be impaired and its brain will not mature properly.

Since a child cannot survive without the care of others, love is its most important nourishment. The happiness of childhood, the allaying of the child's many fears and the healthy development of its self-confidence all depend directly upon love.

Nowadays, many children grow up in unhappy homes. If they do not receive proper affection, in later life they will rarely love their parents and, not infrequently, will find it hard to love others. This is very sad.

As children grow older and enter school, their need for support must be met by their teachers. If a teacher not only imparts academic education, but also assumes responsibility for preparing students for life, his or her pupils will feel trust and respect and what has been taught will leave an indelible impression on their minds. On the other hand, subjects taught by a teacher who does not show true concern for his or her students' overall well-being will be regarded as temporary and not retained for long.

Similarly, if one is sick and being treated in hospital by a doctor who evinces a warm human feeling, one feels at ease and the doctors' desire to give the best possible care is itself curative, irrespective of the degree of his or her technical skill. On the other hand, if one's doctor lacks human feelings and displays an unfriendly expression, impatience or casual disregard, one will feel anxious, even if he or she is the most highly qualified doctor and the disease has been correctly diagnosed and the right medication prescribed. Inevitably, patients' feelings make a difference to the quality and completeness of their recovery.

Even when we engage in ordinary conversation in everyday life, if someone speaks with human feelings we enjoy listening, and respond accordingly; the whole conversation becomes interesting, however unimportant the topic may be. On the other hand, if a person speaks coldly or harshly, we feel uneasy and wish for a quick end to the interaction. From the least to the most important event, the affection and respect of others are vital for our happiness.

Recently, I met a group of scientists in America who said that the rate of mental illness in their country was quite high-around 12 per cent of the population. It became clear during our discussion that the main cause of depression was not lack of material necessities, but deprivation of the affection of others.

So, as you can see from everything I have written so far, one thing seems clear

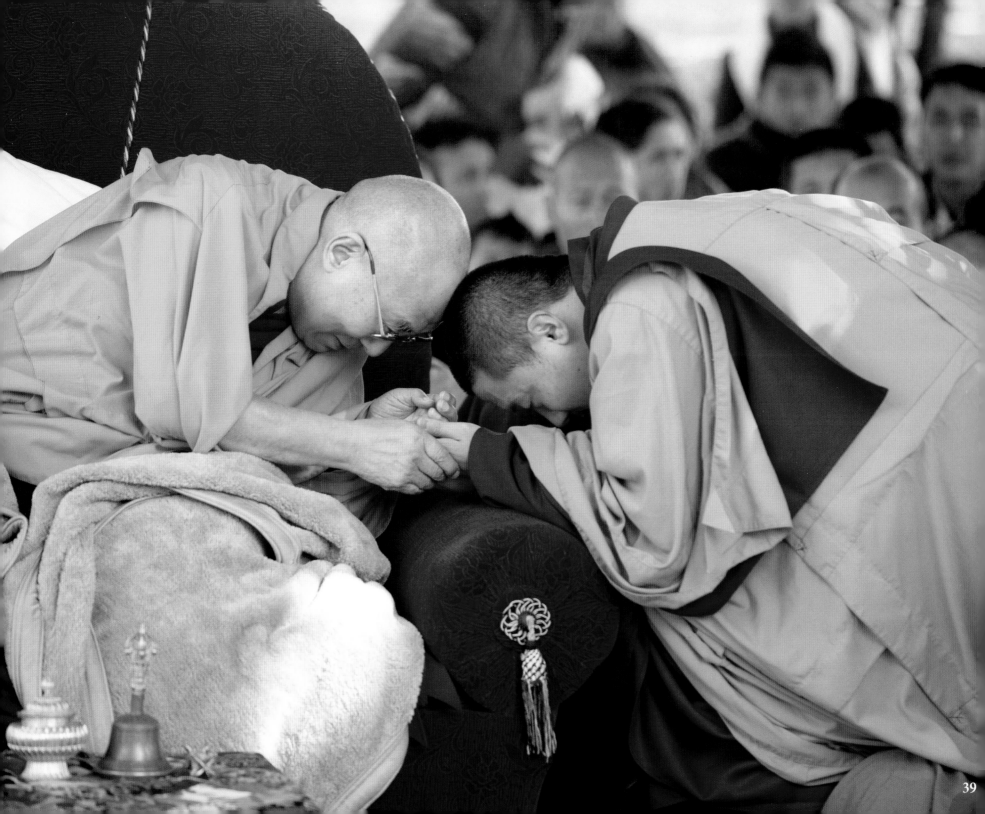

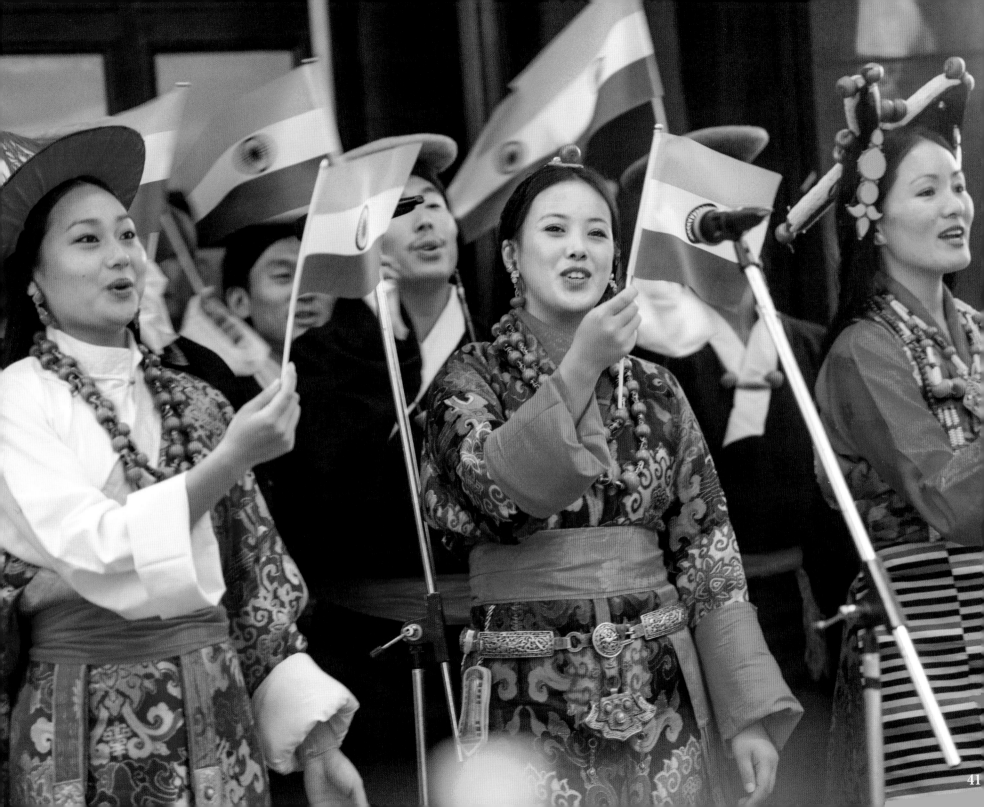

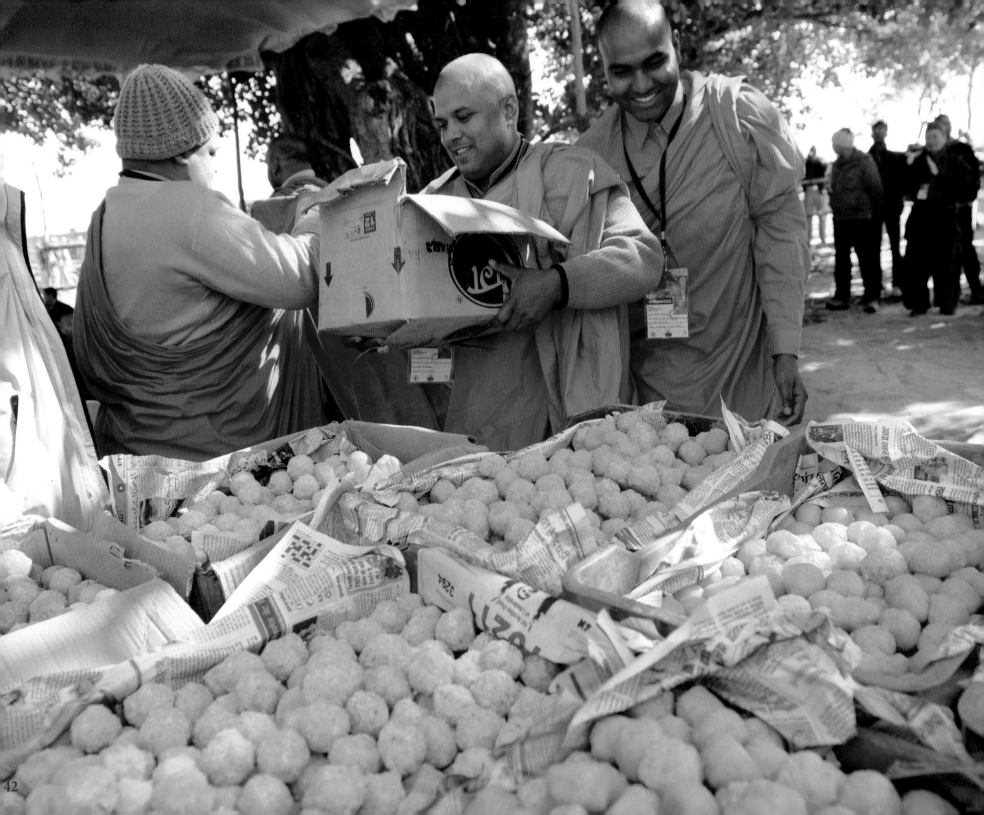

to me: whether or not we are consciously aware of it, from the day we are born, the need for human affection is in our very blood. Even if the affection comes from an animal or someone we would normally consider an enemy, both children and adults will naturally gravitate towards it.

I believe that no one is born free from the need for love. And this demonstrates that, although some modern schools of thought seek to do so, human beings cannot be defined as solely physical. No material object, however beautiful or valuable, can make us feel loved, because our deeper identity and true character lie in the subjective nature of the mind.

Developing Compassion

Some of my friends have told me that, while love and compassion are marvelous and good, they are not really very relevant. Our world, they say, is not a place where such beliefs have much influence or power. They claim that anger and hatred are so much a part of human nature that humanity will always be dominated by them. I do not agree.

We humans have existed in our present state for about a hundred-thousand years. I believe that if during this time the human mind had been primarily controlled by anger and hatred, our overall population would have decreased. But today, despite all our wars, we find that the human population is greater than ever. This clearly indicates to me that love and compassion predominate in the world. And this is why unpleasant events are news, compassionate activities are so much part of daily life that they are taken for granted and, therefore, largely ignored.

So far I have been discussing mainly the mental benefits of compassion, but it contributes to good physical health as well. According to my personal experience, mental stability and physical well-being are directly related. Without question, anger and agitation make us more susceptible to illness. On the other hand, if the mind is tranquil and occupied with positive thoughts, the body will not easily fall prey to disease.

But, of course, it is also true that we all have an innate self-centredness that inhibits our love for others. So, since we desire true happiness that is brought about by only a calm mind, and since such peace of mind is brought about by only a compassionate attitude, how can we develop this? Obviously, it is not enough for us simply to think about how nice compassion is! We need to make concerted efforts to develop it; we must use all the events of our daily life to transform our thoughts and behaviour.

First of all, we must be clear about what we mean by compassion. Many forms of compassionate feelings are mixed with desire and attachment. For instance, the love parents feel for their child is often strongly associated with their own emotional needs, so it is not fully compassionate. Again, in marriage, the love between husband and wife – particularly at the beginning, when each partner still may not know the other's deeper character very well – depends more on attachment than genuine love. Our desire can be so strong that the person to whom we are attached appears to be good, when in fact he or she is very negative. In addition, we have a tendency to exaggerate small positive qualities. Thus, when one partner's attitude changes, the other partner is often disappointed and his or her attitude changes too. This is an indication that love has been motivated more by personal need, than by genuine care for the other individual.

True compassion is not just an emotional response but a firm commitment founded on reason. Therefore, a truly compassionate attitude towards others does not change even if they behave negatively.

Of course, developing this kind of compassion is not at all easy! As a start, let us consider the following facts:

Whether people are beautiful and friendly or unattractive and disruptive, ultimately they are human beings, just like oneself. Like oneself, they want happiness and do not want suffering. Furthermore, their right to overcome suffering and to be happy is equal to one's own. Now, when you recognize that all beings are equal in both their desire for happiness and their right to obtain it, you automatically feel empathy and closeness to them. Through accustoming your mind to this sense of universal altruism, you develop a

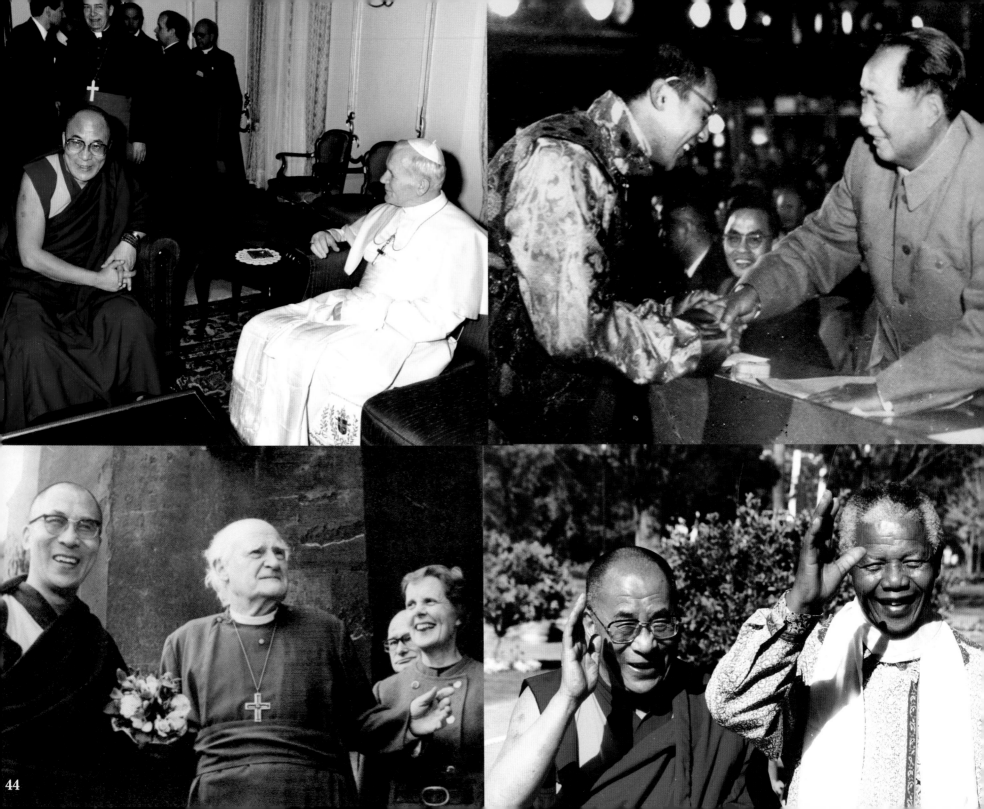

feeling of responsibility for others: the wish to help them actively overcome their problems. Nor is this wish selective; it applies equally to all. As long as they are human beings experiencing pleasure and pain just as you do, there is no logical basis to discriminate between them or to alter your concerns for them if they behave negatively.

Let me emphasize that it is within your power, given patience and time, to develop this kind of compassion. Of course, our self-centredness, our distinctive attachment to the feeling of an independent, self-existent, works fundamentally to inhibit our compassion. Indeed, true compassion can be experienced only when this type of self-grasping is eliminated. But this does not mean that we cannot start and make progress now.

How Can We Start

We should begin by removing the greatest hindrances to compassion: anger and hatred. As we all know, these are extremely powerful emotions and they can overwhelm our entire mind. Nevertheless, they can be controlled. If, however, they are not, these negative emotions will plague us – with no extra effort on their part – and impede our quest for the happiness of a loving mind.

So as a start, it is useful to investigate whether or not anger is of value. Sometimes, when we are discouraged by a difficult situation, anger does seem helpful, appearing to bring with it more energy, confidence and determination.

Here, though, we must examine our mental state carefully. While it is true that anger brings extra energy, if we explore the nature of this energy, we discover that it is blind: we cannot be sure whether its result will be positive or negative. This is because anger eclipses the best part of our brain: its rationality. So the energy of anger is almost always unreliable. It can cause an immense amount of destructive, unfortunate behaviour. Moreover, if anger increases to the extreme, one becomes like a mad person, acting in ways that are as damaging to oneself as they are to others.

It is possible, however, to develop an equally forceful but far more controlled energy with which to handle difficult situations.

This controlled energy comes not only from a compassionate attitude, but also from reason and patience. These are the most powerful antidotes to anger. Unfortunately, many people misjudge these qualities as signs of weakness. I believe the opposite to be true: that they are the true signs of inner strength. Compassion is by nature gentle, peaceful and soft, but it is very powerful, because those who easily lose their patience are those who are insecure and unstable. Thus, to me, the arousal of anger is a direct sign of weakness.

So, when a problem arises, try to remain humble, maintain a sincere attitude and be concerned that the outcome is fair. Of course, others may try to take advantage of you, and if your remaining detached only encourages unjust aggression, adopt a strong stand. This, however, should be done with compassion, and if it is necessary to express your views and take strong countermeasures, do so without anger or ill-intent.

You should realize that even though your opponents appear to be harming you, in the end, their destructive activity will damage only themselves. In order to check your own selfish impulse to retaliate, you should recall your desire to practice compassion and assume responsibility for helping prevent the other person from suffering the consequences of his or her acts.

Thus, because the measures you employ have been calmly chosen, they will be more effective, more accurate and more forceful. Retaliation based on the blind energy of anger seldom hits the target.

Friends and Enemies

I must emphasize again that merely thinking that compassion and reason and patience are good will not be enough to develop them. We must wait for difficulties to arise and then attempt to practice them.

And who creates such opportunities? Not our friends, of course, but our enemies. They are the ones who give us the most trouble. So if we truly wish to learn, we should consider enemies to be our best teachers!

For a person who cherishes compassion and love, the practice of tolerance is essential, and for that, an enemy is indispensable. So we should feel grateful

to our enemies, for it is they who can best help us develop a tranquil mind! Also, it is often the case in both personal and public life, that with a change in circumstances, enemies become friends.

So anger and hatred are always harmful, and unless we train our minds and work to reduce their negative force, they will continue to disturb us and disrupt our attempts to develop a calm mind. Anger and hatred are our real enemies. These are the forces we most need to confront and defeat, not the temporary enemies who appear intermittently throughout life.

Of course, it is natural and right that we all want friends. I often joke that if you really want to be selfish, you should be very altruistic! You should take good care of others, be concerned for their welfare, help them, serve them, make more friends, smile more, and the result? When you yourself need help, you find plenty of helpers! If, on the other hand, you neglect the happiness of others, in the long term you will be the loser. And is friendship produced through quarrels and anger, jealousy and intense competitiveness? I do not think so. Only affection brings us genuinely close friends.

In today's materialistic society, if you have money and power, you seem to have many friends. But they are not friends of yours; they are the friends of your money and power. When you lose your wealth and influence, you will find it very difficult to track down these people.

The trouble is that when things in the world go well for us, we become confident that we can manage by ourselves and feel we do not need friends, but as our status and health decline, we quickly realize how wrong we were. That is the moment when we learn who is really helpful and who is completely useless. So to prepare for that moment, to make genuine friends who will help us when the need arises – we ourselves must cultivate altruism!

Though sometimes people laugh when I say it, I myself always want more friends. I love smiles. Because of this I have the problem of knowing how to make more friends and how to get more smiles, in particular, genuine smiles. For there are many kinds of smile, such as sarcastic, artificial or diplomatic smiles. Many smiles produce no feelings of satisfaction, and sometimes they can even create suspicion or fear, can't they? But a genuine smile really gives us a feeling of freshness, and is, I believe, unique to human beings. If these are the smiles we want, then we ourselves must create the reasons for them to appear.

Compassion and the World

In conclusion, I would briefly like to expand my thoughts beyond the topic of this short piece and make a wider point: individual happiness can contribute in a profound and effective way to the overall improvement of our entire human community.

Because we all share an identical need for love, it is possible to feel that anybody we meet, in whatever circumstances, is a brother or a sister. No matter how new the face, or how different the dress and behaviour, there is no significant division between us and other people. It is foolish to dwell on external differences, because our basic nature is the same.

Ultimately, humanity is one and this small planet is our only home; if we are to protect this home of ours, each of us needs to experience a vivid sense of universal altruism. It is only this feeling that can remove the self-centred motives that cause people to deceive and misuse one another.

If you have a sincere and open heart, you naturally feel self-worth and confidence, and there is no need to be fearful of others.

I believe that at every level of society – familial, tribal, national and international – the key to a happier and more successful world is the growth of compassion. We do not need to become religious, nor do we need to believe in an ideology. All that is necessary is for each of us to develop our good human qualities.

I try to treat whoever I meet as an old friend. This gives me a genuine feeling of happiness. It is the practice of compassion.

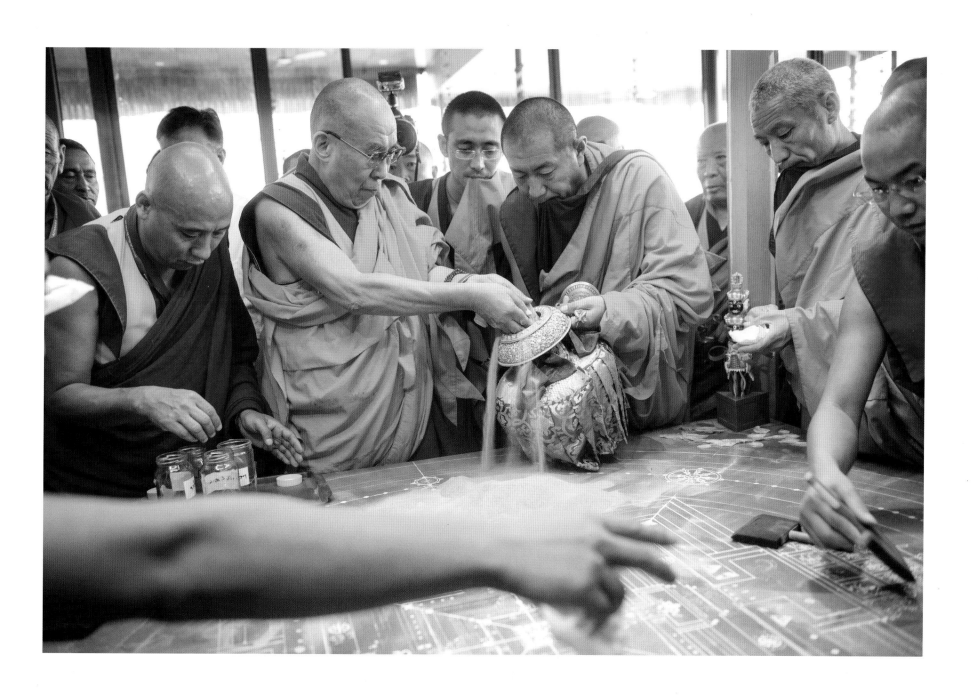

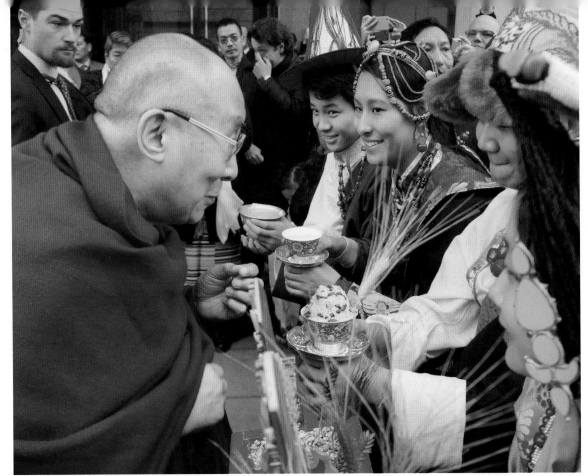

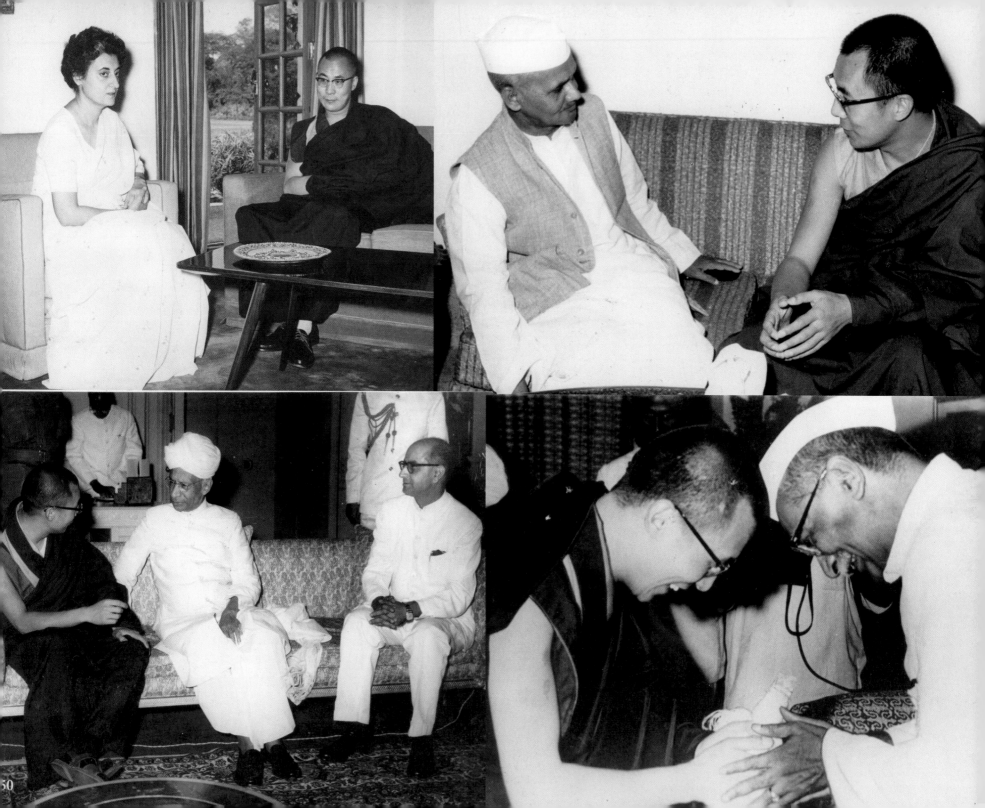

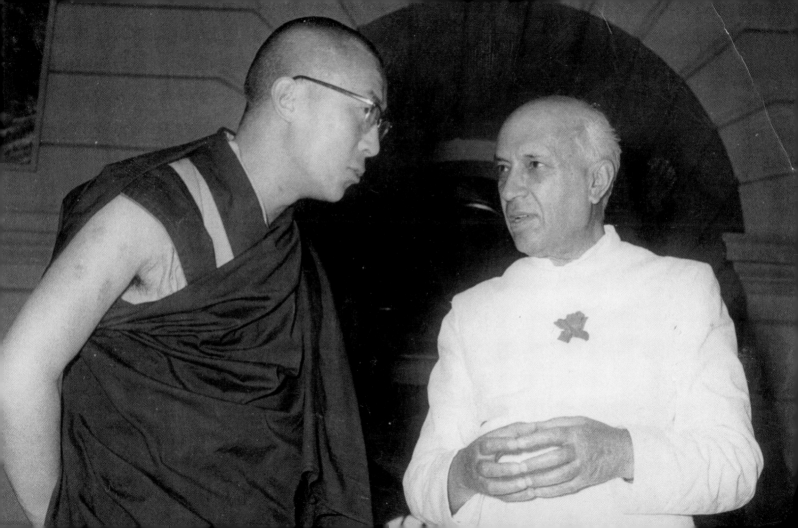

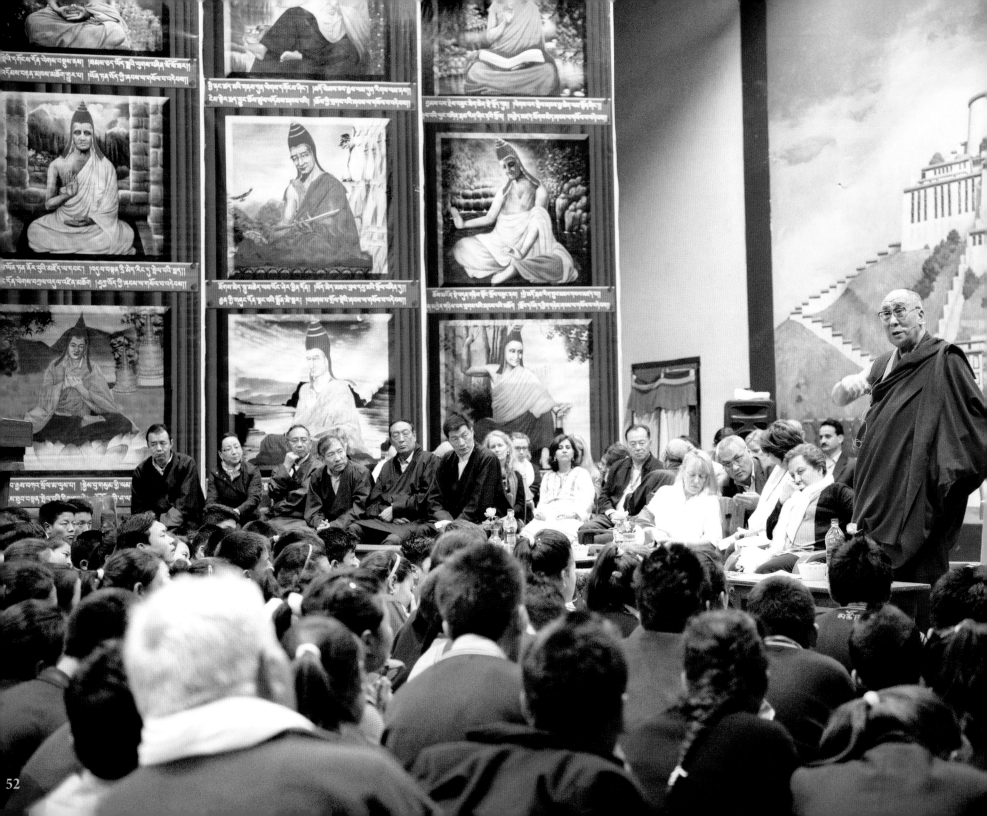

The Dalai Lamas

A Brief History

The Dalai Lamas are believed by Tibetan Buddhist followers to be manifestations of Avalokiteshvara or Chenrezig, the Bodhisattva of Compassion and the patron saint of Tibet. Bodhisattvas are believed to be enlightened beings who have postponed their own nirvana and chosen to take rebirth in order to serve humanity.

THE FIRST DALAI LAMA, GEDUN DRUPA

The First Dalai Lama, Gedun Drupa, was born in 1391 in Gyurmey Rupa, near Sakya in the Tsang region of central Tibet to Gonpo Dorjee and Jomo Namkha Kyi, a nomadic family. His given name was Pema Dorjee.

He did his primary study of reading and writing the Tibetan script with Gya-Ton Tsenda Pa-La, and then at the age of fourteen, he took his novice vows from Khenchen Drupa Sherab, abbot of Narthang monastery, who gave him the religious name of Gedun Drupa. Later, in the year 1411, he took the Gelong vows (full ordination) from the abbot.

The young Gedun Drupa was aware of the fame of the Great Tsongkhapa, the founder of the Gelugpa School and became his disciple in 1416. His loyalty and devotion to Tsongkhapa persuaded the great master to make Gedun Drupa his principal disciple. Tsongkhapa handed Gedun Drupa a brand new set of robes as a sign that he would spread the Buddhist teachings all over Tibet. In 1447, Gedun Drupa founded the Tashi Lhunpo monastery in Shigatse, one of the biggest monastic universities of the Gelugpa School.

The First Dalai Lama, Gedun Drupa was a great scholar, famous for combining study and practice, and wrote more than eight voluminous books on his insights into the Buddha's teachings and philosophy. In 1474, at the age of eighty-four, he died while in meditation at Tashi Lhunpo monastery.

THE SECOND DALAI LAMA, GEDUN GYATSO

The Second Dalai Lama, Gedun Gyatso was born in 1475 in Tanag Sekme, near Shigatse in the Tsang region of central Tibet to Kunga Gyaltso and Machik Kunga Pemo, in a farming family.

His father was a well-known tantric practitioner belonging to the Nyingmapa sect. When Gedun Gyatso was able to speak, he was reported to have told his parents that his name was Pema Dorjee, the birth name of the First Dalai Lama and that he would like to live in Tashi Lhunpo monastery. When he was conceived, his father had a dream in which someone dressed in white appeared and told him to name his son Gendun Drupa and also said that his son would be a person with the ability to recollect his past lives. However, his father named him Sangye Phel.

He received his primary education from his father and at the age of eleven was recognized as the reincarnation of Gendun Drupa, the First Dalai Lama and was enthroned at Tashi Lhunpo monastery. In 1486, he took his novice vows from Panchen Lungrig Gyatso and his vows of Gelong (full ordination) from Choje Choekyi Gyaltsen, who gave him the ordained name of Gedun Gyatso. He studied at Tashi Lhunpo and Drepung monasteries.

In 1517, Gedun Gyatso became the abbot of Drepung monastery and in the following year, he revived the Monlam Chenmo, the Great Prayer Festival and presided over the events with monks from Sera, Drepung and Gaden, the three great monastic universities of the Gelugpa sect. In 1525, he became the abbot of Sera Monastery. He died at the age of sixty-seven in 1542.

THE THIRD DALAI LAMA, SONAM GYATSO

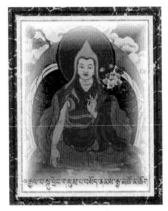

The Third Dalai Lama, Sonam Gyatso was born in 1543 at Tolung, near Lhasa, to Namgyal Drakpa and Pelzom Bhuti, in a rich family.

His parents already had many children, but they had all died and to ward off any misfortune that might take away this newborn child from them, they fed him on the milk of a white goat and named him Ranu Sicho Pelzang – the prosperous one saved by goat's milk.

In 1546, at the age of three, Sonam Dakpa Gyaltsen, the ruler of Tibet, and Panchen Sonam Dakpa recognized him as the reincarnation of Gedun Gyatso. He was escorted to Drepung monastery in a great procession and was enthroned and his hair was cut, symbolizing his renunciation of the world. He took novice vows from Sonam Dakpa at the age of seven and assumed the name of Sonam Gyatso. At twenty-two, he took the Gelong vows (full ordination) of Bhiksu from Gelek Palsang.

In 1552, Sonam Gyatso became the abbot of Drepung monastery and in 1558, the abbot of Sera monastery. In 1574, he established the Phende Lekshe Ling in order to assist him in carrying out his religious activities, which is now known as Namgyal monastery and still serves as the Dalai Lama's personal monastery. It was during his time, the Mongolian King Altan Khan offered him the title of Dalai Lama, which literally means Ocean of Wisdom, and in return, the Dalai Lama conferred on Altan Khan the title of Brahma, the king of religion. The Third Dalai Lama also founded Kumbum monastery in Tsongkhapa's birthplace and Lithang monastery in Kham. In 1588, he died while teaching in Mongolia.

THE FOURTH DALAI LAMA, YONTEN GYATSO

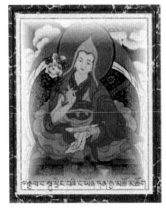

The Fourth Dalai Lama, Yonten Gyatso, was born in 1589 in Mongolia to the Chokar tribal chieftain Tsultrim Choeje, who was the grandson of Altan Khan, and his second wife PhaKhen Nula.

With predictions from the state oracles and auspicious signs at his birth, the abbot of Gaden monastery recognized him as the true reincarnation of the Third Dalai Lama and was given the name of Yonten Gyatso. His parents, however, refused to part with their son until he was older, so he received his primary religious education in Mongolia from Tibetan Lamas.

In 1601, at the age of twelve, Yonten Gyatso was escorted to Tibet accompanied by his father and the former Gaden throne holder, Sangya Rinchen, who bestowed the vows of novice monk on him. In 1614, at the age of twenty-six, he took the Gelong vows (full ordination) from the Fourth Panchen Lama, Lobsang Choegyal. He later became the abbot of Drepung monastery and then Sera monastery. In 1617, at the age of twenty-seven he died at Drepung monastery.

THE FIFTH DALAI LAMA, LOBSANG GYATSO

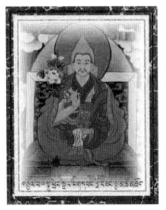

The Fifth Dalai Lama, Lobsang Gyatso, was born in 1617 in Lhoka Chingwar Taktse, south of Lhasa to Dudul Rabten and Kunga Lhanzi.

When Sonam Choephel, the chief attendant of the Fourth Dalai Lama heard of the exceptional abilities of the Chong-Gya boy, he paid a visit to the child and showed him articles belonging to the previous Dalai Lama. The boy at once said that

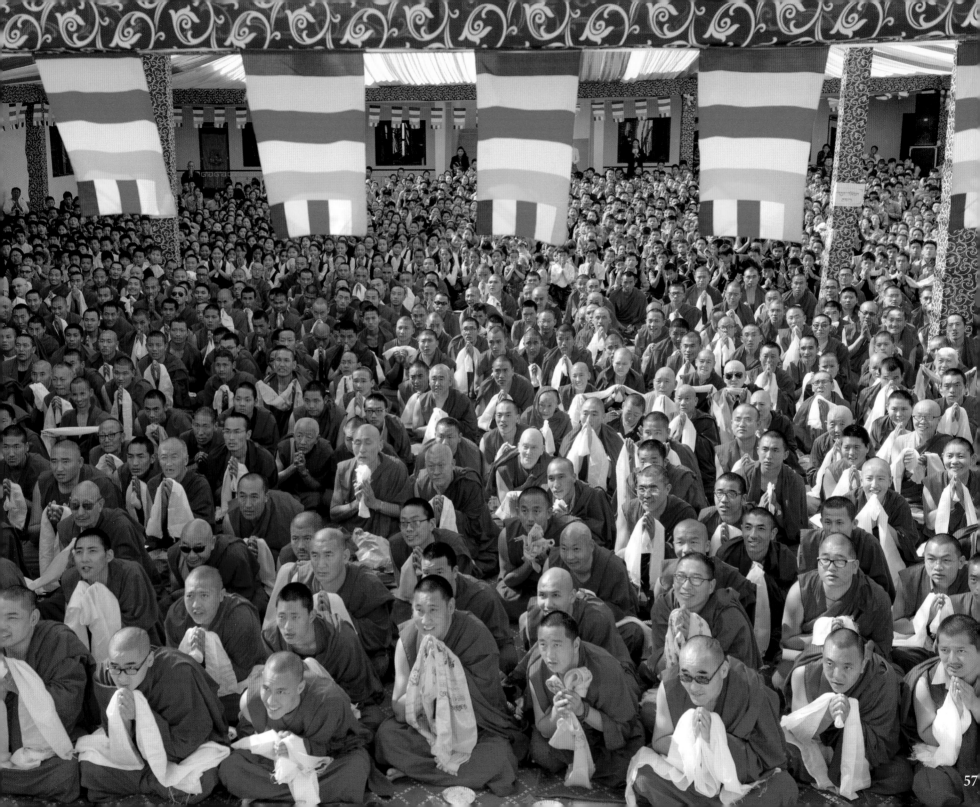

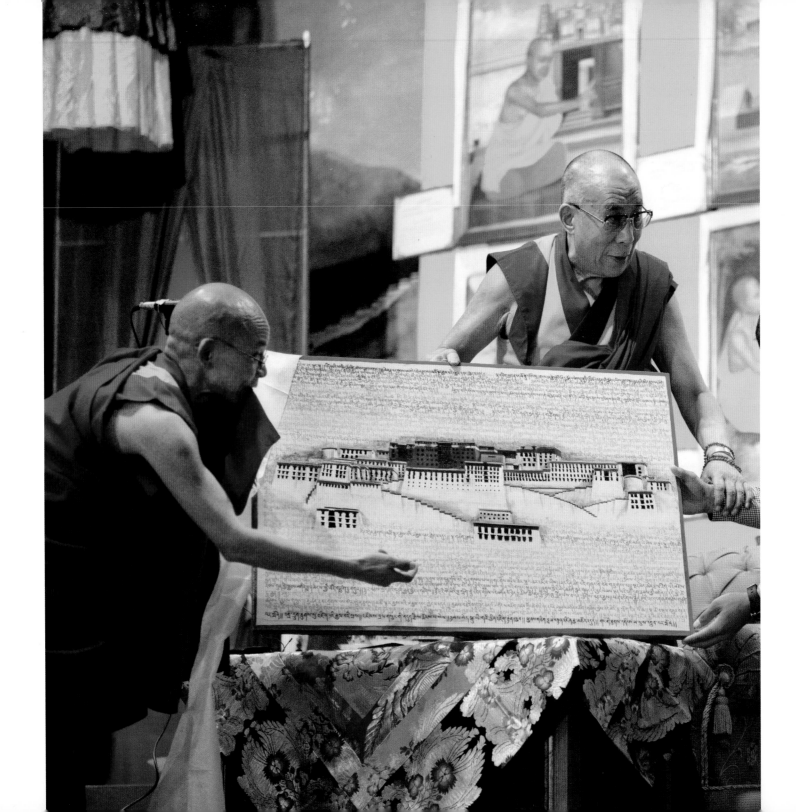

those belonged to him. Sonam Choephel kept the discovery of the Fifth Dalai Lama a secret because of the turbulent political situation. When things settled down, the Fifth Dalai Lama was taken to Drepung monastery where he was ordained into monkhood by the Third Panchen Lama, Lobsang Chogyal, and was given the name Ngawang Lobsang Gyatso.

The Fifth Dalai Lama was recognized at a time when Tibet was in political turmoil. However, all this uncertainty was laid to rest by Gushir Khan, the chief of the Qoshot Mongols and in 1642, the Dalai Lama was enthroned in the main hall of Shigatse as both the spiritual and political leader of Tibet. In 1645, the Dalai Lama held a meeting with high officials of Gaden Phodrang on the construction of the Potala Palace on the Red Hill, where the 33rd King of Tibet Songtsen Gampo had built a red fort. In the same year, construction started and it took almost forty-three years to complete.

In 1649, Sunzhi, the Manchu emperor, invited the Dalai Lama to Peking. When he reached the Chinese province of Ningxia, he was greeted by the emperor's minister and military commander who came with three thousand cavalry to escort the Tibetan leader. The emperor himself travelled from Peking and greeted him at a place called Kothor. In the Chinese capital, the Dalai Lama stayed at the Yellow Palace, built for him by the emperor. When the emperor officially met the Dalai Lama, the two of them exchanged titles. In 1653, the Dalai Lama returned to Tibet.

Gushir Khan died in 1655, as did Sonam Choephel. The Dalai Lama appointed Gushir Khan's son Tenzin Dorjee as the new Mongol king, and Drong Mey-Pa Thinley Gyatso succeeded the latter to the post of Desi. When the Manchu Emperor died in 1662, his son, K'ang-si, ascended the Manchu throne. In the same year, the Panchen Lama died at the age of ninety-one. In 1665, after a petition from Tashilhunpo monastery, the Dalai Lama recognized a boy from Tsang region as the reincarnation of the late Panchen Lama and gave the boy the name of Lobsang Yeshi.

The Fifth Dalai Lama was a great scholar, well versed in Sanskrit. He wrote many books, including one on poetry. He also established two educational institutions, one for amateur officials and another for monk officials, where they were taught Mongolian, Sanskrit, astrology, poetry, and administration. He was a man of few words, but what he said carried conviction and influenced rulers beyond the borders of Tibet. In 1682, at the age of sixty-five he died before completing the construction of the Potala Palace, however, not before entrusting the responsibility of the construction to Sangya Gyatso, the new Desi with the advice to hold the secret of his death for the time being.

THE SIXTH DALAI LAMA, TSANGYANG GYATSO

The Sixth Dalai Lama, Tsangyang Gyatso, was born in 1682 in the region of Mon Tawang in present-day Arunachal Pradesh, India, to Tashi Tenzin and Tsewang Lhamo.

In order to complete the Potala Palace, Desi Sangye Gyatso carried out the wishes of the Fifth Dalai Lama and kept his death a secret for fifteen years. People were told that the Great Fifth was continuing his long retreat. On important occasions, the Dalai Lama's ceremonial gown was placed on the throne. However, when Mongol princes insisted on an audience, an old monk called Depa Deyrab of Namgyal Monastery, who resembled the Dalai Lama, was hired to pose in his place. He wore a hat and eyeshadow to conceal the fact that he lacked the Dalai Lama's piercing eyes. The Desi managed to maintain this charade till he heard that a boy in Mon exhibited remarkable abilities. He sent his trusted attendants to the area and in 1688, the boy was brought to Nankartse, a place near Lhasa. He was educated there by teachers appointed by the Desi until 1697, when the Desi sent his trusted minister, Shabdrung Ngawang Shonu to the Manchu court to inform Emperor K'ang-si of the death of the Fifth and discovery of the Sixth Dalai Lama. He announced the fact to the people of Tibet, who greeted the news with gratitude

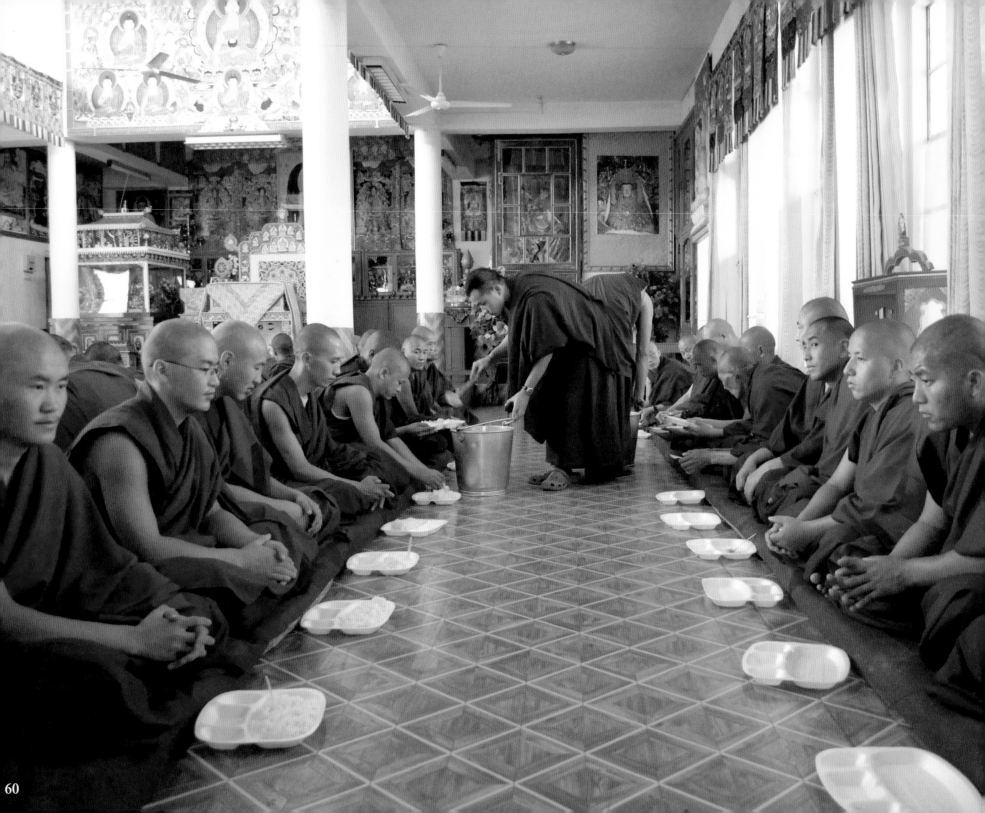

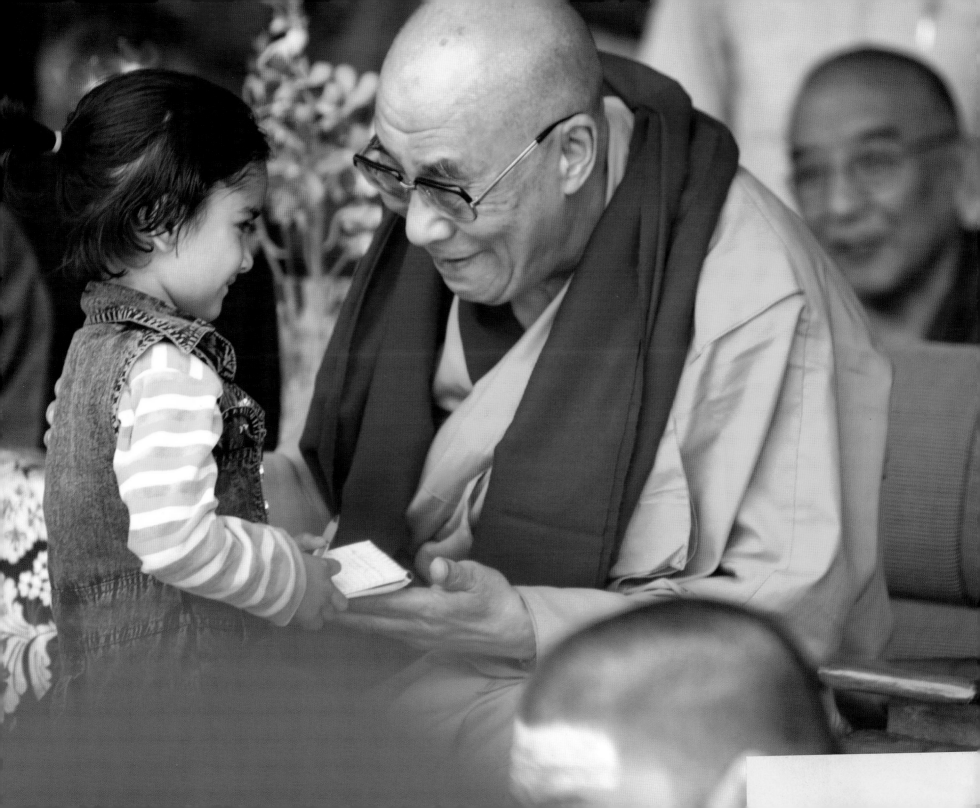

and joy and thanked the Desi for saving them from lamenting the setting of the sun and, instead, making them rejoice in its rising.

The Desi invited the Fifth Pachen Lama, Lobsang Yeshi, to Nankartse, where Tibet's second highest religious leader administered the vows of a novice monk to the youth and named him Tsangyang Gyatso. In 1697, the fourteen year old was enthroned as the Sixth Dalai Lama in a ceremony attended by Tibetan government officials representing the three major monasteries – Sera, Gaden, and Drepung – Mongol princes, representatives of Emperor K'ang-si and the Lhasa populace.

In 1701 there was a conflict between the Desi and Lhasang Khan, the descendant of Gushir Khan, and the latter killed the Desi Sangya Gyatso, which disturbed the young Dalai Lama. He left his monastic studies and chose an outdoor life, and planned not to take the fully ordained vows. In fact, he visited the Panchen Lama in Shigatse and requested his forgiveness, and renounced even the vows of a novice monk. Though he continued to live in the Potala Palace, he roamed around Lhasa and other outlying villages, spending his days with his friends in the park behind the Potala Palace and nights in taverns in Lhasa and Shol (an area below the Potala) drinking chang and singing songs. He was known to be a great poet and writer and wrote several poems. In 1706, he was invited to China and died on the way.

THE SEVENTH DALAI LAMA, KELSANG GYATSO

In retrospect, Tibetans believed that Tsangyang Gyatso predicted his own rebirth at Lithang in Kham when he wrote this song:

> *White crane, lend me your wings,*
> *I go no farther than Lithang,*
> *And thence, return again.*

Sure enough, the Seventh Dalai Lama was born in 1708 to Sonam Dargya and Lobsang Chotso in Lithang, two years after the disappearance of the Sixth.

Thupten Jampaling Monastery, which was founded in Lithang by the Third Dalai Lama, was astonished by the wonders of the child, and also the state oracles of Lithang had predicted that the newborn child would be the reincarnation of the late Dalai Lama. However due to the turbulent political situation, they could not escort the new Dalai Lama to Lhasa, and he was taken to Kumbum monastery, where he was ordained by Ngawang Lobsang Tenpai Gyaltsen.

In 1720, he was enthroned in the Potala Palace and took the novice vows of monkhood from Panchen Lobsang Yeshi, who gave him the name Kelsang Gyatso. In 1726, during the auspicious month of Saka Dawa, he took the Gelong vows (full ordination) from Panchen Rinpoche. He sought the tutor of Panchen Lobsang Yeshi, the abbot of Gyumey monastery and the abbot of Shalu monastery, Ngawang Yonten, from whom he studied the entire major Buddhist philosophical treatises and became a master in both the sutra and tantra.

In 1751, at the age of forty-three, he constituted the 'Kashag' or council of ministers to administer the Tibetan government and then abolished the post of Desi, as it placed too much power in one man's hand. The Dalai Lama became the spiritual and political leader of Tibet. At the age of forty-five, he founded the Tse-School in the Potala Palace and built the new palace of Norling Kalsang Phodrang. The Seventh Dalai Lama was a great scholar and wrote many books, especially on the tantra. He was also a great poet who, unlike Tsangyang Gyatso, dwelt on spiritual themes. His simple and unblemished life won him the hearts of all Tibetans. He died in 1757.

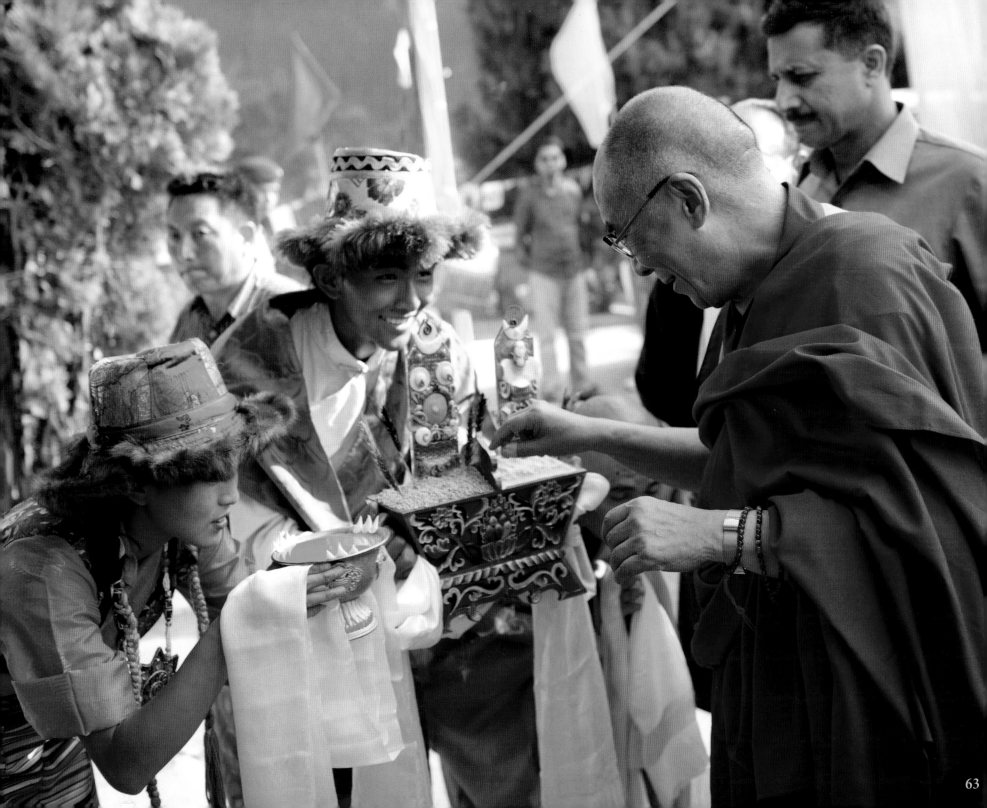

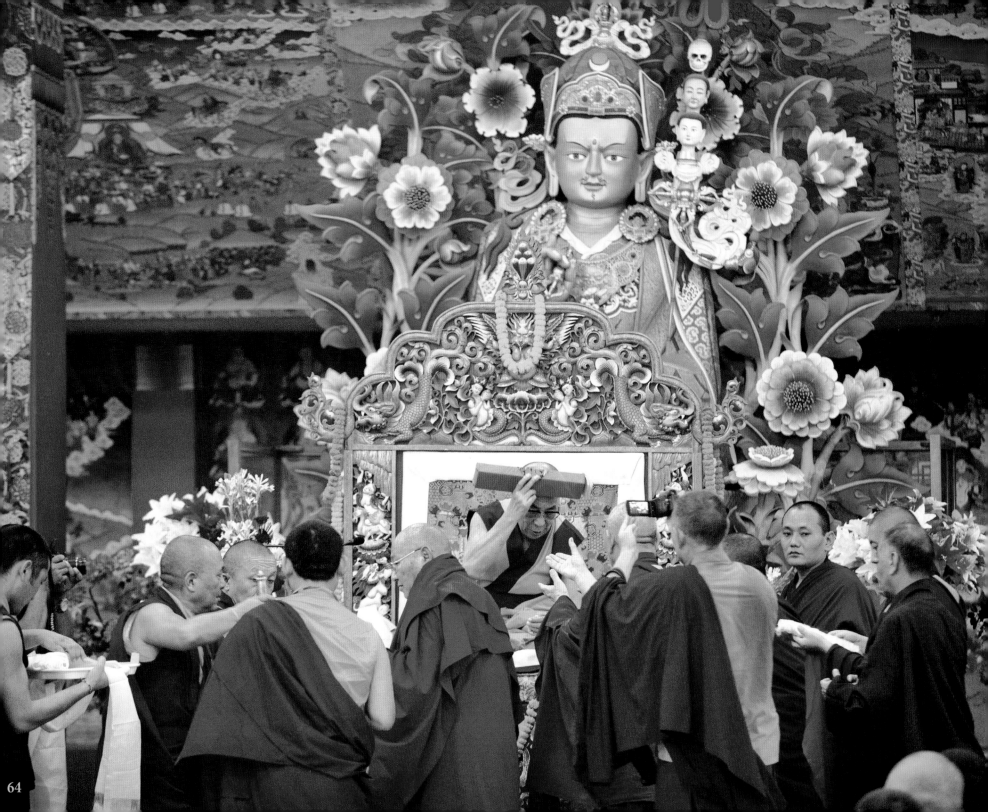

THE EIGHTH DALAI LAMA, JAMPHEL GYATSO

The Eighth Dalai Lama, Jamphel Gyatso, was born in 1758 at Thobgyal, Lhari Gang in the Tsang region of southwestern Tibet. His father, Sonam Dhargye, and mother, Phuntsok Wangmo, were originally from Kham and traced their ancestry to Dhrala Tsegyal, one of the legendary heroes of the Gesar epic.

As soon as Jamphel Gyatso was conceived, Lhari Gang was blessed with a bumper harvest with each stalk of barley bearing three, four and five ears — something unprecedented. When the mother and a relative were having their supper in the garden, a huge rainbow appeared, one end of which touched the mother's shoulder. (This is regarded to be a very auspicious omen, associated with the birth of a holy being.) Not long after his birth, Jamphel Gyatso was frequently observed to be looking heavenward with a smile on his face. He was also seen to be attempting to sit in a meditative, lotus posture. When Palden Yeshi, the Sixth Panchen Lama, heard about this boy, he pronounced: This is the authentic reincarnation of the Dalai Lama.

As the child began to speak, he said: "I will go to Lhasa at the age of three." Now the whole of Tibet was convinced that this child was the Eighth Dalai Lama. Darkpa Thaye, the chief attendant of the Seventh Dalai Lama, came to Lhasa with a large contingent of lamas and Tibetan government officials. They took the boy, then two-and-a-half years old, to Tashi Lhunpo monastery in Shigatse, performed the recognition ceremony and the Panchen Lama gave the boy the name Jamphel Gyatso.

In 1762, the boy was escorted to Lhasa and enthroned in the Potala Palace. The enthronement ceremony was presided over by Demo Tulku Jamphel Yeshi, who was the first regent to represent the Dalai Lamas when they were minors. At the age of seven, he took the novice vows of monkhood from the Panchen Lama and then he was fully ordained in 1777. In addition to his remarkable

spiritual legacy, it was the Eighth Dalai Lama who built the famous Norbulingka Park and Summer Palace on the outskirts of Lhasa. In 1804, he died at the age of forty-seven.

THE NINTH DALAI LAMA, LUNGTOK GYATSO

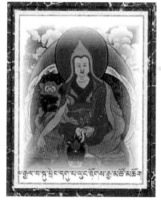

The Ninth Dalai Lama, Lungtok Gyatso was born in 1805 in Dan Chokhor, a small village in Kham to Tenzin Choekyong and Dhondup Dolma.

In 1807, he was recognized as the reincarnation of the Eighth Dalai Lama and was escorted to Lhasa with great ceremony. In 1810, he was enthroned at the Potala Palace. He took his novice vows from the Panchen Lama, who gave him the name Lungtok Gyatso. Unfortunately, he died in 1815 at the very young age of nine.

THE TENTH DALAI LAMA, TSULTRIM GYATSO

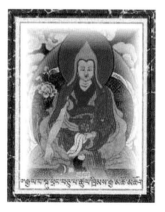

The Tenth Dalai Lama, Tsultrim Gyatso, was born in 1816 in Lithang in Kham to Lobsang Dakpa and Namgyal Bhuti.

In 1822, he was recognized and enthroned in the Potala Palace and in the same year, he took his novice vows of monkhood from the Panchen Lama, Tenpai Nyima, who gave him the name Tsultrim Gyatso. In 1826, at the age of ten, he was enrolled in Drepung monastery where he studied various Buddhist philosophical texts and mastered both the sutra and tantra. In 1831, he reconstructed the Potala Palace and at the age of nineteen, he took the Gelong vows (full ordination) from the Panchen Lama. However, he was constantly in poor health and died in 1837.

THE ELEVENTH DALAI LAMA, KHEDRUP GYATSO

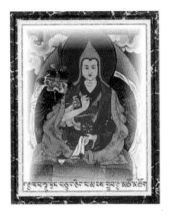

The Eleventh Dalai Lama, Khedrup Gyatso, was born in 1838 at Gathar in Kham Minyak to Tsetan Dhondup and Yungdrung Bhuti.

In 1841 he was recognized as the new Dalai Lama and the Panchen Lama, Tenpai Nyipa, cut his hair and gave him the name Khedrup Gyatso. In 1842, he was enthroned in the Potala Palace and at the age of eleven, took the novice vows of monkhood from the Panchen Lama. Despite his young age, he assumed the responsibility of being the Tibetan spiritual and political leader at the request of the Tibetan people. However, he suddenly died in 1856 in the Potala Palace.

THE TWELFTH DALAI LAMA, TRINLEY GYATSO

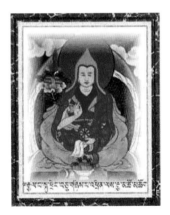

The Twelfth Dalai Lama, Trinley Gyatso was born in 1856 in Lhoka, a place near Lhasa to Phuntsok Tsewang and Tsering Yudon.

In 1858, the young boy as Dalai Lama was escorted to Lhasa where Reting Ngawang Yeshi Tsultrim Gyaltsen, the regent gave him the name Thupten Gyatso. In 1860, at the age of five he took the novice vows of monkhood from the Gaden Throne Holder Lobsang Khenrab and was enthroned in the Potala Palace. In 1873, at the age of eighteen, he took on full responsibility as both spiritual and political leader of Tibet. In 1875, he died at the age of twenty in the Potala Palace.

THE THIRTEENTH DALAI LAMA, THUPTEN GYATSO

The Thirteenth Dalai Lama, Thupten Gyatso, was born in the Fire Mouse year of 1876 at Langdun in Dagpo, central Thakpo Tibet to Kunga Rinchen and Lobsang Dolma, a peasant couple.

In 1877, he was recognized as the reincarnation of the 12th Dalai Lama following predictions from the State Oracle Nechung and other auspicious signs at his birthplace. He was then escorted to Lhasa. In 1878 the Eighth Panchen Lama, Tenpai Wangchuk, performed the hair-cutting ceremony and gave him the name Ngawang Lobsang Thupten Gyatso Jigdral Chokley Namgyal. In 1879, he was enthroned in the Grand Reception Hall at the Potala Palace. Later that year, he received the Upasaka (Tib.: ge-nyen) vows from the Regent Tatsak Rinpoche, Ngawang Palden Yeshi. In 1882, at age six, the Thirteenth Dalai Lama was formally ordained as a novice monk (Tib.: ge-tsul) by the same regent.

And in 1895 he took the full monk ordination (Tib.: ge-long) from his tutor, Phurchok Ngawang Jampa Rinpoche, in the Jokhang Temple, Lhasa, who served as both Preceptor and Procedural Master of the ceremony. Phurbuchok was assisted by many eminent Buddhist masters of Tibet at that time, including Ling Rinpoche Lobsang Lungtok Tenzn Thinley and the Gaden Throne Holder, who served as the Secret Inquiry Master so required by the ordination ceremony. On 27 September 1895 he finally assumed the political and spiritual authority of Tibet and was thrown into the thick of the Great Game played out by Czarist Russia and British India on the fringes of their sprawling empires. He went through the British invasion of Tibet in 1904 and the Chinese invasion of his country in 1909/10 but survived the ordeals of both experiences, with his authority enormously enhanced.

When the news spread in 1910 that Lu Chan, a Chinese General of the Manchu force, arrived in Lhasa, the Dalai Lama and some of the most important

officials fled Lhasa and headed to India. The group crossed Dromo and held negotiations with the Chinese invaders at the Jelep-la Pass, which separates Tibet and Sikkim.

In 1911, the Manchu Dynasty was overthrown and the Tibetans took this opportunity to expel the remnant Manchu forces from Tibet. The Dalai Lama returned to Tibet and went on to exercise unprecedented political authority not seen since the reign of the Fifth Dalai Lama. Besides attempting to modernize Tibet, the Dalai Lama also tried to eliminate some of the more oppressive features of the Tibetan monastic system. During his exile in India, the Dalai Lama was fascinated by the modern world and introduced the first Tibetan currency notes and coins. On 13 February 1913, he made public the five-point statement reasserting Tibet's independence. Also, in 1913 he established the first post office in Tibet and sent four young Tibetans to study engineering in England.

In 1914, he strengthened Tibet's military force by organizing special training for the Tibetan army. In 1917 he established the Men-Tsee-Khang (Tibetan Medical and Astrology Institute) in Lhasa to preserve the unique traditional Tibetan medical and astrological systems. For that reason, he selected about a hundred young and intelligent students to train in Men-Tse-Khang. In 1923, he established a police headquarter in Lhasa for the security and welfare of the Tibetan people. In the same year he established the first English school of Tibet in Gyaltse. Sadly, he died in 1933 at the age of fifty-eight before completing his goal of Tibet's modernization.

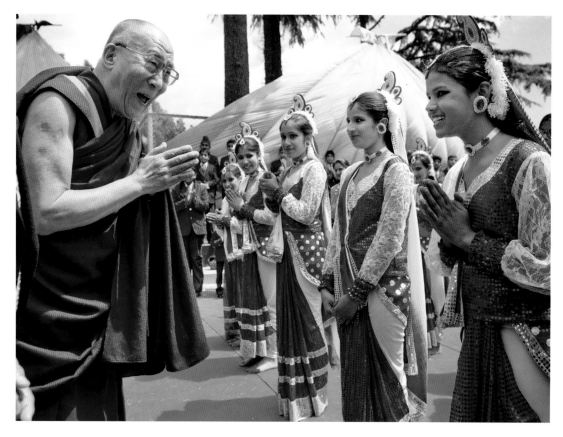

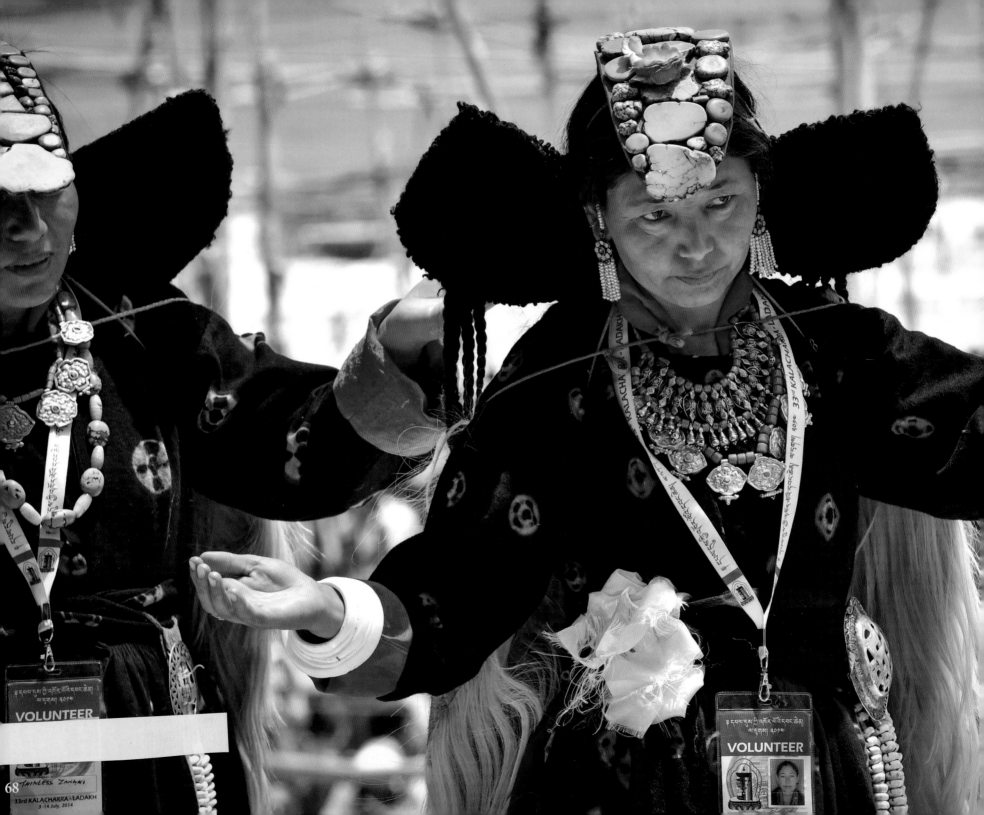

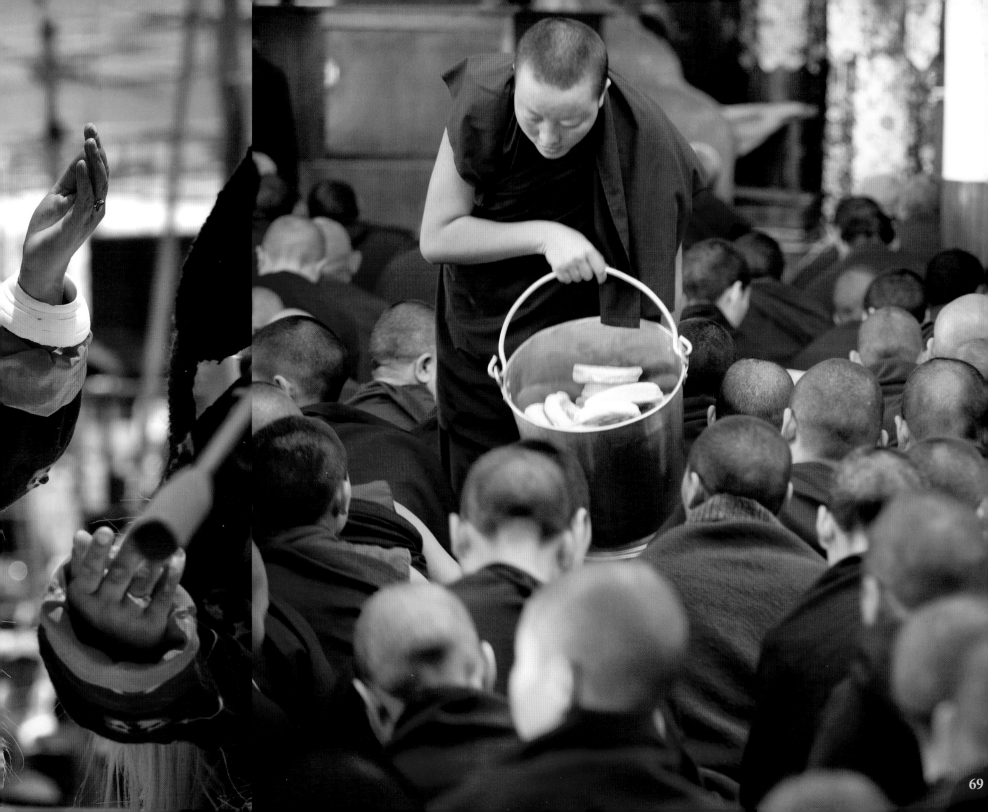

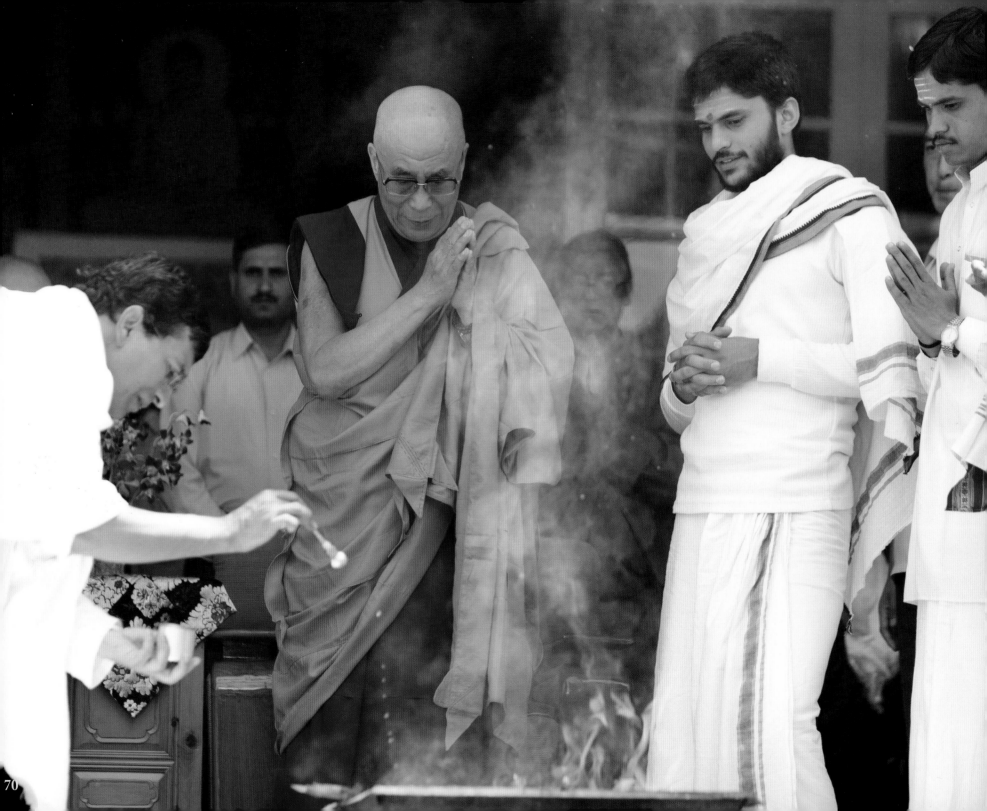

His Holiness
The 14th Dalai Lama of Tibet

A Biography

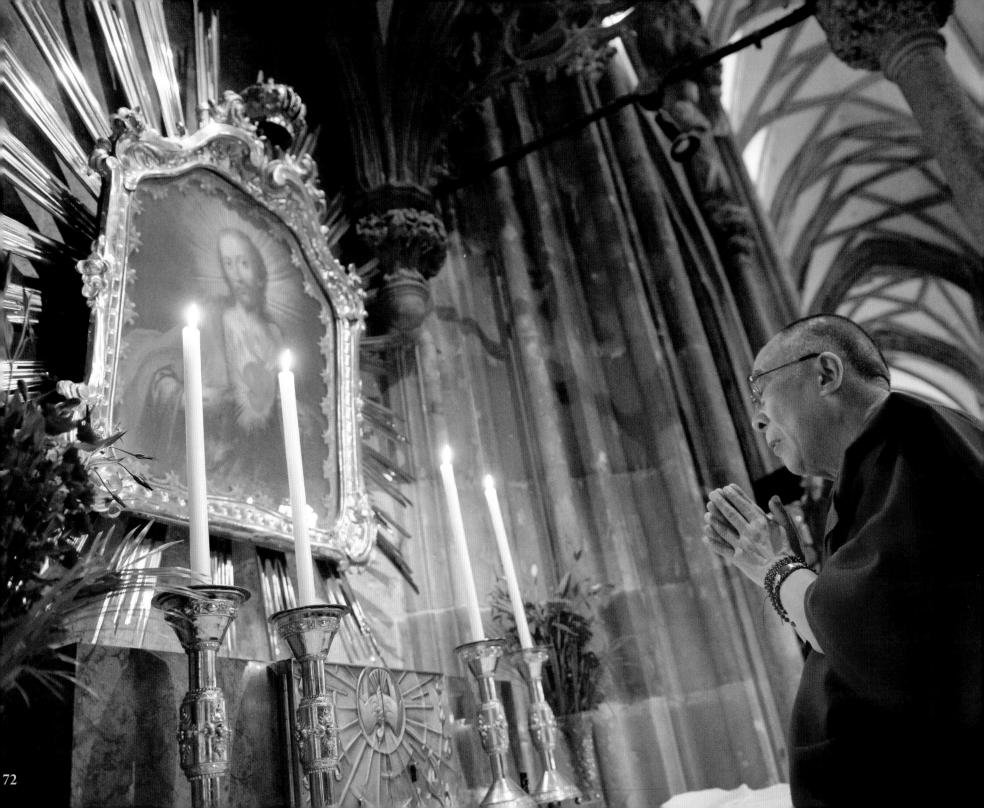

His Holiness the 14th Dalai Lama, Tenzin Gyatso, describes himself as a simple Buddhist monk. He is the spiritual leader of Tibet. He was born on 6 July 1935, to a farming family, in a small hamlet located in Taktser, Amdo, northeastern Tibet. At the very young age of two, the child who was named Lhamo Dhondup at that time, was recognized as the reincarnation of the previous 13th Dalai Lama, Thubten Gyatso.

The Dalai Lamas are believed to be manifestations of Avalokiteshvara or Chenrezig, the Bodhisattva of Compassion and the patron saint of Tibet. Bodhisattvas are believed to be enlightened beings who have postponed their own nirvana and chosen to take rebirth in order to serve humanity.

EDUCATION IN TIBET

His Holiness began his monastic education at the age of six. The curriculum consisted of five major and five minor subjects. The major subjects were logic, Tibetan art and culture, Sanskrit, medicine, and Buddhist philosophy which was further divided into further five categories: Prajnaparimita, the perfection of wisdom; Madhyamika, the philosophy of the middle way; Vinaya, the canon of monastic discipline; Abidharma, metaphysics; and, Pramana, logic and epistemology. The five minor subjects were poetry, music and drama, astrology, composition and phrasing, and synonyms. At 23, His Holiness sat for his final examination in Lhasa's Jokhang Temple, during the annual Monlam (prayer) Festival in 1959. He passed with honors and was awarded the Geshe Lharampa degree, the highest-level degree, equivalent to a doctorate of Buddhist philosophy.

LEADERSHIP RESPONSIBILITIES

In 1950, His Holiness was called upon to assume full political power after China's invasion of Tibet in 1949/50. In 1954, he went to Beijing for peace talks with Mao Zedong and other Chinese leaders, including Deng Xiaoping and Chou Enlai. But finally, in 1959, with the brutal suppression of the Tibetan national uprising in Lhasa by Chinese troops, His Holiness was forced to escape into exile. Since then he has been living in Dharamsala, India.

Since the Chinese invasion, the Central Tibetan Administration led by His Holiness appealed to the United Nations on the question of Tibet. The General Assembly adopted three resolutions on Tibet in 1959, 1961 and 1965.

DEMOCRATIZATION PROCESS

In 1963, His Holiness presented a draft democratic constitution for Tibet that was followed by a number of reforms to democratize the Tibetan administrative setup. The new democratic constitution promulgated as a result of this reform was named "The Charter of Tibetans in Exile". The charter enshrines freedom of speech, belief, assembly and movement. It also provides detailed guidelines on the functioning of the Tibetan Administration with respect to those living in exile.

In 1992, the Central Tibetan Administration issued guidelines for the constitution of a future, free Tibet. The guidelines outlined that when Tibet became free the immediate task would be to set up an interim government whose first responsibility would be to elect a constitutional assembly to frame and adopt Tibet's democratic constitution. His Holiness also stated that he hoped that Tibet, comprising the three traditional provinces of U-Tsang, Amdo and Kham, would be federal and democratic.

In May 1990, the reforms called for by His Holiness saw the realization of a truly democratic administration in exile for the Tibetan community. The Tibetan Cabinet (Kashag), which till then had been appointed by His Holiness, was dissolved along with the Tenth Assembly of the Tibetan People's Deputies (Tibetan Parliament in exile). In the same year, exiled Tibetans in the Indian subcontinent and in more than 33 other countries elected 46 members to the expanded Eleventh Tibetan Assembly on a one-man one-vote basis. The Assembly, in its turn, elected new members of the cabinet.

In September 2001, a further major step in democratization was taken when the

Tibetan electorate directly elected the Kalon Tripa, the senior-most minister of the Cabinet. The Kalon Tripa, in turn, appointed his own cabinet who had to be approved by the Tibetan Assembly. In Tibet's long history, this was the first time that the people elected the political leadership of Tibet. Since the direct election of the Kalon Tripa, the system of the institution of Gaden Phodrang of the Dalai Lama, as both the spiritual and temporal authority ended. Since then, His Holiness describes himself as being semi-retired.

PEACE INITIATIVES

On 21 September 1987 in his address to members of the United States Congress in Washington, DC, His Holiness proposed a Five-point Peace Plan for Tibet as the first step towards a peaceful solution to the worsening situation in Tibet. The peace plan contained five basic components:

1. Transformation of the whole of Tibet into a zone of peace.

2. Abandonment of China's population transfer policy that threatens the very existence of Tibetans as people.

3. Respect for the Tibetan people's fundamental human rights and democratic freedoms.

4. Restoration and protection of Tibet's natural environment and the abandonment of China's use of Tibet for the production of nuclear weapons and dumping of nuclear waste.

5. Commencement of earnest negotiations on the future status of Tibet and of relations between the Tibetan and Chinese peoples.

On 15 June 1988 in an address to members of the European Parliament in Strasbourg, His Holiness made another detailed proposal elaborating on the last point of the Five-point Peace Plan. He proposed talks between the Chinese and Tibetans leading to a self-governing democratic political entity for all three provinces of Tibet. This entity would be in association with the People's Republic of China, and the Chinese government would continue to remain responsible for Tibet's foreign policy and defence.

UNIVERSAL RECOGNITION

His Holiness the Dalai Lama is a man of peace. In 1989 he was awarded the Nobel Peace Prize for his non-violent struggle for the liberation of Tibet. He has consistently advocated policies of non-violence, even in the face of extreme aggression. He also became the first Nobel Laureate to be recognized for his concerns for global environmental problems.

His Holiness has travelled to more than 67 countries spanning six continents. He has received over 150 awards, honorary doctorates and prizes in recognition of his message of peace, non-violence, inter-religious understanding, universal responsibility and compassion. He has also authored or co-authored more than 110 books.

His Holiness has held dialogues with heads of different religions and participated in many events promoting inter-religious harmony and understanding.

Since the mid-1980s, His Holiness has begun a dialogue with modern scientists, mainly in the fields of psychology, neurobiology, quantum physics and cosmology. This has led to a historic collaboration between Buddhist monks and world-renowned scientists in trying to help individuals achieve peace of mind. This has also led to the introduction of modern science in the traditional curriculum of Tibetan monastic institutions re-established in exile.

POLITICAL RETIREMENT

On 14 March 2011, His Holiness sent a letter to the Assembly of Tibetan People's Deputies (Tibetan Parliament in exile) requesting them to devolve him of his temporal (political) power. According to The Charter of the Tibetans in Exile, His Holiness was technically still considered to be the Head of State. The historic announcement would bring to an end the dual spiritual and political authority of the Dalai Lama and revert to the previous tradition of the first four Dalai Lamas being only the spiritual leaders of Tibet. The democratically elected leadership would assume complete formal political leadership of Tibet. The Ganden Phodrang, the institution of the Dalai Lamas, would continue and remain intact.

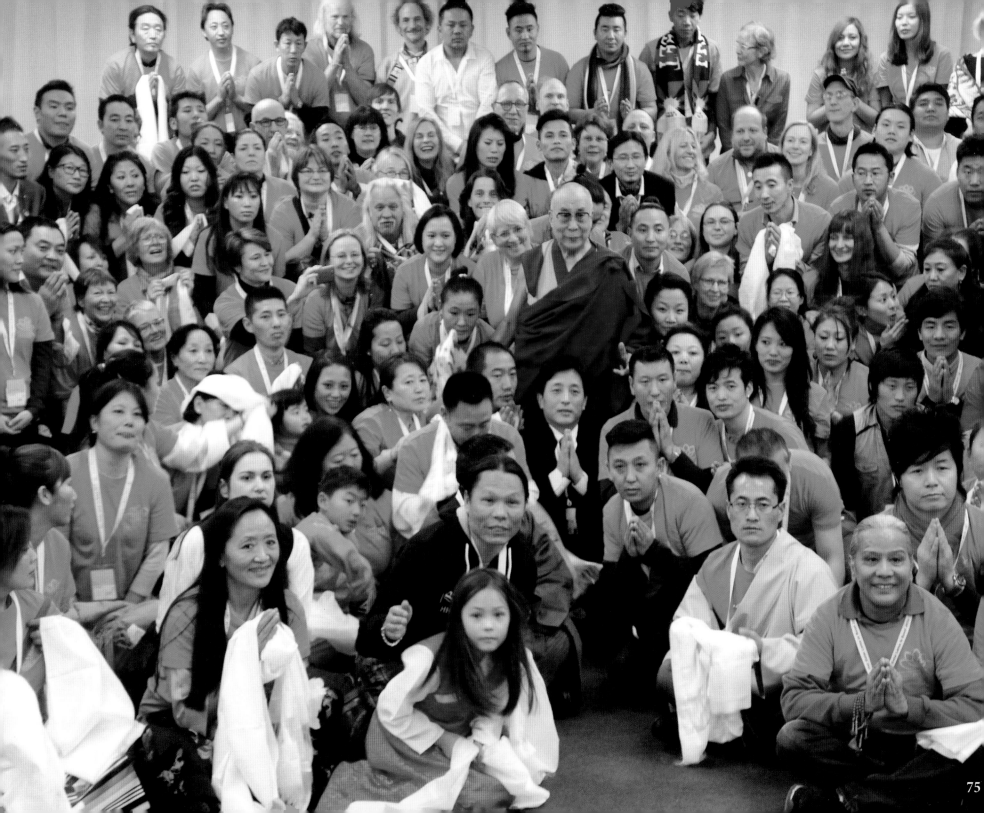

On 29 May 2011, His Holiness signed the formal transfer of his temporal power to the democratically elected leader. This brought to an end the 368-year-old tradition of the Dalai Lamas being both spiritual and temporal heads of Tibet.

THE FUTURE

As far back as 1969, His Holiness made clear that concerned people should decide whether the Dalai Lama's reincarnations should continue in the future. However, in the absence of clear guidelines, should the concerned public express a strong wish for the Dalai Lamas to continue, there is an obvious risk of vested political interests misusing the reincarnation system to fulfill their own political agenda. Therefore, on 24 September 2011, clear guidelines were drawn up to recognize the next Dalai Lama so that there is no room for doubt or deception.

His Holiness has stated that when he is about ninety he will consult the high Lamas of the Tibetan Buddhist traditions, the Tibetan public, and other concerned people who follow Tibetan Buddhism, and re-evaluate whether the institution of the Dalai Lama should continue or not. On that basis, a decision will be made. If it is decided that the reincarnation of the Dalai Lama should continue and there is a need for the Fifteenth Dalai Lama to be recognized, responsibility for doing so will primarily rest on the concerned officers of the Dalai Lama's Gaden Phodrang Trust. They should consult the various heads of the Tibetan Buddhist traditions and reliable oath-bound Dharma Protectors who are linked inseparably to the lineage of the Dalai Lamas. They should seek advice and direction from these concerned beings, and carry out the procedures of search and recognition in accordance with past traditions. His Holiness would leave clear written instructions about this. Bear in mind that, apart from the reincarnation recognized through such legitimate methods, no recognition or acceptance should be given to a candidate chosen for political ends by anyone, including those in the People's Republic of China.

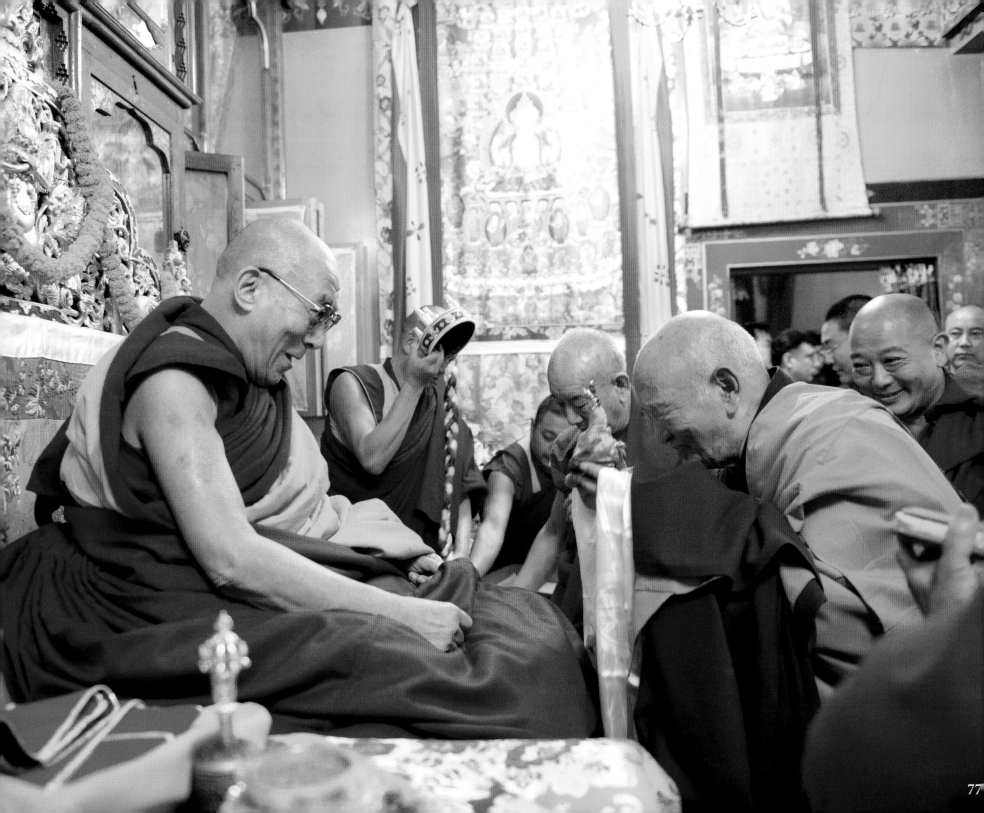

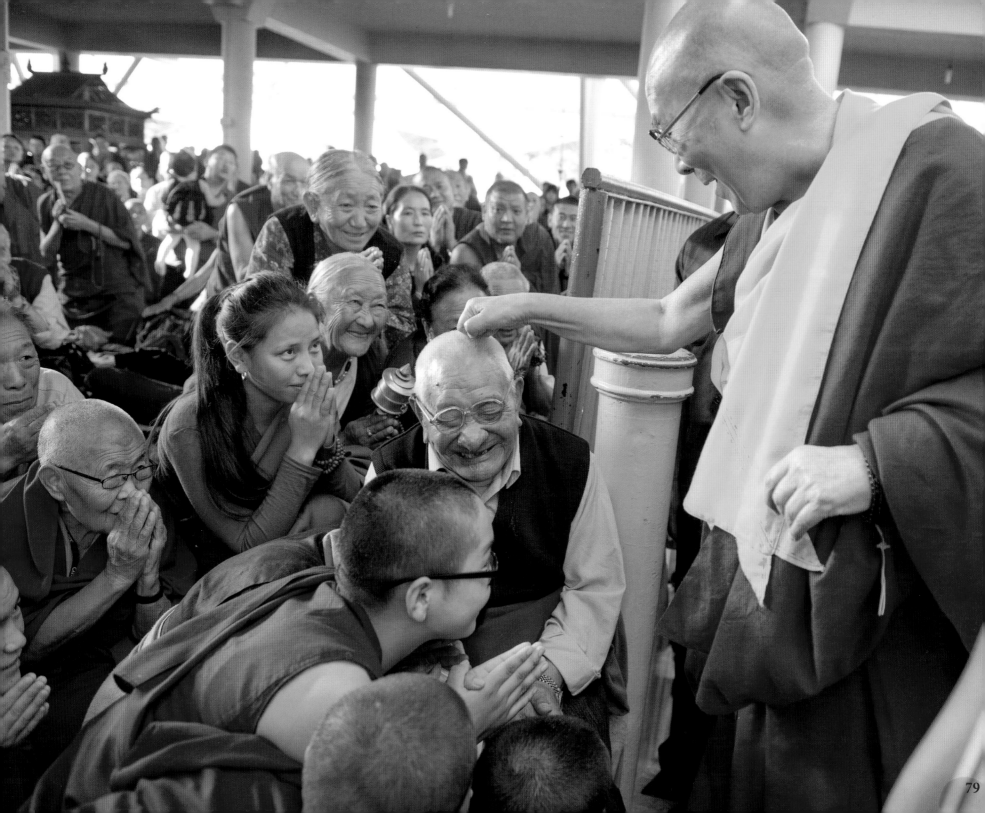

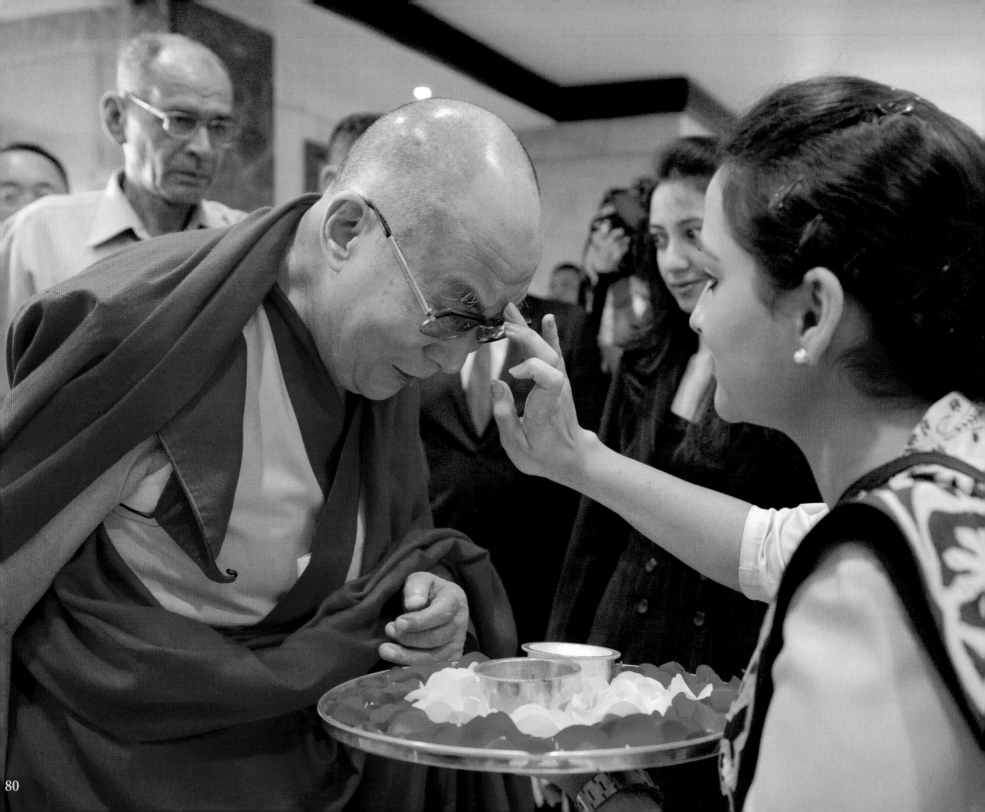

Three Main Commitments

His Holiness has three main commitments in life.

First: On the level of a human being, His Holiness' first commitment is the promotion of human values such as compassion, forgiveness, tolerance, contentment and self-discipline. All human beings are the same. We all want happiness and do not want suffering. Even people who do not believe in religion, recognize the importance of these human values in making their life happier. His Holiness refers to these human values as secular ethics. He remains committed to talk about the importance of these human values and share them with everyone he meets.

Second: On the level of a religious practitioner, His Holiness' second commitment is the promotion of religious harmony and understanding among the world's major religious traditions. Despite philosophical differences, all major world religions have the same potential to create good human beings. It is, therefore, important for all religious traditions to respect one another and recognize the value of each other's respective traditions. As far as one truth, one religion is concerned, this is relevant at an individual level. However, for the community at large, several truths, several religions are necessary.

Third: His Holiness is a Tibetan and carries the name of the 'Dalai Lama'. Therefore, his third commitment is to work to preserve Tibet's Buddhist culture, a culture of peace and non-violence.

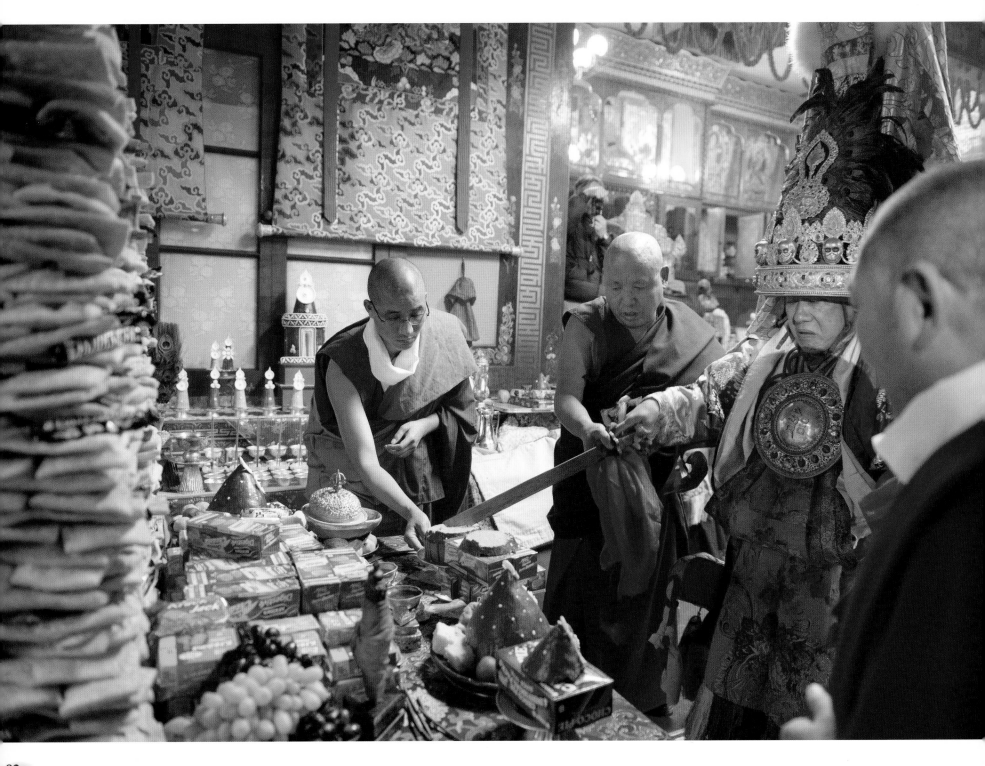

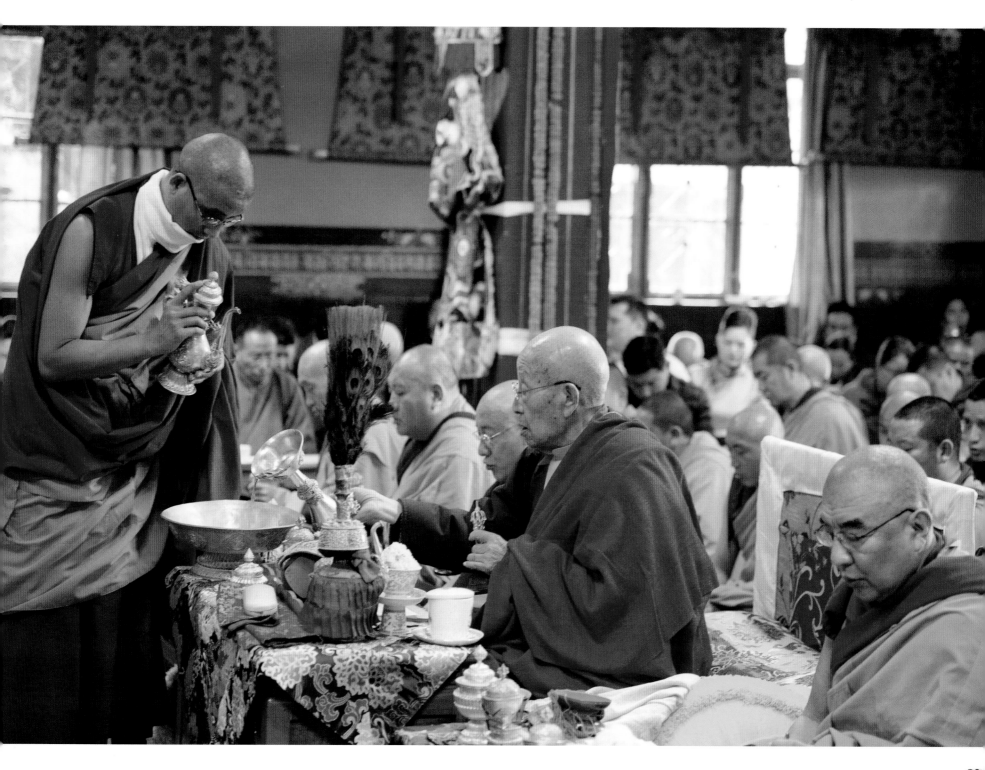

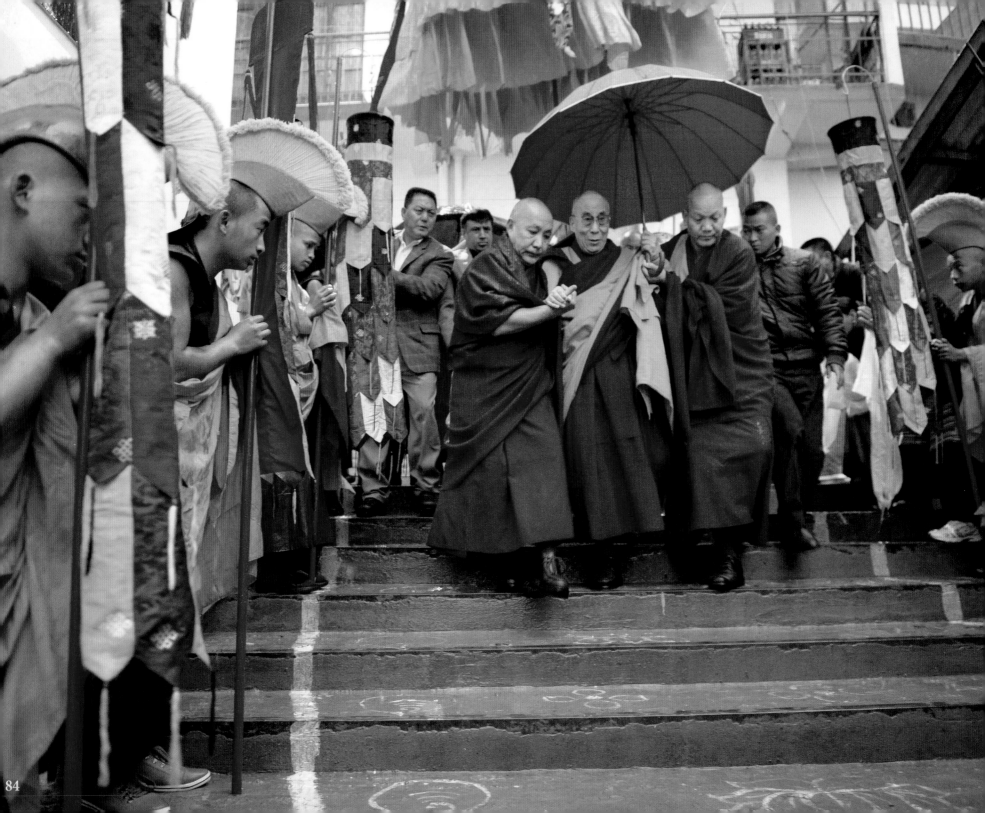

His Holiness
The 14th Dalai Lama of Tibet

Birth to Exile

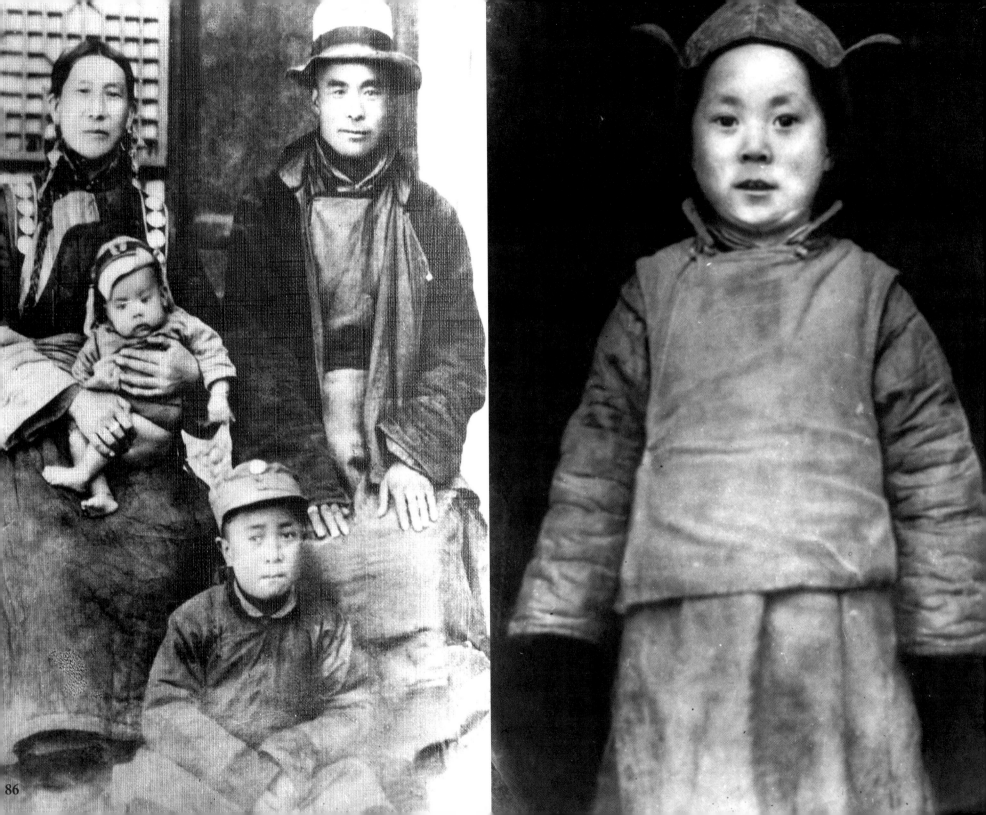

His Holiness the Dalai Lama was born on 6 July 1935, and named Lhamo Thondup, to a Tibetan farming family in the small village of Taktser, located in the province of Amdo. The name, Lhamo Thondup, literally means 'Wish-Fulfilling Goddess'. Taktser (Roaring Tiger) was a small village that stood on a hill overlooking a wide valley. Its pastures had not been settled or farmed for long, only grazed by nomads. The reason for this was the unpredictability of the weather in that area. His Holiness writes in his autobiography, "During my early childhood, my family was one of twenty or so making a precarious living from the land there."

His Holiness' parents were small farmers who mostly grew barley, buckwheat and potatoes. His father was a man of medium height with a very quick temper. "I remember pulling at his moustache once and being hit hard for my trouble," recalls His Holiness. "Yet he was a kind man too and he never bore grudges." His Holiness recalls his mother as undoubtedly one of the kindest people he has ever known. She had a total of sixteen children, of whom seven lived.

His Holiness had two sisters and four brothers who survived their infancy. Tsering Dolma, the eldest child, was eighteen years older than His Holiness. At the time of His Holiness' birth, she helped his mother run the house and acted as his midwife. "When she delivered me, she noticed that one of my eyes was not properly open. Without hesitation she put her thumb on the reluctant lid and forced it wide fortunately without any ill effect," narrates His Holiness. He had three elder brothers: Thubten Jigme Norbu – the eldest, who was recognized as the reincarnation of a high lama, Taktser Rinpoche – Gyalo Thondup and Lobsang Samden. The youngest brother, Tenzin Choegyal was also recognized as the reincarnation of another high lama, Ngari Rinpoche.

"Of course, no one had any idea that I might be anything other than an ordinary baby. It was almost unthinkable that more than one tulku (reincarnation) could be born into the same family and certainly my parents had no idea that I would be proclaimed Dalai Lama," His Holiness writes. Though the remarkable recovery made by His Holiness' father from his critical illness at the time of His Holiness' birth was auspicious, it was not taken to be of great significance.

"I myself likewise had no particular intimation of what lay ahead. My earliest memories are very ordinary." His Holiness recollects his earliest memory, among others, of observing a group of children fighting and running to join in with the weaker side.

"One thing that I remember enjoying particularly as a very young boy was going into the chicken coop to collect the eggs with my mother and then staying behind. I liked to sit in the hens' nest and make clucking noises. Another favourite occupation of mine as a child was to pack things in a bag as if I was about to go on a long journey. I'm going to Lhasa, I'm going to Lhasa, I would say. This, coupled with my insistence that I be allowed always to sit at the head of the table, was later said to be an indication that I must have known that I was destined for greater things."

His Holiness is considered to be the reincarnation of each of the previous thirteen Dalai Lamas of Tibet (the first having been born in AD 1391), who are in turn considered to be manifestations of Avalokiteshvara, or Chenrezig, the Bodhisattva of Compassion, holder of the White Lotus. Thus, while His Holiness is believed to be a manifestation of Chenrezig, in fact the seventy-fourth in a lineage that can be traced back to a Brahmin boy who lived in the time of Buddha Shakyamuni. "I am often asked whether I truly believe this. The answer is not simple to give. But as a fifty-six year old, when I consider my experience during this present life, and given my Buddhist beliefs, I have no difficulty accepting that I am spiritually connected, to the 13 previous Dalai Lamas, to Chenrezig and to the Buddha himself."

DISCOVERY AS DALAI LAMA

When Lhamo Thondup was two years old, a search party that had been sent out by the Tibetan government to find the new incarnation of the Dalai Lama arrived at Kumbum monastery. It was led there by a number of signs. One of these concerned the embalmed body of his predecessor, Thupten Gyatso, the Thirteenth Dalai Lama, who had died aged 57 in 1933. During its period of sitting in state, the head was discovered to have turned from facing south to

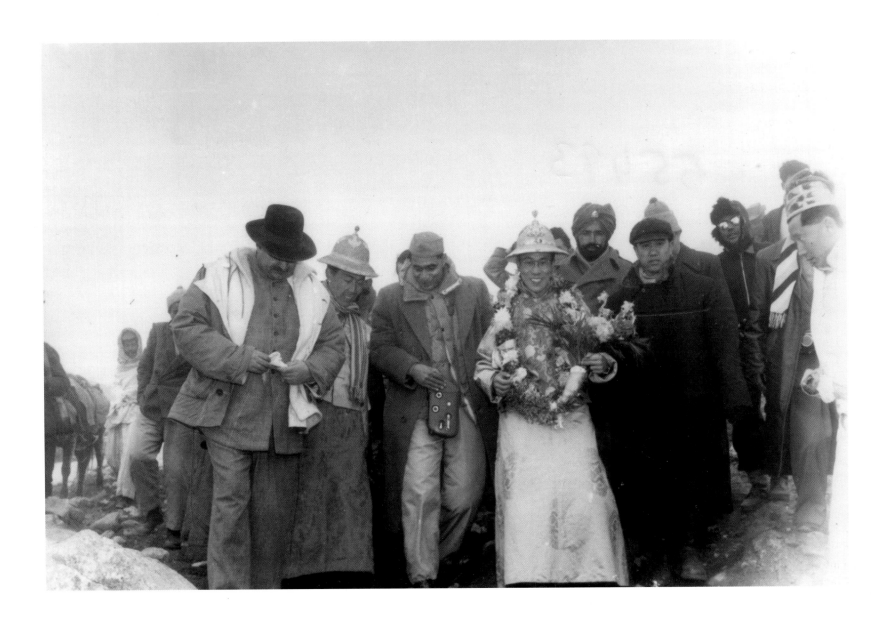

northeast. Shortly after that, the regent, himself a senior lama, had a vision. Looking into the waters of the sacred lake, Lhamoi Lhatso, in southern Tibet, he clearly saw the Tibetan letters Ah, Ka and Ma float into view. These were followed by the image of a three-storied monastery with a turquoise and gold roof, and a path running from it to a hill. Finally, he saw a small house with strangely shaped guttering. He was sure that the letter Ah referred to Amdo, the northeastern province, so it was there that the search party was sent.

By the time they reached Kumbum, the members of the search party felt that they were on the right track. It seemed likely that if the letter Ah referred to Amdo, then Ka must indicate the monastery at Kumbum, which was indeed three-storied and turquoise-roofed. They now only needed to locate a hill and a house with peculiar guttering. So they began to search the neighbouring villages. When they saw the gnarled branches of juniper wood on the roof of His Holiness' parent's house, they were certain that the new Dalai Lama would not be far away. Nevertheless, rather than reveal the purpose of their visit, the group asked only to stay the night. The leader of the party, Kewtsang Rinpoche, then disguised himself as a servant and spent much of the evening observing and playing with the youngest child in the house.

The child recognized him and called out "Sera Lama, Sera Lama". Sera was Kewtsang Rinpoche's monastery. The next day they left only to return a few days later as a formal deputation. This time they brought with them a number of possessions that had belonged to the Thirteenth Dalai Lama, along with several similar items that did not belong to the Thirteenth Dalai Lama. In every case, the infant correctly identified those belonging to the Thirteenth Dalai Lama saying, "It's mine. It's mine". This more or less convinced the search party that they had found the new incarnation. It was not long before the boy from Taktser was recognized to be the new Dalai Lama.

The boy Lhamo Thondup was first taken to Kumbum monastery. "There now began a somewhat unhappy period of my life," His Holiness was to write later, reflecting on his separation from his parents and the unfamiliar surroundings. However, there were two consolations to life at the monastery. First, His

Holiness' immediate elder brother Lobsang Samden was already there. The second consolation was the fact that his teacher was a very kind old monk, who often seated his young disciple inside his gown.

Lhamo Thondup was eventually to be reunited with his parents and together they were to journey to Lhasa. This did not come about for almost eighteen months, as Ma Bufeng, the local Chinese Muslim warlord, refused to let the boy-incarnate be taken to Lhasa without payment of a large ransom. It was not until the summer of 1939 that he left for the capital, Lhasa, in a large party consisting of his parents, his brother Lobsang Samden, members of the search party, and other pilgrims.

The journey to Lhasa took three months. "I remember very little detail apart from a great sense of wonder at everything I saw: the vast herds of drong (wild yaks) grazing across the plains, the smaller groups of kyang (wild asses) and occasionally a herd of gowa and nawa, small deer which were so light and fast they might have been ghosts. I also loved the huge flocks of hooting geese we saw from time to time."

Lhamo Thondup's party was received by a group of senior government officials and escorted to Doeguthang plain, two miles outside the gates of the capital. The next day, a ceremony was held in which Lhamo Thondup was conferred the spiritual leadership of his people. Following this, he was taken off with Lobsang Samden to the Norbulingka, the summer palace of His Holiness, which lay just to the west of Lhasa.

During the winter of 1940, Lhamo Thondup was taken to the Potala Palace, where he was officially installed as the spiritual leader of Tibet. Soon after, the newly recognized Dalai Lama was taken to the Jokhang temple where he was inducted as a novice monk in a ceremony known as Taphue, meaning cutting of the hair. "From now on, I was to be shaven-headed and attired in maroon monk's robes." In accordance with ancient custom, His Holiness forfeited his name Lhamo Thondup and assumed his new name, Jamphel Ngawang Lobsang Yeshe Tenzin Gyatso.

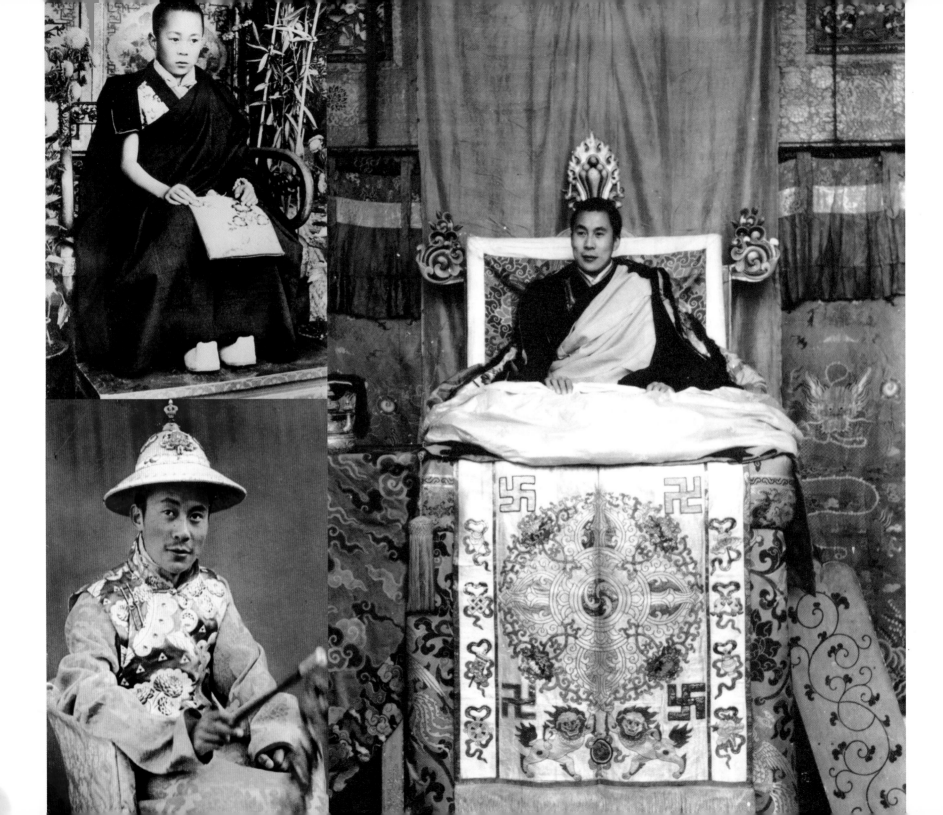

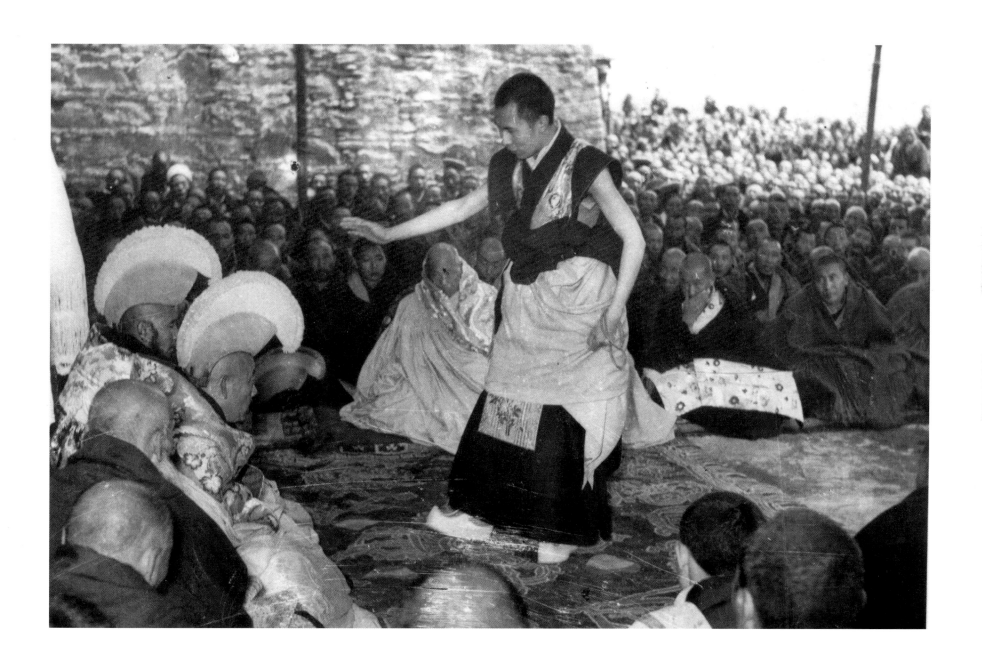

DALAI LAMA IN HIS YOUTH

On the day before the opera festival in the summer of 1950, His Holiness was just coming out of the bathroom at the Norbulingka when he felt the earth beneath begin to move. As the scale of this natural phenomenon began to sink in, people naturally began to say that this was more than a simple earthquake: it was an omen.

Two days later, Regent Tatra received a telegram from the Governor of Kham, based in Chamdo, reporting a raid on a Tibetan post by Chinese soldiers. Already the previous autumn there had been cross-border incursions by Chinese Communists, who stated their intention of liberating Tibet from the hands of imperialist aggressors. "It now looked as if the Chinese were making good their threat. If that were so, I was well aware that Tibet was in grave danger for our army comprised no more than 8,500 officers and men. It would be no match for the recently victorious People's Liberation Army (PLA)."

Two months later, in October, news reached Lhasa that an army of 80,000 soldiers of the People's Liberation Army had crossed the Drichu river east of Chamdo. So the axe had fallen. And soon, Lhasa would have to fall. As the winter drew on and the news got worse, people began to advocate that His Holiness be given his full temporal (political) power. At a ceremony, the government consulted the Nechung Oracle, a very tense moment, who came over to where His Holiness was seated and laid a *kata*, a white offering scarf, on His Holiness' lap with the words *thu-la bap*, his time has come. Thus, at the young age of fifteen, His Holiness was, on 17 November 1950, officially enthroned as the temporal leader of Tibet, in a ceremony held at the Norbulingka Palace.

At the beginning of November, about a fortnight before the day of His Holiness' investiture, his eldest brother arrived in Lhasa. "As soon as I set eyes on him, I knew that he had suffered greatly. Because Amdo, the province where we were both born, and in which Kumbum is situated, lies so close to China, had quickly fallen under control of the Communists. He himself was kept as a virtual prisoner in his monastery. At the same time, the Chinese endeavoured to indoctrinate him in the new Communist way of thinking and tried to subvert him. They had a plan whereby they would set him free to go to Lhasa if he would undertake to persuade me to accept Chinese rule. If I resisted, he was to kill me. They would then reward him."

To mark the occasion of his ascension to power, His Holiness granted a general amnesty whereby all prisoners were set free.

Shortly after the 15-year-old Dalai Lama found himself the undisputed leader of six million people facing the threat of a full-scale war, His Holiness appointed two new Prime Ministers. Lobsang Tashi became the monk Prime Minister and an experienced lay administrator, Lukhangwa, the lay Prime Minister.

Then in consultation with the two Prime Ministers and the Kashag, His Holiness decided to send delegations abroad to America, Great Britain and Nepal in the hope of persuading these countries to intervene on Tibet's behalf. Another was to go to China in the hope of negotiating a withdrawal. These missions left towards the end of the year. "Shortly afterwards, with the Chinese consolidating their forces in the east, we decided that I should move to southern Tibet with the most senior members of the government. That way, if the situation deteriorated, I could easily seek exile across the border with India. Meanwhile, Lobsang Tashi and Lunkhangwa were to remain in an acting capacity."

While His Holiness was in Dromo, which lay just inside the border with Sikkim, he received news that while the delegation to China had reached its destination, each of the others had been turned back. It was almost impossible to believe that the British government was now agreeing that China had some claim to authority over Tibet. His Holiness was equally saddened by America's reluctance to help. "I remember feeling great sorrow when I realized what this really meant: Tibet must expect to face the entire might of Communist China alone."

Frustrated by the indifference shown to Tibet's case by Great Britain and America, His Holiness, in his last bid to avoid a full-scale Chinese invasion,

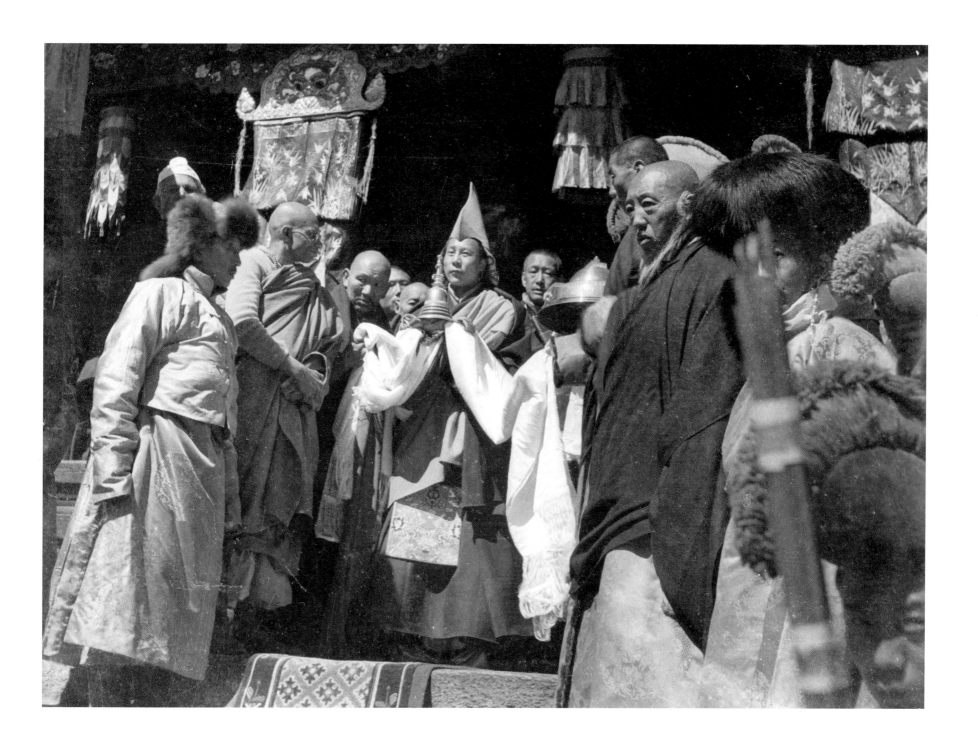

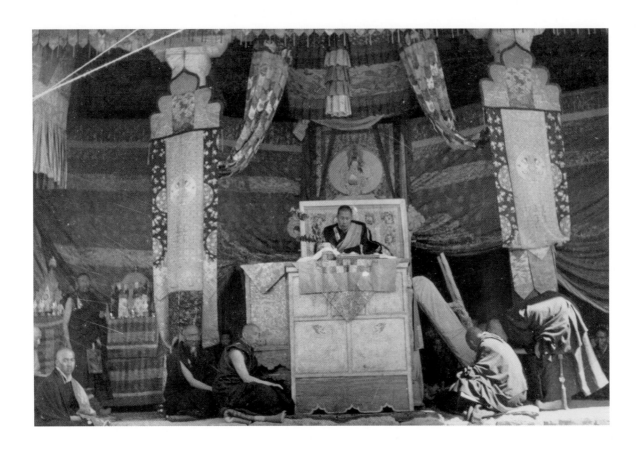

sent Ngabo Ngawang Jigme, governor of Kham, to Beijing to open a dialogue with the Chinese. The delegation hadn't been given the power to reach any settlement, apart from its entrusted task of convincing the Chinese leadership against invading Tibet. However, one evening, as His Holiness sat alone, a harsh, crackling voice on the radio announced that a Seventeen-point 'Agreement' for the Peaceful Liberation of Tibet had that day (23 May 1951) been signed by representatives of the Government of the People's Republic of China and what they called the Local Government of Tibet. As it turned out, the Chinese who even forged the Tibetan seal, had forced the delegation headed by Ngabo into signing the agreement. The Chinese had in effect secured a major coup by winning Tibetan compliance, albeit at gunpoint, to their terms of returning Tibet to the fold of the motherland. His Holiness returned to Lhasa in the middle of August 1951.

COUNTDOWN TO ESCAPE

The next nine years saw His Holiness trying to evade a full-scale military takeover of Tibet by China, on the one hand, and placating the growing resentment among Tibetan resistance fighters against the Chinese aggressors, on the other. His Holiness made a historic visit to China from July 1954 to June 1955 for peace talks and met with Mao Zedong and other Chinese leaders, including Chou Enlai, Zhu Teh and Deng Xiaoping. From November 1956 to March 1957 His Holiness visited India to participate in the 2500th Buddha Jayanti celebrations. But disheartening reports of increasing brutality towards his people continued to pour in when the young Dalai Lama was giving his final monastic examinations in Lhasa in the winter of 1958-59.

ESCAPE INTO EXILE

One winter day of 1959 (March 10), General Zhang Chenwu of Communist China extended a seemingly innocent invitation to the Tibetan leader to attend a theatrical show by a Chinese dance troupe. When the invitation was repeated with new conditions that no Tibetan soldiers were to accompany the Dalai Lama and that his bodyguards be unarmed, an acute anxiety befell the Lhasa population. Soon a crowd of tens of thousands of Tibetans gathered around the Norbulingka Palace, determined to thwart any threat to their young leader's life and preventing His Holiness from going.

On 17 March 1959 during consultations with the Nechung Oracle, His Holiness was given explicit instructions to leave the country. The Oracle's decision was further confirmed when a divinity performed by His Holiness produced the same answer, even though the odds against making a successful break seemed terrifyingly high.

A few minutes before ten o'clock, His Holiness, disguised as a common soldier, slipped past the massive throng of people along with a small escort and proceeded towards the Kyichu river, where he was joined by the rest of the entourage, including some of his immediate family members.

IN EXILE

Three weeks after escaping Lhasa, His Holiness and his entourage reached the Indian border on 30 March 1959 from where they were escorted by Indian guards to the town of Bomdila in the present-day state of Arunachal Pradesh. The Indian government had already agreed to provide asylum to His Holiness and his followers in India. Post that, His Holiness came to Mussoorie on 20 April 1959 and met with the Indian prime minister Jawaharlal Nehru, and the two talked about rehabilitating Tibetan refugees.

Realizing the importance of modern education for the children of Tibetan refugees, His Holiness impressed upon Nehru to undertake the formation of an independent Society for Tibetan Education within the Indian Ministry of Education. The Indian government was to bear all the expenses for setting up schools for the Tibetan children.

Thinking the time was ripe for him to break his silence, His Holiness called a press conference on 20 June 1959 during which he formally repudiated the Seventeen-point Agreement. In the field of administration, too, His Holiness was able to make radical changes. Among others, His Holiness saw the creation of various new Tibetan administrative departments. These included the departments of Information, Education, Home, Security, Religious Affairs and Economic Affairs. Most of the Tibetan refugees, whose number had grown to almost 30,000, were moved to road camps in the hills of northern India.

On 10 March 1960 just before leaving for Dharamsala with eighty or so officials who comprised the Central Tibetan Administration, His Holiness made a statement on the first commemoration anniversary of the Tibetan People's Uprising. "On this first occasion, I stressed the need for my people to take a long-term view of the situation in Tibet. For those of us in exile, I said that our priority must be resettlement and the continuity of our cultural traditions. As to the future, I stated my belief that, with truth, justice and courage as our weapons, we Tibetans would eventually prevail in regaining freedom for Tibet."

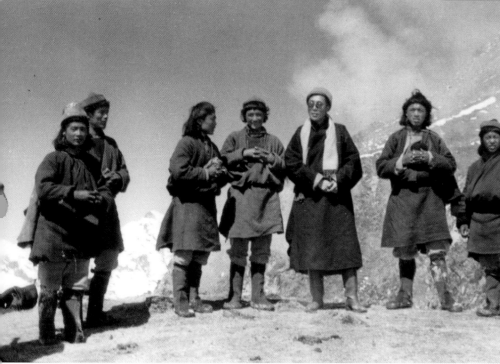

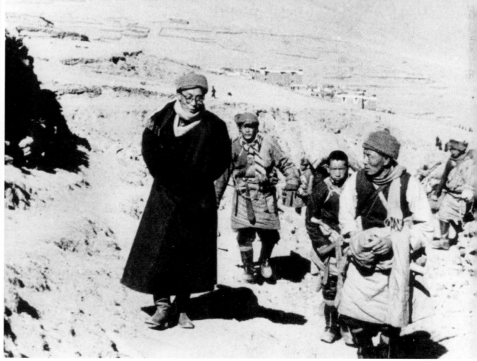

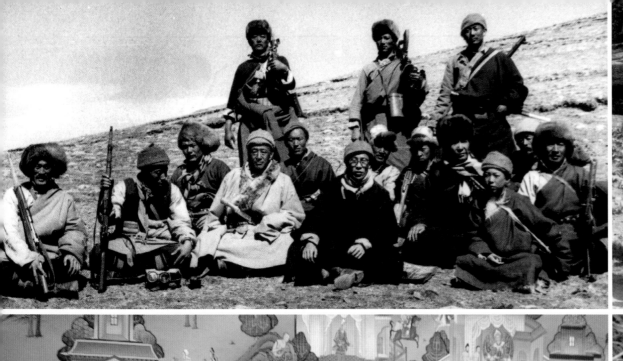
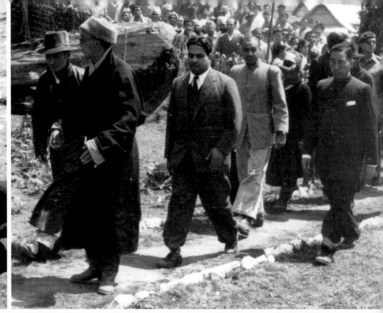
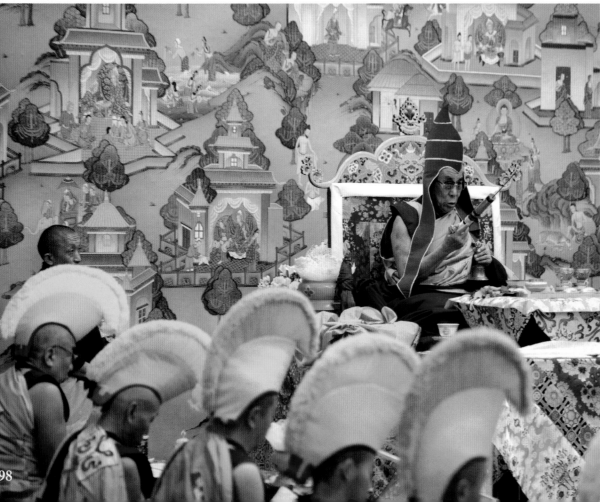
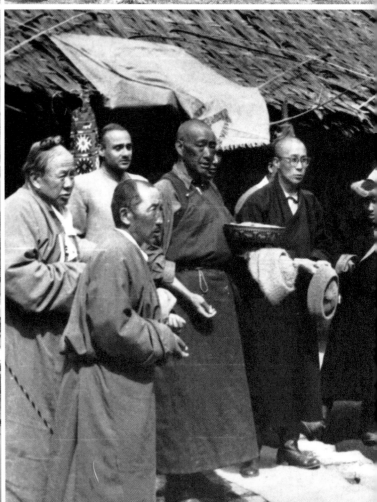

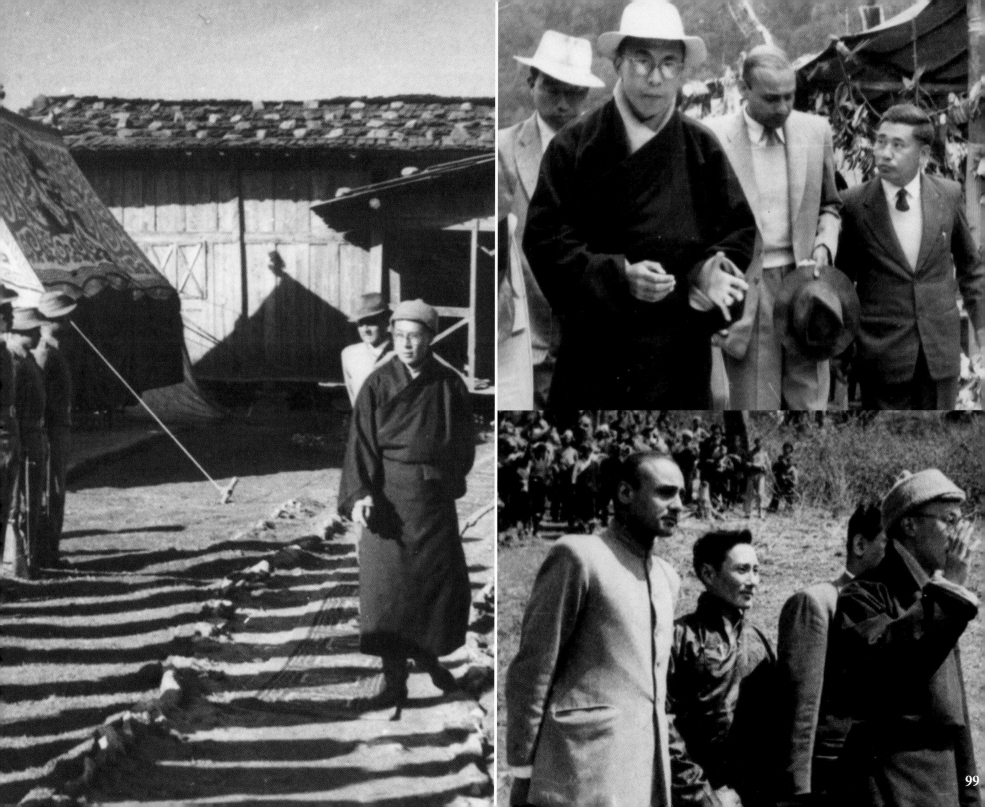

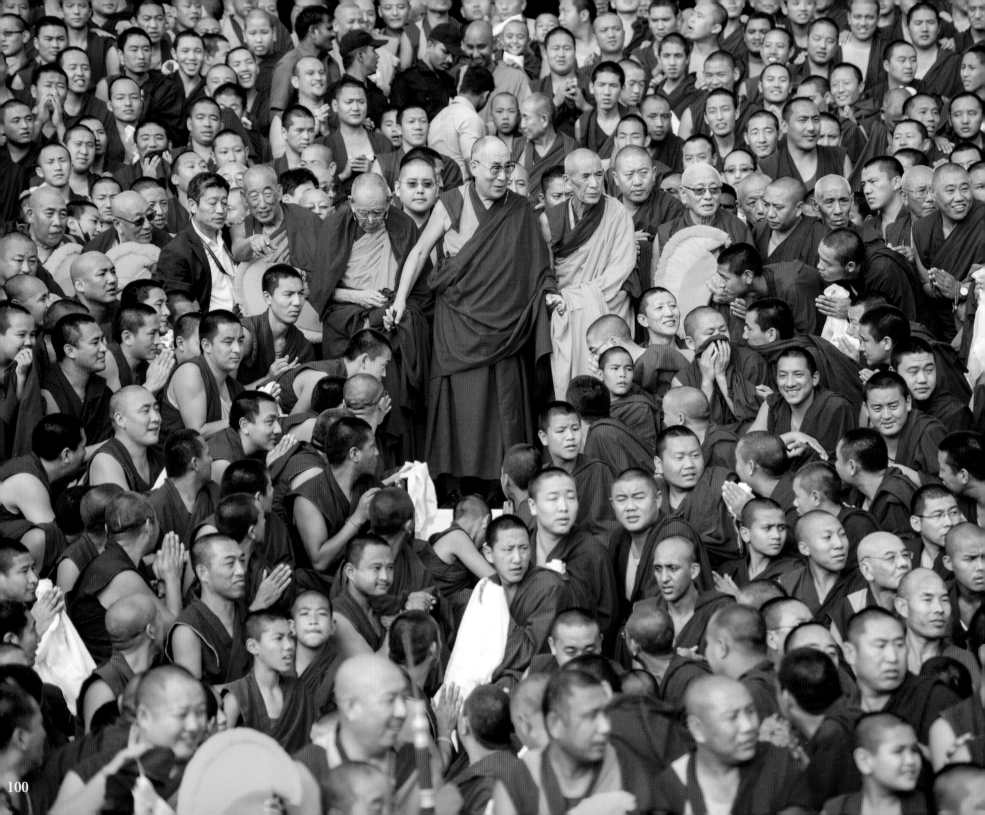

His Holiness
The 14th Dalai Lama of Tibet

Routine Day

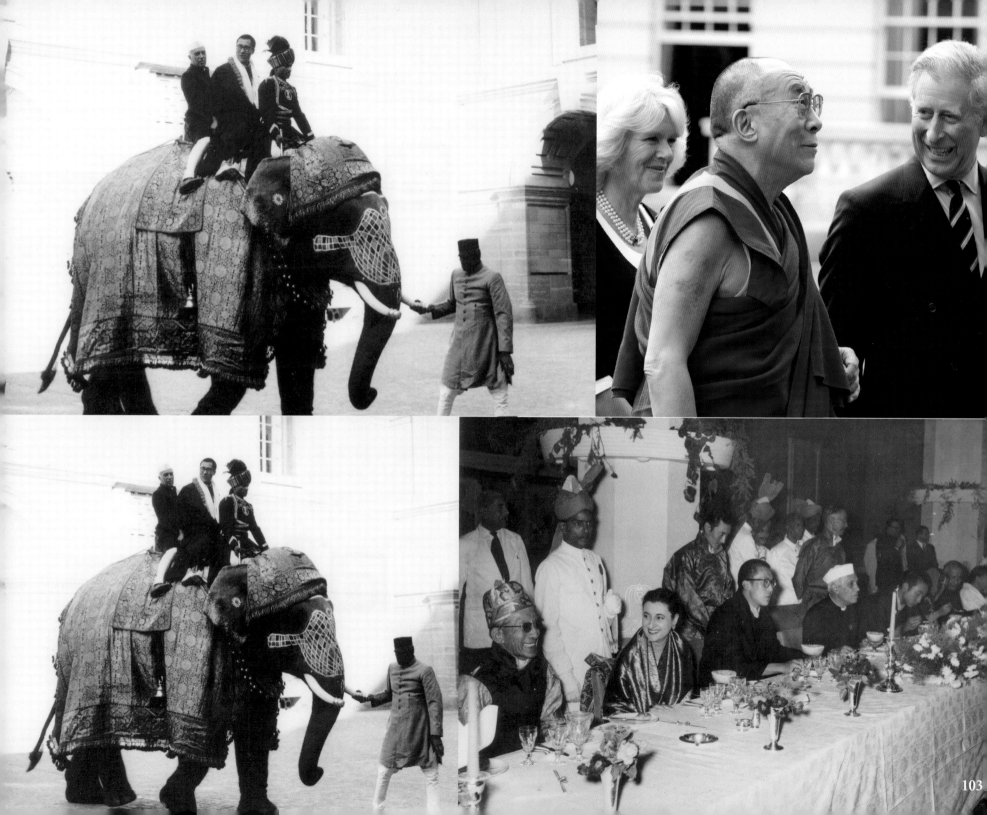

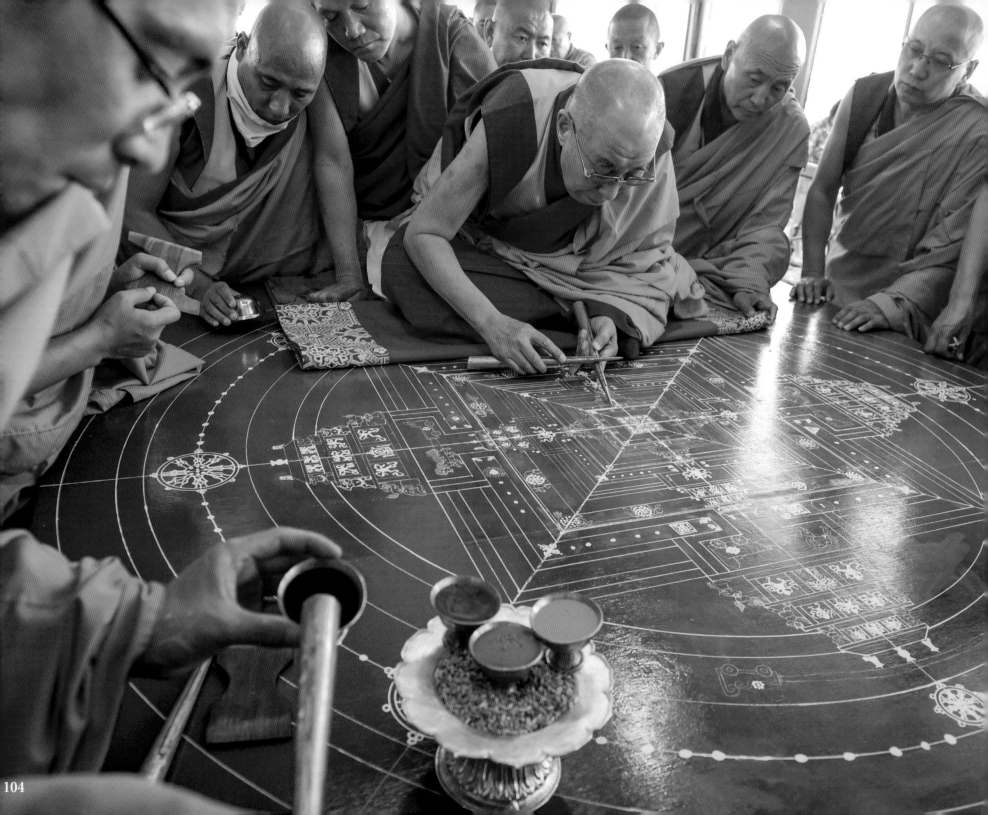

When asked by people how His Holiness the Dalai Lama sees himself, he replies that he is a simple Buddhist monk.

His Holiness is often out of Dharamsala on travels, both within India and abroad. During these travels, His Holiness' daily routine varies depending on his engagement schedule. However, His Holiness is an early riser and tries as far as possible to retire early in the evening.

When His Holiness is at home in Dharamsala, he wakes up at 3 a.m. After his morning shower, His Holiness begins the day with prayers, meditations and prostrations until 5 a.m. From 5 a.m. His Holiness takes a short morning walk around the residential premises. If it is raining outside, His Holiness has a treadmill to use for his walk. Breakfast is served at 5.30 a.m. For breakfast, His Holiness typically has hot porridge, tsampa (barley powder), bread with preserves, and tea. Regularly during breakfast, His Holiness tunes his radio to the BBC World News in English. From 6 a.m. to 9 a.m. His Holiness continues his morning meditation and prayers. From around 9 a.m. he usually spends time studying various Buddhist texts and commentaries written by great Buddhist masters. Lunch is served from 11.30 a.m. His Holiness's kitchen in Dharamsala is vegetarian. However, during visits outside of Dharamsala, His Holiness is not necessarily vegetarian. Following strict *vinaya* rules, His Holiness does not have dinner. Should there be a need to discuss some work with his staff or hold some audiences and interviews, His Holiness will visit his office from 12.30 p.m. until around 3.30 p.m. Typically, during an afternoon at the office, one interview is scheduled along with several audiences, both Tibetan and non-Tibetan. Upon his return to his residence, His Holiness has his evening tea at around 5 p.m. This is followed by his evening prayers and meditation. His Holiness retires in the evening by around 7 p.m.

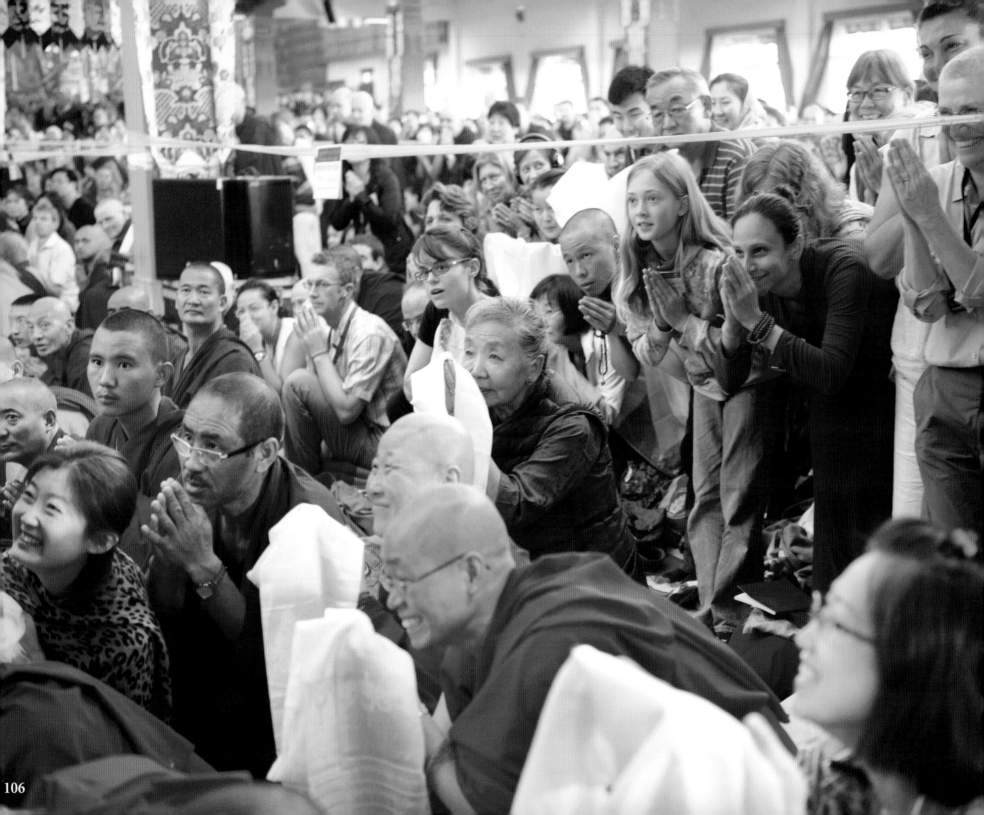

His Holiness
The 14th Dalai Lama of Tibet

Training the Mind

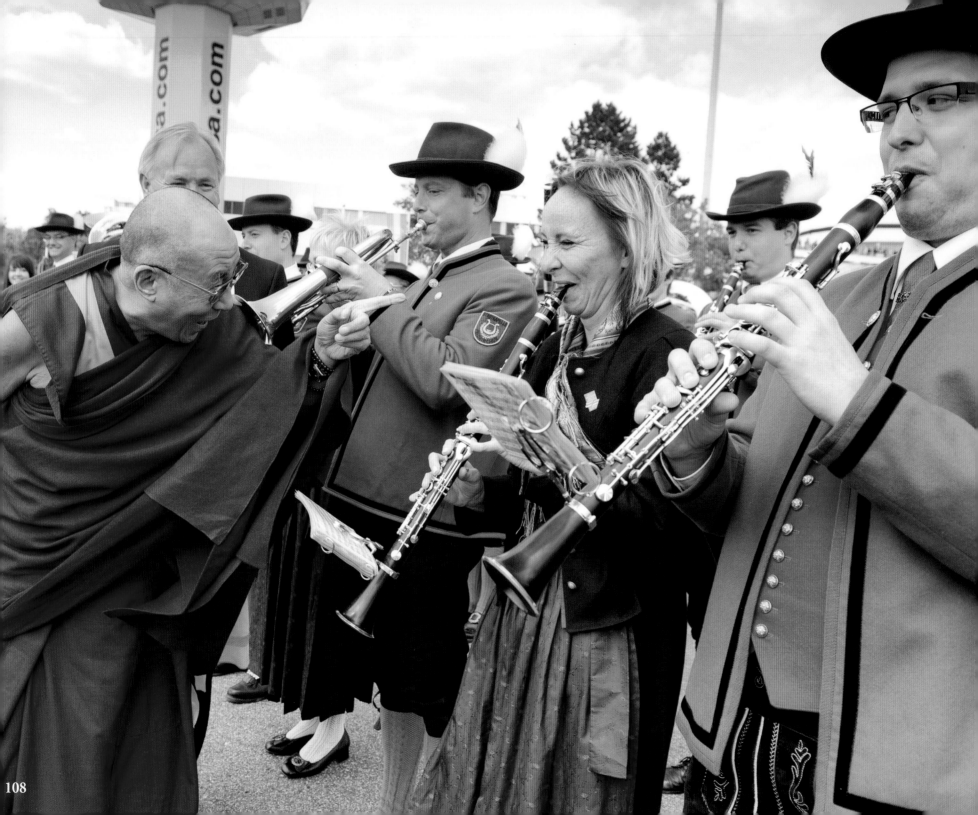

The first seven of the eight verses for Training the Mind deal with the practices associated with cultivating the method aspect of the path such as compassion, altruism, aspiration to attain Buddhahood. The eighth verse deals with practices that are directed towards cultivating the wisdom aspect of the path.

VERSE 1

With a determination to achieve the highest aim,
For the benefit of all sentient beings
Which surpasses even the wish-fulfilling gem,
May I hold them dear at all times.

These four lines are about cultivating a sense of holding for all other sentient beings. The main point this verse emphasizes is to develop an attitude that enables you to regard other sentient beings as precious, much in the manner of precious jewels. The question could be raised, "Why do we need to cultivate the thought that other sentient beings are precious and valuable?"

In one sense, we can say that other sentient beings are really the principal source of all our experiences of joy, happiness, and prosperity, and not only in terms of our day-to-day dealings with people. We can see that all the desirable experiences that we cherish or aspire to attain, are dependent upon cooperation and interaction with other sentient beings. It is an obvious fact. Similarly, from the point of view of a practitioner of the path, many of the high levels of realization that you gain and the progress you make on your spiritual journey are dependent upon cooperation and interaction with other sentient beings. Furthermore, at the resultant state of Buddhahood, the truly compassionate activities of the Buddha can come about spontaneously without any effort only in relation to sentient beings, because they are the recipients and beneficiaries of those enlightened activities. So one can see that other sentient beings are, in a sense, the true source of our joy, prosperity, and happiness. Basic joys and comforts of life such as food, shelter, clothing, and companionship are all dependent upon other sentient beings, as is fame and renown. Our feelings of comfort and sense of security are dependent upon other people's perceptions of us and their affection for us. It is almost as if human affection is the very basis of our existence. Our life cannot start without affection, and our sustenance,

and proper growth, depend on it. In order to achieve a calm mind, the more you have a sense of caring for others, the deeper your satisfaction will be. I think that the very moment you develop a sense of caring, others appear more positive. This is because of your own attitude. On the other hand, if you reject others, they will appear negative to you. Another thing that is quite clear to me is that the moment you think only of yourself, the focus of your mind narrows, and because of this narrow focus, uncomfortable things can appear huge and bring you fear and discomfort and a sense of feeling overwhelmed by misery. The moment you think of others with a sense of caring, your mind widens. Within that wider angle, your problems appear to be of no significance, and this makes a big difference. If you have a sense of caring for others, you will manifest a kind of inner strength, in spite of your own difficult situations and problems. With this strength, your problems will seem less significant and bothersome. By going beyond your problems and taking care of others, you gain inner strength, self-confidence, courage, and a greater sense of calm. This is a clear example of how one's way of thinking can really make a difference.

The Guide to the Bodhisattva's Way of Life (*Bodhicaryavatara*) says that there is a phenomenological difference between the pain that you experience when you take someone else's pain upon yourself and the pain that comes directly from your own pain and suffering. In the former, there is an element of discomfort because you are sharing the other's pain, however, as Shantideva points out, there is also a certain amount of stability because, in a sense, you are voluntarily accepting that pain. In the voluntary participation in other's suffering, there is strength and a sense of confidence. But in the latter case, when you are undergoing your own pain and suffering, there is an element of involuntariness, and because of the lack of control on your part, you feel weak and completely overwhelmed. In the Buddhist teachings on altruism and compassion, certain expressions are used such as "One should disregard one's own well-being and cherish other's well-being". It is important to understand

these statements regarding the practice of voluntarily sharing someone else's pain and suffering in their proper context. The fundamental point is that if you do not have the capacity to love yourself, then there is simply no basis on which to build a sense of caring towards others. Love for yourself does not mean that you are indebted to yourself. Rather, the capacity to love oneself or be kind to oneself should be based on the very fundamental fact of human existence: that we all have a natural tendency to desire happiness and avoid suffering. Once this basis exists in relation to oneself, one can extend it to other sentient beings. Therefore, when we find statements in the teachings such as "Disregard your own well-being and cherish the well-being of others", we should understand them in the context of training yourself according to the ideal of compassion. This is important if we are not to indulge in self-centred ways of thinking that disregard the impact of our actions on other sentient beings. As I said earlier, we can develop an attitude of considering other sentient beings as precious in the recognition of the part their kindness plays in our own experience of joy, happiness, and success. This is the first consideration. The second consideration is as follows: through analysis and contemplation you will come to see that much of our misery, suffering, and pain really result from a self-centred attitude that cherishes one's own well-being at the expense of others, whereas much of the joy, happiness, and sense of security in our lives arise from thoughts and emotions that cherish the well-being of other sentient beings. Contrasting these two forms of thought and emotion convinces us of the need to regard other's well-being as precious.

There is another fact concerning the cultivation of thoughts and emotions that cherish the well-being of others: one's own self-interest and wishes are fulfilled as a by-product of actually working for other sentient beings. As Je Tsong Khapa points out in his Great Exposition of the Path to Enlightenment (Lamrim Chenmo), "The more the practitioner engages in activities and thoughts that are focused and directed toward the fulfillment of others' well-being, the fulfillment or realization of his or her own aspiration will come as a by-product without having to make a separate effort."

Some of you may have actually heard the remark, which I make quite often, that in some sense the bodhisattvas, the compassionate practitioners of the Buddhist path, are wisely selfish people, whereas people like ourselves are the foolishly selfish. We think of ourselves and disregard others, and the result is that we always remain unhappy and have a miserable time. The time has come to think more wisely, hasn't it? This is my belief. At some point the question comes up, "Can we really change our attitude?"

My answer on the basis of my little experience is, without hesitation, "Yes!" This is quite clear to me. The thing that we call "mind" is quite peculiar. Sometimes it is very stubborn and very difficult to change. But with continuous effort and with conviction based on reason, our minds are sometimes quite honest. When we really feel that there is some need to change, then our minds can change. Wishing and praying alone will not transform your mind, but with conviction and reason, and reason based ultimately on your own experience, you can transform your mind. Time is quite an important factor here, and with time our mental attitudes can certainly change. One point I should make here is that some people, especially those who see themselves as very realistic and practical, are too realistic and obsessed with practicality. They may think, "This idea of wishing for the happiness of all sentient beings and this idea of cultivating thoughts of cherishing the well-being of all sentient beings are unrealistic and too idealistic. They don't contribute in any way to the transformation of one's mind or to attaining some kind of mental discipline because they are completely unachievable." Some people may think in these terms and feel that perhaps a more effective approach would be to begin with a close circle of people with whom one has direct interaction. They think that later one can expand and increase the parameters. They feel there is simply no point in thinking about all sentient beings since there is an infinite number of them. They may conceivably feel some kind of connection with their fellow human beings on this planet, but they feel that the infinite sentient beings in the multiple world systems and universes have nothing to do with their own experience as an individual.

They may ask, "What point is there in trying to cultivate the mind that tries to include within its sphere every living being?" In a way that may be a valid

objection, but what is important here is to understand the impact of cultivating such altruistic sentiments.

The point is to try to develop the scope of one's empathy in such a way that it can extend to any form of life that has the capacity to feel pain and experience happiness. It is a matter of defining a living organism as a sentient being. This kind of sentiment is very powerful, and there is no need to be able to identify, in specific terms, with every single living being in order for it to be effective. Take, for example, the universal nature of impermanence. When we cultivate the thought that things and events are impermanent, we do not need to consider every single thing that exists in the universe in order for us to be convinced of impermanence. That is not how the mind works. So it is important to appreciate this point.

In the first verse, there is an explicit reference to the agent "I": "May I always consider others precious." Perhaps a brief discussion on the Buddhist understanding of what this "I" is referring to might be helpful at this stage. Generally speaking, no one disputes that people – you, me, and others – exist. We do not question the existence of someone who undergoes the experience of pain. We say, "I see such-and-such" and "I hear such-and-such", and we constantly use the first-person pronoun in our speech. There is no disputing the existence of the conventional level of "self" that we all experience in our day-to-day life. Questions arise, however, when we try to understand what that "self" or "I" really is. In probing these questions we may try to extend the analysis a bit beyond day-to-day life – we may, for example, recollect ourselves in our youth. When you have a recollection of something from your youth, you have a close sense of identification with the state of the body and your sense of "self" at that age. When you were young, there was a "self". When you get older there is a "self". There is also a "self" that pervades both stages. An individual can recollect his or her experiences of youth. An individual can think about his or her experiences of old age, and so on. We can see a close identification with our bodily states and sense of "self" or "I" consciousness. Many philosophers and, particularly, religious thinkers, have sought to understand the nature of the individual, that "self" or "I", which maintains its continuity across time. This has been especially important within the Indian tradition. The non-Buddhist Indian schools talk about *atman*, which is roughly translated as "self" or "soul"; and in other non-Indian religious traditions we hear discussions about the "soul" of the being and so on. In the Indian context, *atman* has the distinct meaning of an agent that is independent of the empirical facts of the individual. In the Hindu tradition, for example, there is a belief in reincarnation, which has inspired a lot of debate. I have also found references to certain forms of mystical practice in which a consciousness or soul assumes the body of a recently dead person. If we are to make sense of reincarnation, if we are to make sense of a soul assuming another body, then some kind of independent agent that is independent of the empirical facts of the individual must be posited. On the whole, non-Buddhist Indian schools have more or less come to the conclusion that the "self" really refers to this independent agent or *atman*. It refers to what is independent of our body and mind. Buddhist traditions on the whole have rejected the temptation to posit a "self", an *atman*, or a soul that is independent of our body and mind. Among Buddhist schools there is consensus on the point that "self" or "I" must be understood in terms of the aggregation of body and mind. But as to what, exactly, we are referring when we say "I" or "self," there has been divergence of opinion even among Buddhist thinkers. Many Buddhist schools maintain that in the final analysis, we must identify the "self" with the consciousness of the person. Through analysis, we can show how our body is a kind of contingent fact and that what continues across time is really a being's consciousness.

Of course, other Buddhist thinkers have rejected the move to identify "self" with consciousness. Buddhist thinkers such as Buddhapalita and Chandrakirti have rejected the urge to seek some kind of eternal, abiding, or enduring "self". They have argued that following that kind of reasoning is, in a sense, succumbing to the ingrained need to grasp at something. An analysis of the nature of "self" along these lines will yield nothing, because the quest involved here is metaphysical; it is a quest for a metaphysical self in which, Buddhapalita and Chandrakirti argue, we are going beyond the domain of the understanding of everyday language and everyday experience. Therefore, "self", person, and

agent must be understood purely in terms of how we experience our sense of "self". We should not go beyond the level of the conventional understanding of "self" and person. We should develop an understanding of our existence in terms of our bodily and mental existence so that "self" and person are in some sense understood as designations dependent upon mind and body. Chandrakirti used the example of a chariot in his Guide to the Middle Way (Madhyamakavatara). When you subject the concept of chariot to analysis, you are never going to find some kind of metaphysically or substantially real chariot that is independent of the parts that constitute the chariot. But this does not mean the chariot does not exist. Similarly, when we subject "self", the nature of "self", to such analysis, we cannot find a "self" independent of the mind and body that constitutes the existence of the individual or the being. This understanding of the "self" as a dependently originated being must also be extended to our understanding of other sentient beings. Other sentient beings are, once again, designations that are dependent upon bodily and mental existence. Bodily and mental existence is based on the aggregates, which are the psychophysical constituents of beings.

VERSE 2

> *Whenever I interact with someone,*
> *May I view myself as the lowest amongst all,*
> *And, from the very depths of my heart,*
> *Respectfully hold others as superior.*

The first verse pointed to the need to cultivate the thought of regarding all other sentient beings as precious. In the second verse, the point being made is that the recognition of the preciousness of other sentient beings, and the sense of caring that you develop on that basis, should not be grounded on a feeling of pity towards other sentient beings, that is, on the thought that they are inferior. Rather, what is being emphasized is a sense of caring for other sentient beings and a recognition of their preciousness based on reverence and respect, as superior beings. I would like to emphasize here how we should

understand compassion in the Buddhist context. Generally speaking, in the Buddhist tradition, compassion and loving kindness are seen as two sides of the same thing. Compassion is said to be the empathetic wish that aspires to see the object of compassion, the sentient being, free from suffering. Loving kindness is the aspiration that wishes happiness upon others. In this context, love and compassion should not be confused with love and compassion in the conventional sense. For example, we experience a sense of closeness towards people who are dear to us. We feel a sense of compassion and empathy for them. We also have strong love for these people, but often this love or compassion is grounded in self-referential considerations: "So-and-so is my friend", "my spouse", "my child", and so on. What happens with this kind of love or compassion, which may be strong, is that it is tinged with attachment, because it involves self-referential considerations. Once there is attachment, there is also the potential for anger and hatred to arise. Attachment goes hand in hand with anger and hatred. For example, if one's compassion towards someone is tinged with attachment, it can easily turn into its emotional opposite due to the slightest incident. Then instead of wishing that person to be happy, you might wish that person to be miserable.

True compassion and love in the context of training of the mind is based on the simple recognition that others, just like myself, naturally aspire to be happy and to overcome suffering, and that others, just like myself, have the natural right to fulfil that basic aspiration. The empathy you develop towards a person based on recognition of this basic fact is universal compassion. There is no element of prejudice, no element of discrimination. This compassion is able to be extended to all sentient beings, so long as they are capable of experiencing pain and happiness. Thus, the essential feature of true compassion is that it is universal and not discriminatory. As such, training the mind in cultivating compassion in the Buddhist tradition first involves cultivating a thought of even-mindedness, or equanimity, towards all sentient beings. For example, you may reflect upon the fact that such-and-such a person may be your friend, your relative, and so forth in this life, but that this person may have been, from a Buddhist point of view, your worst enemy in a past life.

Similarly, you apply the same sort of reasoning to someone you consider an enemy: although this person may be negative towards you and is your enemy in this life, he or she could have been your best friend in a past life, or could have been related to you. By reflecting upon the fluctuating nature of one's relationships with others and also on the potential that exists in all sentient beings to be friends and enemies, you develop this even-mindedness or equanimity.

The practice of developing or cultivating equanimity involves a form of detachment, but it is important to understand what detachment means. Sometimes when people hear about the Buddhist practice of detachment, they think that Buddhism is advocating indifference towards all things, but that is not the case. First, cultivating detachment, one could say, takes the sting out of discriminatory emotions toward others that are based on considerations of distance or closeness. You lay the groundwork on which you can cultivate genuine compassion extending to all other sentient beings. The Buddhist teaching on detachment does not imply developing an attitude of disengagement from or indifference to the world or life.

Moving on to another line of the verse, I think it is important to understand the expression "May I see myself lower than all others" in the right context. Certainly it is not saying that you should engage in thoughts that would lead to lower self-esteem, or that you should lose all sense of hope and feel dejected, thinking, "I'm the lowest of all. I have no capacity, I cannot do anything and have no power." This is not the kind of consideration of lowness that is being referred to here. The regarding of oneself as lower than others really has to be understood in relative terms. Generally speaking, human beings are superior to animals. We are equipped with the ability to judge between right and wrong and to think in terms of the future. However, one could also argue that in other respects, human beings are inferior to animals. For example, animals may not have the ability to judge between right and wrong in a moral sense, and they might not have the ability to see the long-term consequences of their actions, but within the animal realm, there is at least a certain sense of order. If you look at the African savannah, for example, predators prey on other animals

only out of necessity when they are hungry. When they are not hungry, you can see them coexisting quite peacefully. But we human beings, despite our ability to judge between right and wrong, sometimes act out of pure greed. Sometimes we engage in actions purely out of indulgence – we kill out of a sense of "sport", say, when we go hunting or fishing. So, in a sense, one could argue that human beings have proven to be inferior to animals. It is in such relativistic terms that we can regard ourselves as lower than others. One of the reasons for using the word "lower" is to emphasize that normally when we give in to ordinary emotions of anger, hatred, strong attachment, and greed, we do so without any sense of restraint. Often we are totally oblivious to the impact our behaviour has on other sentient beings. But by deliberately cultivating the thought of regarding others as superior and worthy of your reverence, you provide yourself with a restraining factor. Then, when emotions arise, they will not be so powerful as to cause you to disregard the impact of your actions upon other sentient beings. It is on these grounds that recognition of others as superior to yourself is suggested.

VERSE 3

In all my deeds may I probe into my mind,
And as soon as mental and emotional afflictions arise –
As they endanger myself and others –
May I strongly confront them and avert them.

This verse really gets to the heart of what could be called the essence of the practice of the Buddhadharma. When we talk about Dharma in the context of Buddhist teachings, we are talking about nirvana, or freedom from suffering. Freedom from suffering, nirvana, or cessation, is the true Dharma. There are many levels of cessation – for example, restraint from killing or murder could be a form of Dharma. But this cannot be called Buddhist Dharma specifically because restraint from killing is something that even someone who is non-religious can adopt as a result of following the law. The essence of the Dharma in the Buddhist tradition is that state of freedom from suffering and defilements (Skt. klesha, Tib. nyonmong) that lie at the root of suffering. This verse addresses how to combat these defilements or afflictive emotions and thoughts. One could say that for a Buddhist practitioner, the real enemy is this enemy within – these mental and emotional defilements. It is these emotional and mental afflictions that give rise to pain and suffering. The real task of a buddhadharma practitioner is to defeat this inner enemy. Since applying antidotes to these mental and emotional defilements lies at the heart of the Dharma practice and is in some sense its foundation, the third verse suggests that it is very important to cultivate mindfulness right from the beginning. Otherwise, if you let negative emotions and thoughts arise inside you without any sense of restraint, without any mindfulness of their negativity, then in a sense you are giving them free reign. They can then develop to the point where there is simply no way to counter them. However, if you develop mindfulness of their negativity, then when they occur, you will be able to stamp them out as soon as they arise. You will not give them the opportunity or the space to develop into full-blown negative emotional thoughts. The way in which this third verse suggests we apply an antidote is, I think, at the level of the manifested and felt experience of emotion. Instead of getting at the root of emotion in general, what is being suggested is the application of antidotes that are appropriate to specific negative emotions and thoughts. For example, to counter anger, you should cultivate love and compassion. To counter strong attachment to an object, you should cultivate thoughts about the impurity of that object, its undesirable nature, and so on. To counter one's arrogance or pride, you need to reflect upon shortcomings in you that can give rise to a sense of humility. For example, you can think about all the things in the world about which you are completely ignorant. Take the sign language interpreter here in front of me. When I look at her and see the complex gestures with which she performs the translation, I haven't a clue what is going on, and to see that is quite a humbling experience. From my own personal experience, whenever I have a little tingling sense of pride, I think of computers. It really calms me down!

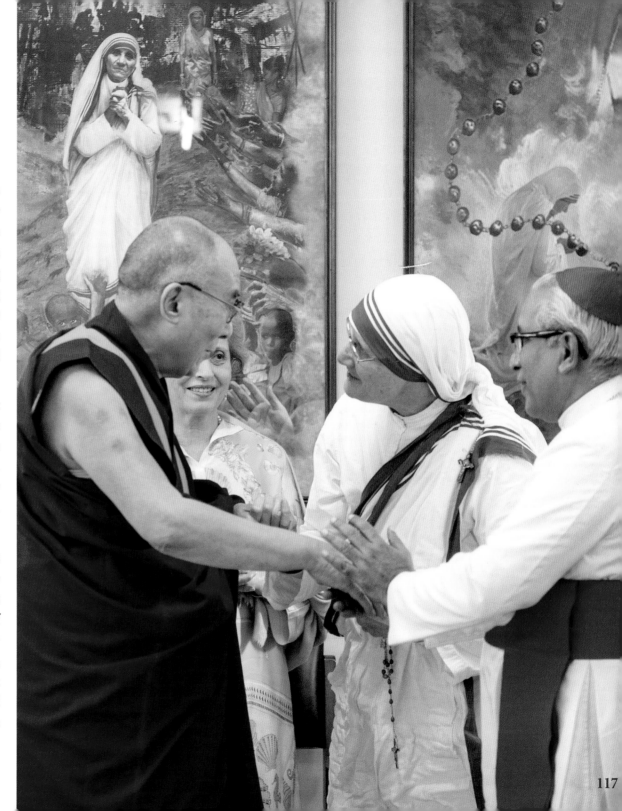

VERSE 4

When I see beings of unpleasant character
Oppressed by strong negativity and suffering,
May I hold them dear — for they are rare to find —
As if I have discovered a jewel treasure!

This verse refers to the special case of relating to people who are socially marginalized, perhaps because of their behavior, their appearance, their destitution, or on account of some illness. Whoever practices Bodhichitta must take special care of these people, as if on meeting them, you have found a real treasure. Instead of feeling repulsed, a true practitioner of these altruistic principles should engage and take on the challenge of relating. In fact, the way we interact with people of this kind could give a great impetus to our spiritual practice.

In this context, I would like to point out the great example set by many Christian brothers and sisters who engage in the humanitarian and caring professions especially directed to marginalized members of society. One such example in our times was the late Mother Teresa, who dedicated her life to caring for the destitute. She exemplified the ideal that is described in this verse.

It is on account of this important point that when I meet members of Buddhist centres in various parts of the world, I often point out to them that it is not sufficient for a Buddhist centre simply to have programmes of teaching or meditation. There are, of course, very impressive Buddhist centres, and some retreat centres, where the Western monks have been trained so well that they are capable of playing the clarinet in the traditional Tibetan way! But I also emphasize to them the need to

bring the social and caring dimension into their programme of activities, so that the principles presented in the Buddhist teachings can make a contribution to society.

I am glad to say that I've heard that some Buddhist centers are beginning to apply Buddhist principles socially. For example, I believe that in Australia there are Buddhist centers which are establishing hospices and helping dying people, and caring for patients with Aids. I have also heard of Buddhist centers involved in some form of spiritual education in prisons, where they give talks and offer counseling. I think these are great examples. It is of course deeply unfortunate when such people, particularly prisoners, feel rejected by society. Not only is it deeply painful for them, but also from a broader point of view, it is a loss for society. We are not providing the opportunity for these people to make a constructive social contribution when they actually have the potential to do so. I therefore think it is important for society as a whole not to reject such individuals, but to embrace them and acknowledge the potential contribution they can make. In this way they will feel they have a place in society, and will begin to think that they might perhaps have something to offer.

VERSE 5 AND 6

When others, out of jealousy,
treat me wrongly with abuse, slander, and scorn,
May I take upon myself the defeat
And offer to others the victory.

The point that is made here is that when others provoke you, perhaps for no reason or unjustly, instead of reacting in a negative way, as a true practitioner of altruism, you should be able to be tolerant towards them. You should remain unperturbed by such treatment. In the next verse we learn that not only should we be tolerant of such people, but in fact we should view them as our spiritual teachers. It reads:

When someone whom I have helped,
Or in whom I have placed great hopes,
Mistreats me in extremely hurtful ways,
May I regard him still as my precious teacher.

In Shantideva's Guide to the Bodhisattva's Way of Life, there is an extensive discussion of how we can develop this kind of attitude, and how we can actually learn to see those who perpetrate harm on us as objects of spiritual learning. And also, in the third chapter of Chandrakirti's Entry to the Middle Way, there are profoundly inspiring and effective teachings on the cultivation of patience and tolerance.

VERSE 7

The seventh verse summarizes all the practices that we have been discussing. It reads:

In brief, may I offer benefit and joy
to all my mothers, both directly and indirectly,
May I quietly take upon myself
All hurts and pains of my mothers.

This verse presents a specific Buddhist practice known as "the practice of giving and taking" (Tong Len), and it is by means of the visualization of giving and taking that we practice equalizing and exchanging ourselves with others.

"Exchanging ourselves with others" should not be taken in the literal sense of turning oneself into the other and the other into oneself. This is impossible anyway. What is meant here is a reversal of the attitudes one normally has towards oneself and others. We tend to relate to this so-called "self" as a precious core at the center of our being, something that is really worth taking care of, to the extent that we are willing to overlook the well-being of others. In contrast, our attitude towards others often resembles indifference; at best we may have some concern for them, but even this may simply remain at the level of a feeling or an emotion. On the whole, we are indifferent towards others'

well-being and do not take it seriously. So the point of this particular practice is to reverse this attitude so that we reduce the intensity of our grasping and the attachment we have to ourselves, and endeavor to consider the well-being of others as significant and important.

When approaching Buddhist practices of this kind, where there is a suggestion that we should take harm and suffering upon ourselves, I think it is vital to consider them carefully and appreciate them in their proper context. What is actually being suggested here is that if, in the process of following your spiritual path and learning to think about the welfare of others, you are led to take on certain hardships or even suffering, then you should be totally prepared for this. The texts do not imply that you should hate yourself, or be harsh on yourself, or somehow wish misery upon yourself in a masochistic way. It is important to know that this is not the meaning.

Another example we should not misinterpret is the verse in a famous Tibetan text which reads, "May I have the courage if necessary to spend aeons and aeons, innumerable lifetimes, even in the deepest hell realm." The point that is being made here is that the level of your courage should be such that if this is required of you as part of the process of working for others' well-being, then you should have the willingness and commitment to accept it.

A correct understanding of these passage is very important, because otherwise you may use them to reinforce any feelings of self-hatred, thinking that if the self is the embodiment of self-centeredness, one should banish oneself into oblivion. Do not forget that ultimately the motivation behind wishing to follow a spiritual path is to attain supreme happiness, so, just as one seeks happiness for oneself, one is also seeking happiness for others. Even from a practical point of view, for someone to develop genuine compassion towards others, first he or she must have a basis upon which to cultivate compassion, and that basis is the ability to connect to one's own feelings and to care for one's own welfare. If one is not capable of doing that, how can one reach out to others and feel concern for them? Caring for others requires caring for oneself.

The practice of Tong Len, giving and taking, encapsulates the practices of loving-kindness and compassion: the practice of giving emphasizes the practice of loving-kindness, whereas the practice of taking emphasizes the practice of compassion.

Shantideva suggests an interesting way of doing this practice in his Guide to the Bodhisattva's Way of Life. It is a visualization to help us appreciate the shortcomings of self-centeredness, and provide us with methods to confront it. On one side you visualize your own normal self, the self that is totally impervious to others' well-being, and an embodiment of self-centeredness. This is the self that only cares about its own well-being, to the extent that it is often willing to exploit others quite arrogantly to reach it sown ends. Then, on the other side, you visualize a group of beings who are suffering, with no protection and no refuge. You can focus your attention on specific individuals if you wish. For example, if you wish to visualize someone you know well and _____ then you can take that person as a specific _____ the entire practice of giving and taking in relation to him or her. Thirdly, you view yourself as a neutral third person, an

impartial observer, who tries to assess whose interest is more important here. Isolating yourself in the position of neutral observer makes it easier for you to see the limitations of self-centeredness, and realize how much fairer and more rational it is to concern yourself with the welfare of other sentient beings.

As a result of this visualization, you slowly begin to feel an affinity with others and a deep empathy with their suffering, and at this point you can begin the actual meditation of giving and taking.

In order to carry out the meditation on taking, it is often quite helpful to do another visualization. First, you focus your attention on suffering beings, and try to develop and intensify your compassion towards them, to the point where you feel that their suffering is almost unbearable. At the same time, however, you realize that there is not much you can do to help them in a practical sense. So in order to train yourself to become more effective, with a compassionate motivation, you visualize taking upon yourself their suffering, the cause of their suffering, their negative thoughts and emotions, and so forth. You can do this by imagining all their suffering and negativity as a stream of dark smoke, and you visualize this smoke dissolving into you.

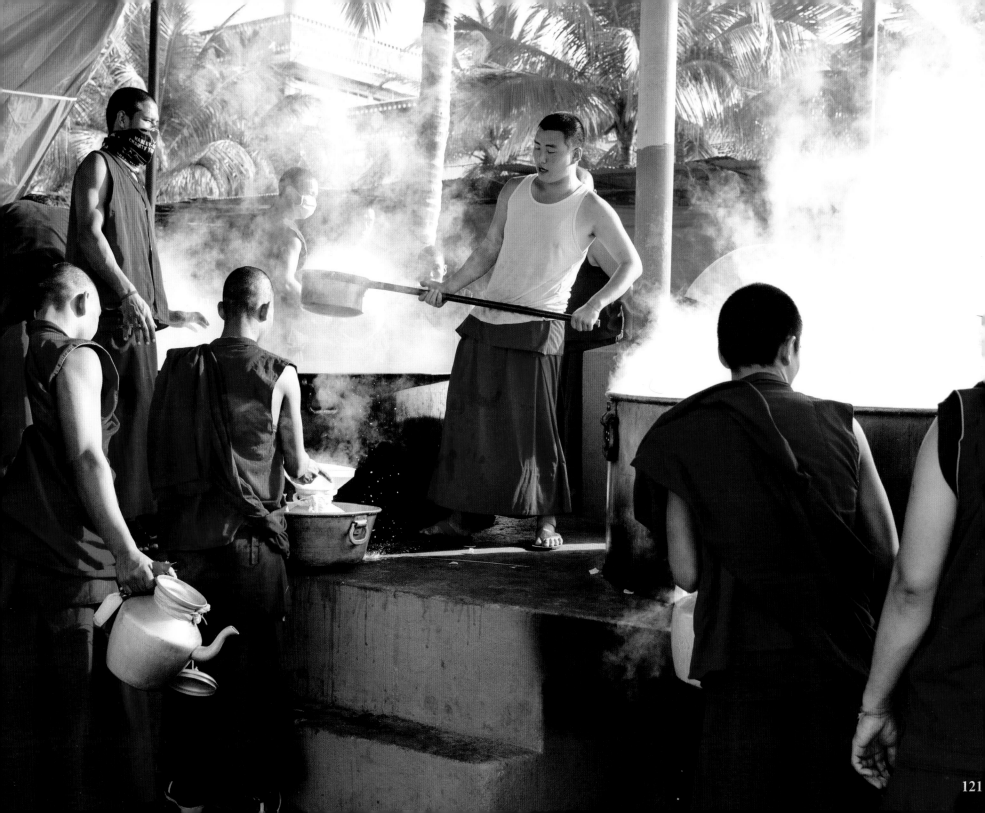

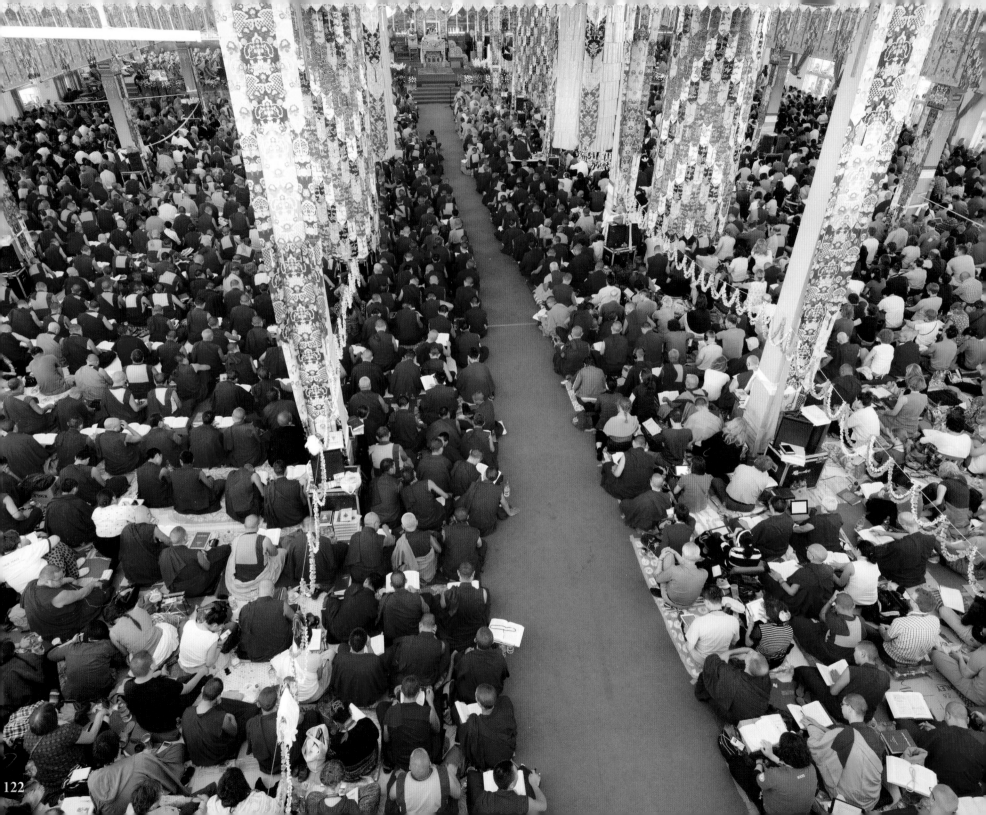

In the context of this practice, you can also visualize sharing your own positive qualities with others. You can think of any meritorious actions that you have done, any positive potential that may lie in you, and also any spiritual knowledge or insight that you may have attained. You send them out to other sentient beings, so that they too can enjoy their benefits. You can do this by imagining your qualities in the form of either a bright light or a whitish stream of light, which penetrates other beings and is absorbed into them. This is how to practice the visualization of taking and giving.

Of course, this kind of meditation will not have a material effect on others because it is a visualization, but what it can do is help increase your concern for others and your empathy with their suffering, while also helping to reduce the power of your self-centeredness. These are the benefits of the practice.

This is how you train your mind to cultivate the altruistic aspiration to help other sentient beings. When this arises together with the aspiration to attain full enlightenment, then you have realized Bodhichitta, that is, the altruistic intention to become fully enlightened for the sake of all sentient beings.

VERSE 8

In the final verse, we read:

> *May all this remain undefiled*
> *By the stains of the eight mundane concerns,*
> *And may I, recognizing all things as illusion,*
> *Devoid of clinging, be released from bondage.*

The first two lines of this verse are very critical for a genuine practitioner. The eight mundane concerns are attitudes that tend to dominate our lives generally. They are: becoming elated when someone praises you, becoming depressed when someone insults or belittles you, feeling happy when you experience success, being depressed when you experience failure, being joyful when you acquire wealth, feeling dispirited when you become poor, being pleased when you have fame, and feeling depressed when you lack recognition.

A true practitioner should ensure that his or her cultivation of altruism is not defiled by these thoughts. For example, if, as I am giving this talk, I have even the slightest thought in the back of my mind that I hope people admire me, then that indicates that my motivation is defiled by mundane considerations, or what the Tibetans call the "eight mundane concerns." It is very important to check oneself and ensure that is not the case. Similarly, a practitioner may apply altruistic ideals in his daily life, but if all of a sudden he feels proud about it and thinks, "Ah, I'm a great practitioner," immediately the eight mundane concerns defile his practice. The same applies if a practitioner thinks, "I hope people admire what I'm doing," expecting to receive praise for the great effort he is making. All these are mundane concerns that spoil one's practice, and it is important to ensure that this is does not happen so we keep our practice pure.

As you can see, the instructions that you can find in the Lojong teachings on transforming the mind are very powerful. They really make you think. For example there is a passage which says:

May I be gladdened when someone belittles me, and may I not take pleasure when someone praises me. If I do take pleasure in praise then it immediately increases my arrogance, pride, and conceit; whereas if I take pleasure in criticism, then at least it will open my eyes to my own shortcomings.

This is indeed a powerful sentiment.

Up to this point we have discussed all the practices that are related to the cultivation of what is known as "conventional Bodhichitta," the altruistic intention to become fully enlightened for the benefit of all sentient beings. Now, the last two lines of the Eight Verses relate to the practice of cultivating what is known as "ultimate Bodhichitta," which refers to the development of insight into the ultimate nature of reality.

Although the generation of wisdom is part of the Bodhisattva ideal, as embodied in the six perfections, generally speaking, as we saw earlier, there are two main aspects to the Buddhist path-method and wisdom. Both are included in the definition of enlightenment, which is the non-duality of perfected form

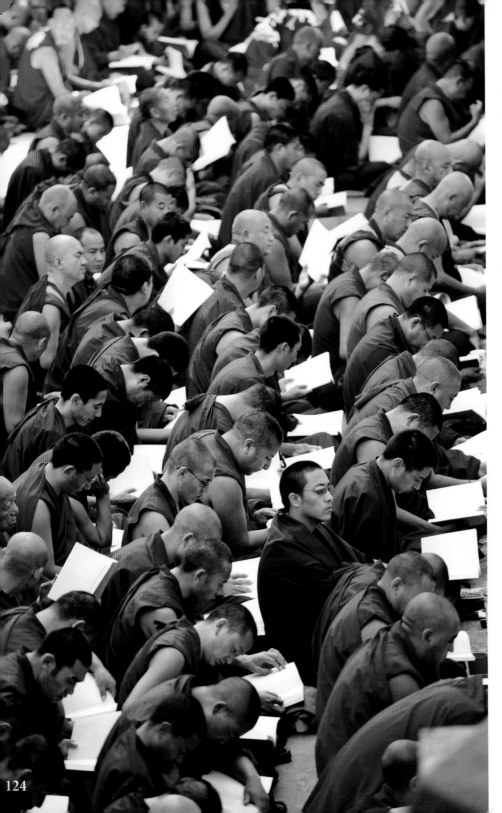

and perfected wisdom. The practice of wisdom or insight correlates with the perfection of wisdom, while the practice of skillful means or methods correlates with the perfection of form.

The Buddhist path is presented within a general framework of what are called Ground, Path, and Fruition. First, we develop an understanding of the basic nature of reality in terms of two levels of reality, the conventional truth and the ultimate truth; this is the ground. Then, on the actual path, we gradually embody meditation and spiritual practice as a whole in terms of method and wisdom. The final fruition of one's spiritual path takes place in terms of the non-duality of perfected form and perfected wisdom.

The last two lines read:

> *And may I, recognizing all things as illusion,*
> *Devoid of clinging, be released from bondage.*

These lines actually point to the practice of cultivating insight into the nature of reality, but on the surface they seem to denote a way of relating to the world during the stages of post-meditation. In the Buddhist teachings on the ultimate nature of reality, two significant time periods are distinguished; one is the actual meditation on emptiness, and the other is the period subsequent to the meditative session when you engage actively with the real world, as it were. So, here, these two lines directly concern the way of relating to the world in the aftermath of one's meditation on emptiness. This is why the text speaks of appreciating the illusion-like nature of reality, because this is the way one perceives things when one arises from single-pointed meditation on emptiness.

In my view, these lines make a very important point because sometimes people have the idea that what really matters is single-pointed meditation on emptiness within the meditative session. They pay much less attention to how this experience should be applied in post-meditation periods. However, I think the post-meditation period is very important. The whole point of meditating on the ultimate nature of reality is to ensure that you are not fooled by appearances can often be deluding. With a deeper understanding of reality, you

can go beyond appearances and relate to the world in a much more appropriate, effective, and realistic manner.

I often give the example of how we should relate to our neighbours. Imagine that you are living in a particular part of town where interaction with your neighbors is almost impossible, and yet it is actually better if you do interact with them rather than ignore them. To do so in the wisest way depends on how well you understand your neighbors' personality.

If, for example, the man living next door is very resourceful, then being friendly and communicating with him will be to your benefit. At the same time, if you know that deep down he can also be quite tricky, that knowledge is invaluable if you are to maintain a cordial relationship and be vigilant so that he does not take advantage of you. Likewise, once you have a deeper understanding of the nature of reality, then in post-meditation, when you actually engage with the world, you will relate to people and things in a much more appropriate and realistic manner.

When the text refers to viewing all phenomena as illusions, it is suggesting that the illusion-like nature of things can only be perceived if you have freed yourself from attachment to phenomena as independent discrete entities. Once you have succeeded in freeing yourself from such attachment, the perception of the illusion-like nature of reality will automatically arise. Whenever things appear to you, although they appear to have an independent or objective existence, you will know as a result of your meditation that this is not really the case. You will be aware that things are not as substantial and solid as they seem. The term "illusion" therefore points to the disparity between how you perceive things and how they really are.

The first three verses from the eight verses of Training the Mind along with the commentary by His Holiness the Dalai Lama were given on 8 November 1998 in Washington D.C. The remaining five verses are extracted from the book Transforming the Mind by His Holiness the Dalai Lama.

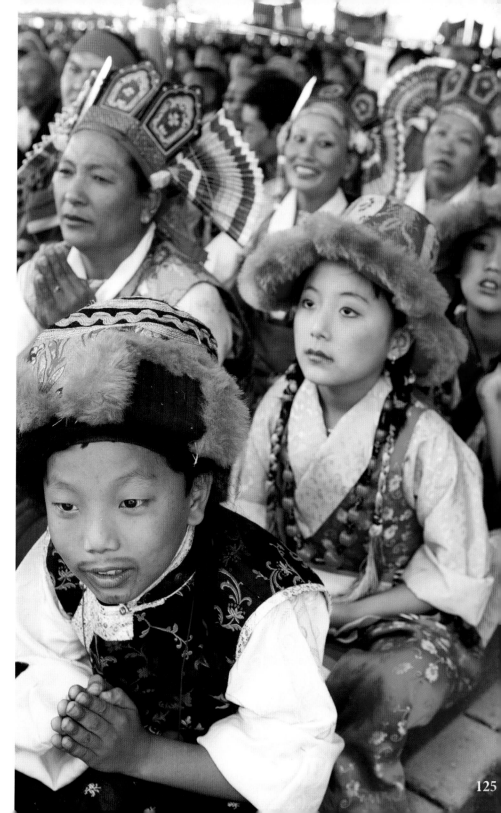

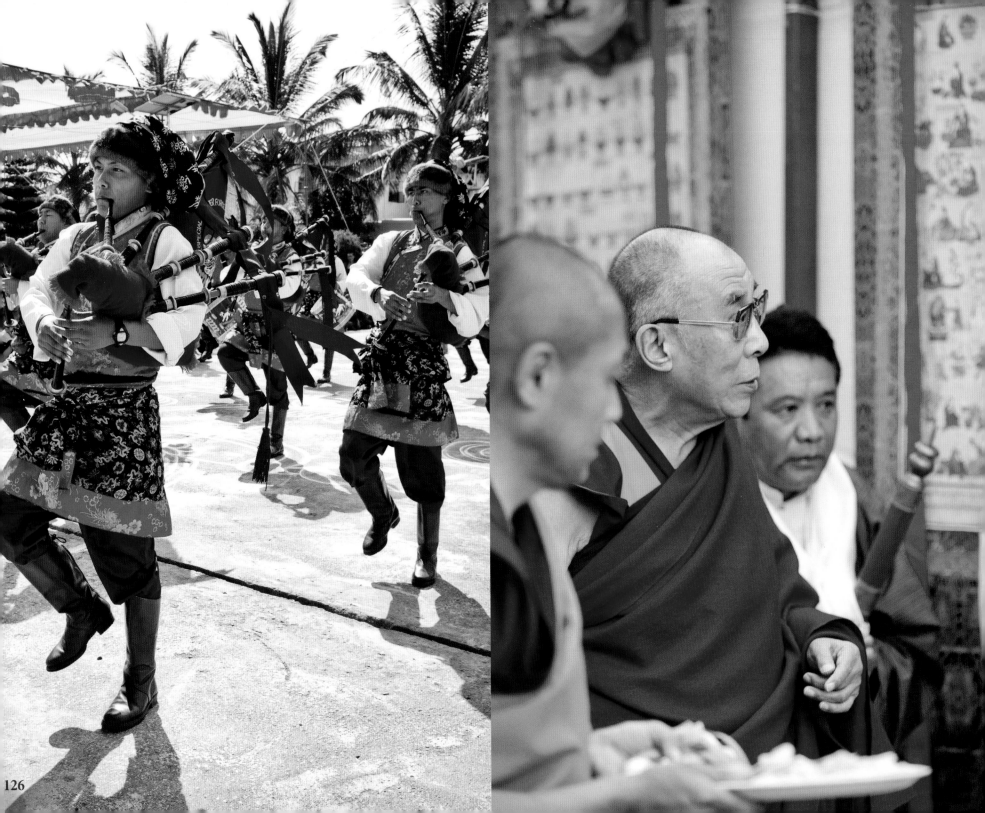

GENERATING THE MIND FOR ENLIGHTENMENT

For those who admire the spiritual ideals of the Eight verses on Transforming the Mind, it is helpful to recite the following verses for generating the mind for enlightenment. Practicing Buddhists should recite the verses and reflect upon the meaning of the words, while trying to enhance their altruism and compassion. Those of you who are practitioners of other religious traditions can draw from your own spiritual teachings, and try to commit yourselves to cultivating altruistic thoughts in pursuit of the altruistic ideal.

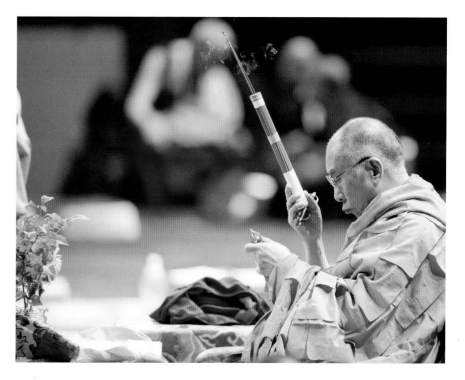

With a wish to free all beings
I shall always go for refuge
to the Buddha, Dharma and Sangha
until I reach full enlightenment.

Enthused by wisdom and compassion,
today in the Buddha's presence
I generate the Mind for Full Awakening
for the benefit of all sentient beings.

As long as space endures,
as long as sentient being remain,
until then, may I too remain
and dispel the miseries of the world.

In conclusion, those, who like myself, consider themselves to be followers of Buddha, should practice as much as we can. To followers of other religious traditions, I would like to say, "Please practice your own religion seriously and sincerely." And to non-believers, I request you to try to be warm-hearted. I ask this of you because these mental attitudes actually bring us happiness. As I have mentioned before, taking care of others actually benefits you.

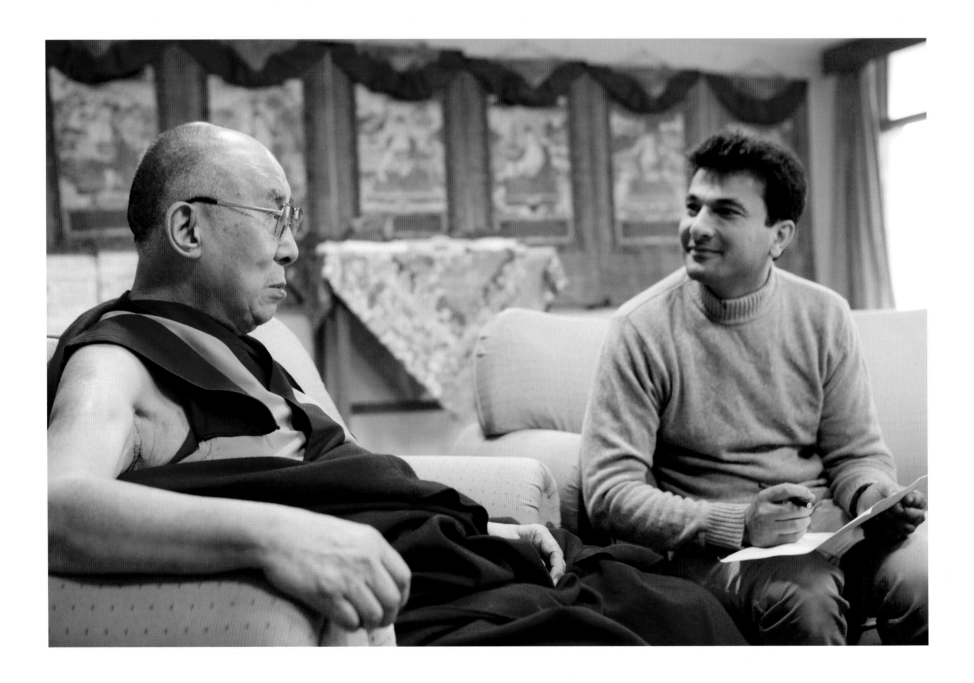

His Holiness
The 14th Dalai Lama of Tibet

In Conversation

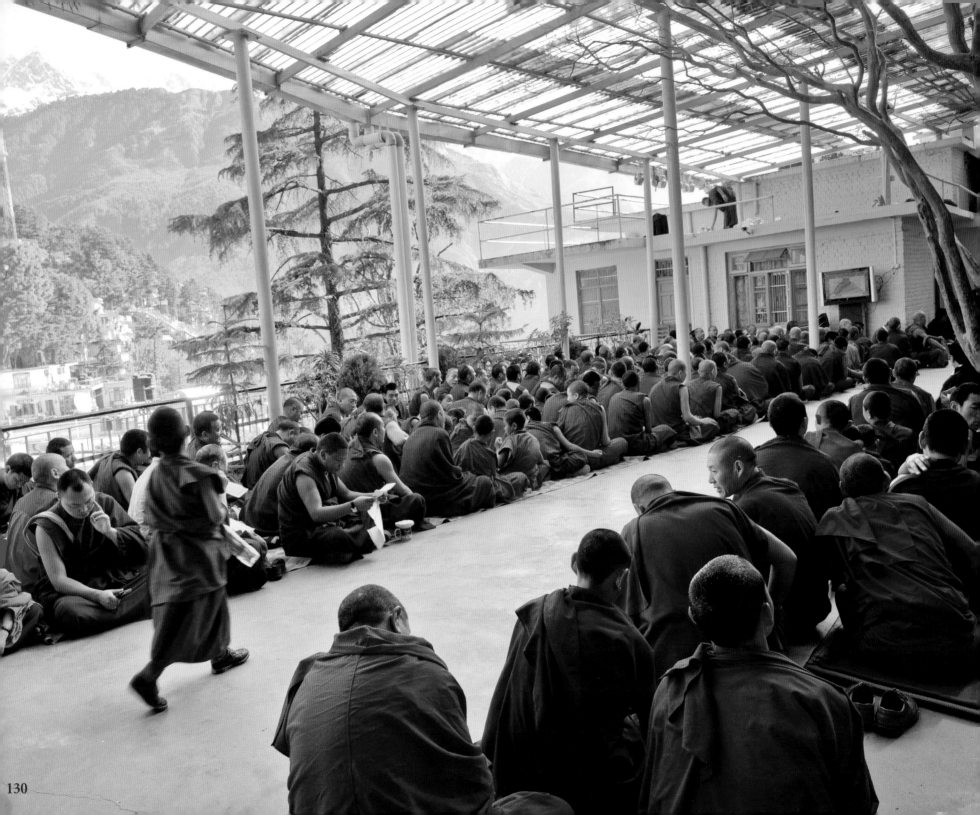

Do you watch TV?

Yes, I do.

Favourite movie?

ET (It is this strange character who comes from an alien land).

Favourite book?

Teachings by Nagarjuna,
the Nalanda scholar.

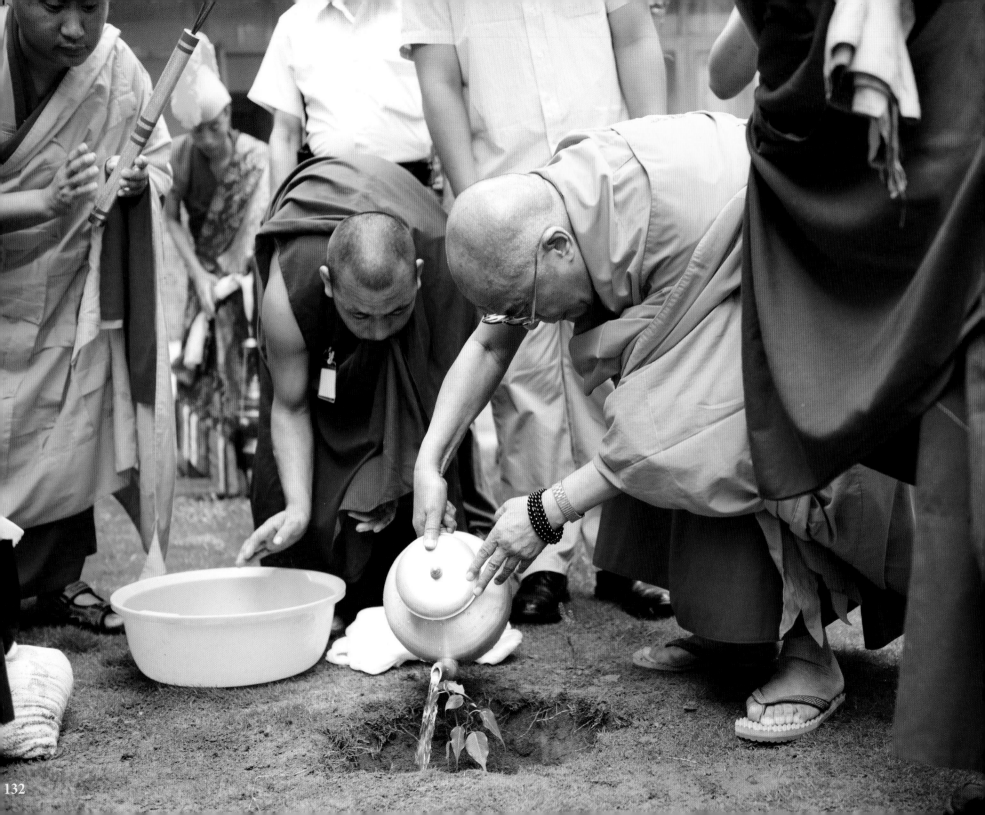

What is the most important thing for daily life?

Affection and compassion are indispensable in daily life.

What is the true meaning of compassion?

True compassion isn't just an emotional response. It is a firm commitment founded on reason, which doesn't change if others behave badly.

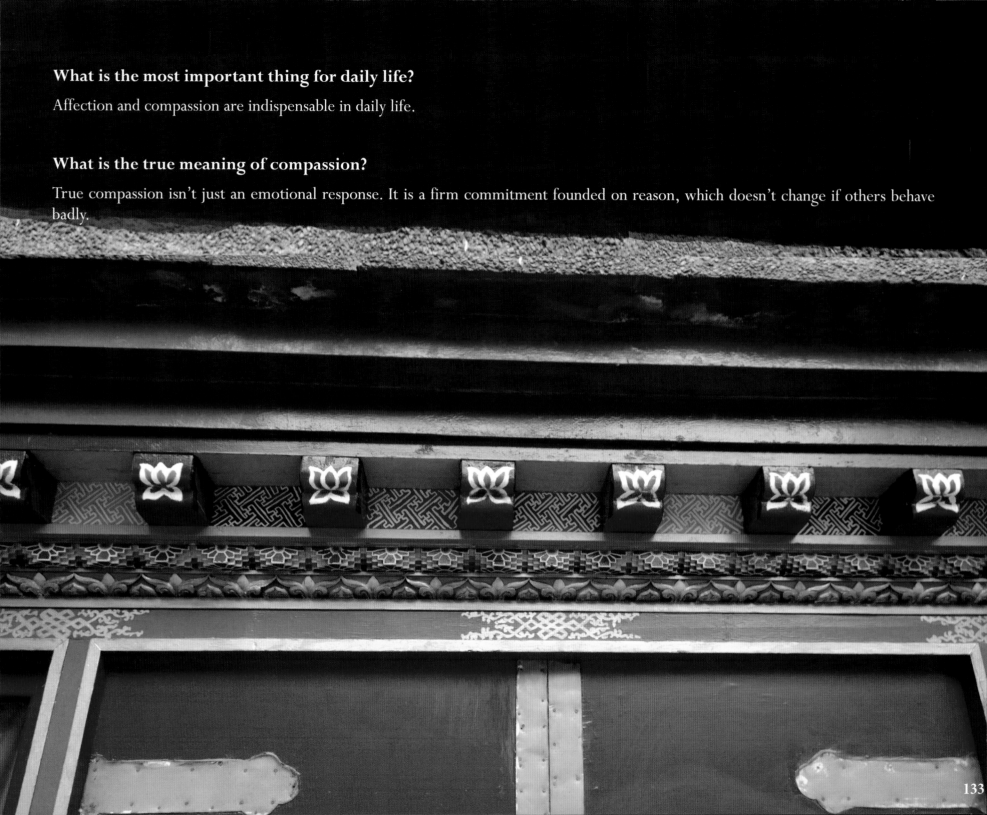

What is fame?

An empty word.

What is the singular most important thing in life?

Life should be useful, sensitive and meaningful. Then life is good.

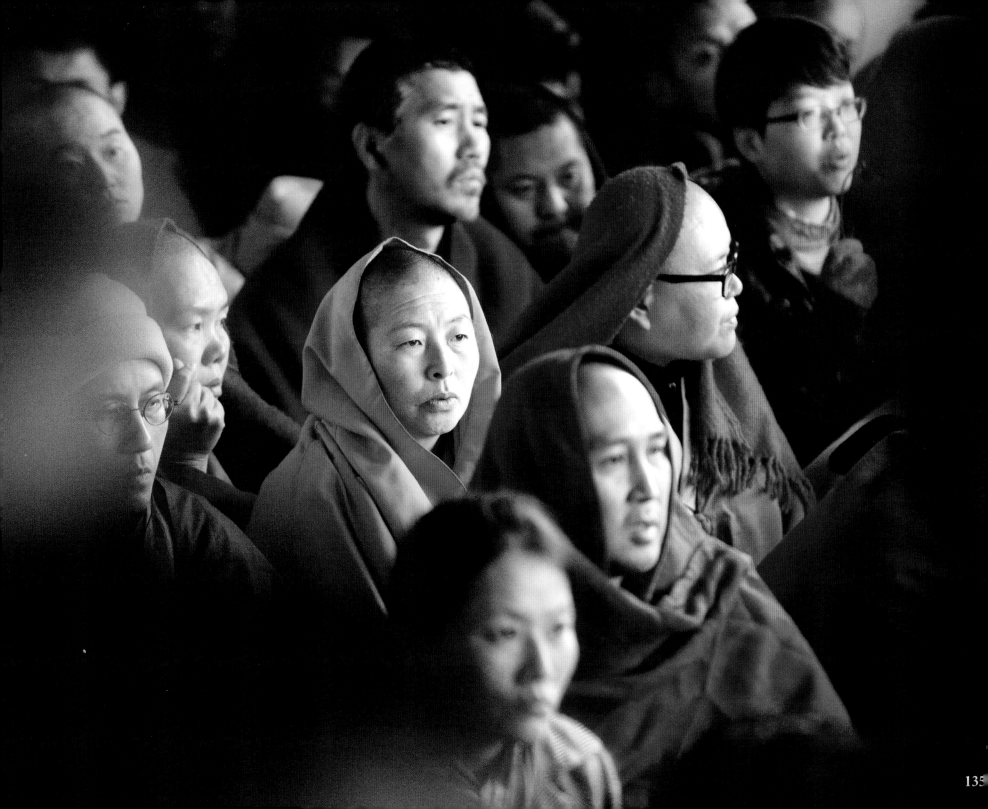

Favourite song?

Tibetan opera. When I was a young kid, I would hear it at all the festivals. My mother used to attend the festivals and it would also mean no lessons. I think opera evokes childhood memories and that makes it my favourite.

Favourite music?

Tibetan music.

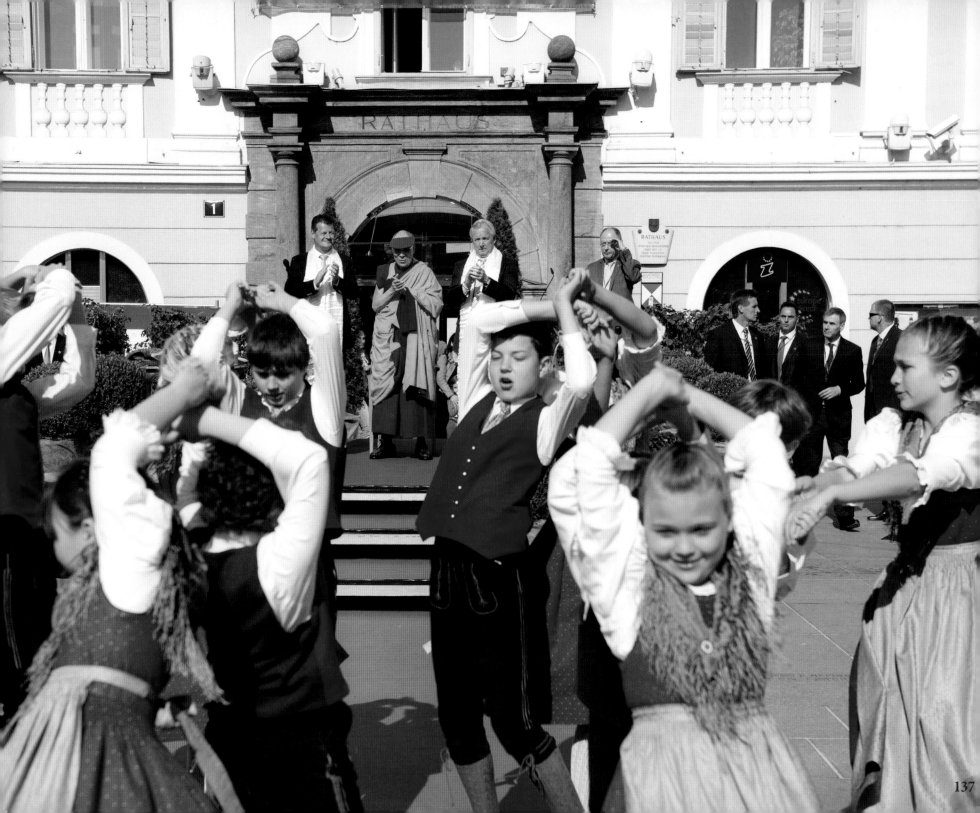

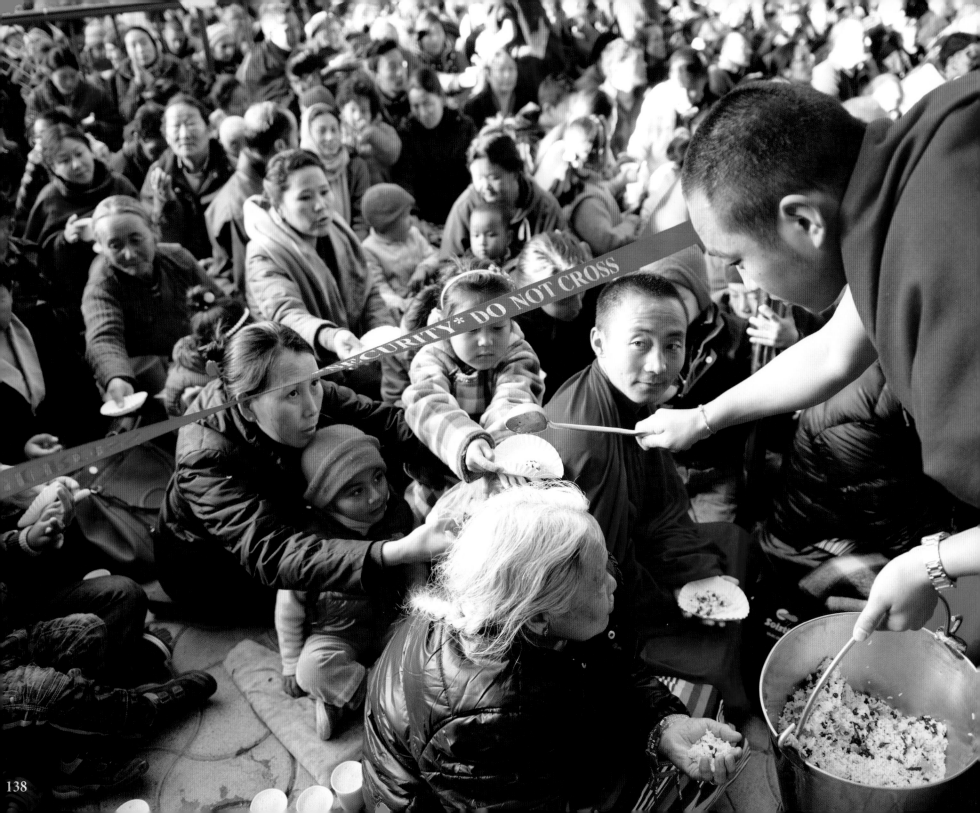

Most favourite story?

I have always loved stories that are about individuals helping each other, without a self-centred attitude, for example, Mahatma Gandhi, who spent his life serving other people.

What does betrayal mean to you?

When you think of only self and not others.

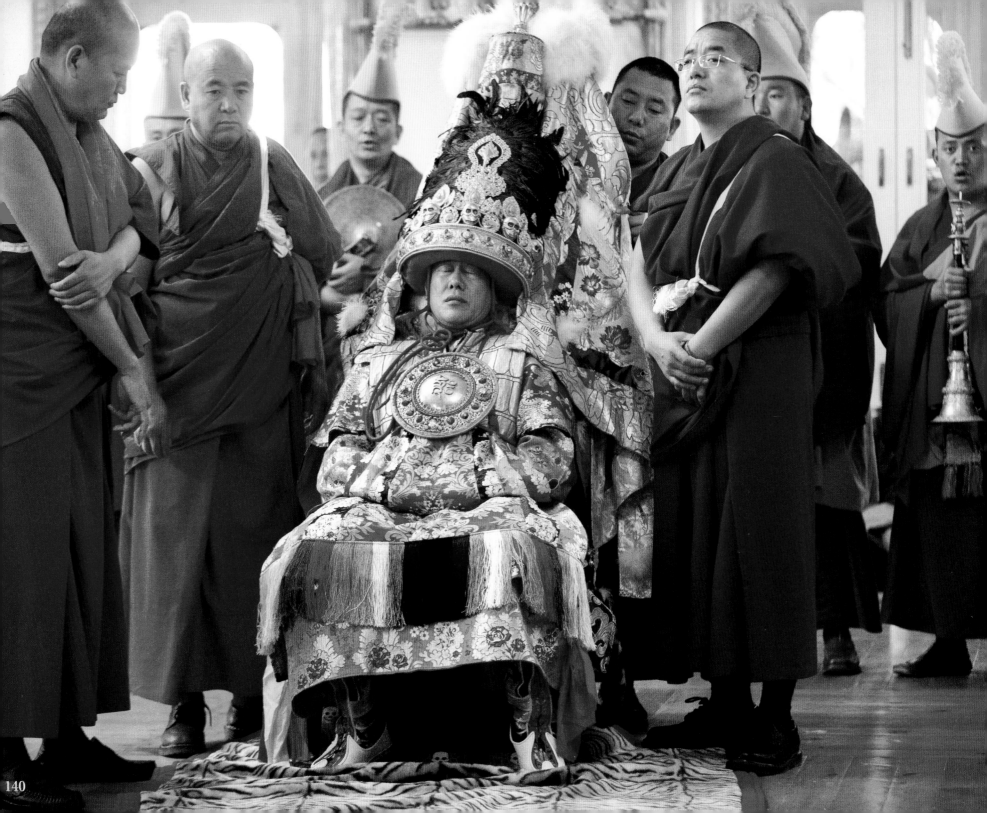

Can man/woman achieve anything?

Yes, but a female cannot be a father and male cannot be a mother, and they cannot reproduce in an isolated, absolute case.

Favourite person?

From an olden era, Nagarjuna, the Nalanda scholar; while in the modern day, I am very fond of genuine scientists because their mind is unbiased, always shows curiosity. I love German scientist Prof Dr Ernst Ulrich von Weizsäcker who is no more.

What does ego mean to you?

One is the strong, feeling of 'I', with no hesitation to cheat or bully. That's the negative ego which needs to be reduced, preferably eliminated. And then there is another ego, which is the basis of your self-confidence, which should help you take a courageous stand and is beneficial to others. It is a strong sense of self and this is the good ego.

What do you think of art?

Important way to communicate messages. Paintings, poems – these are all mediums to carry the meaning.

I believe art is very good but depends on how we use it.

Artist you admire?

Nature is the biggest artist and creates different things.

142

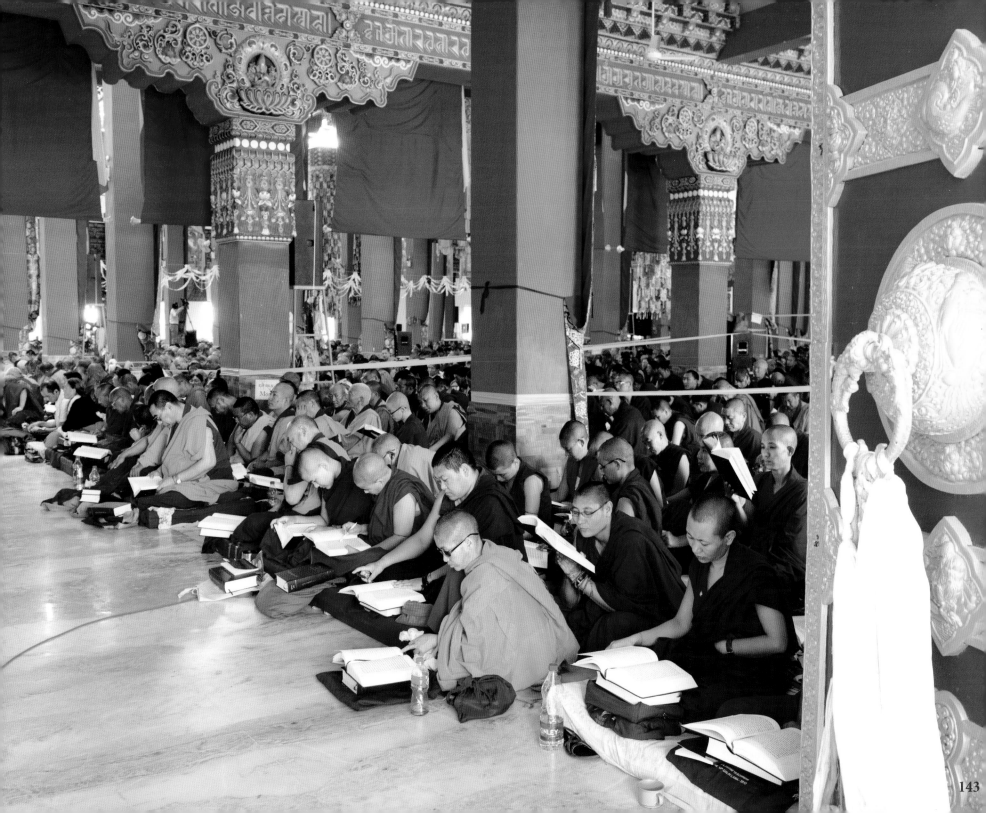

A poet you admire?

As a Buddhist monk and a student of Nalanda tradition, we emphasize on meaning and not just the teachings. Again, its not on the person but on the meaning of the teachings. Again, the meaning cannot be superficial but has to have depth. Not about sensorial but deeper, mental wisdom.

What do you think of poetry?

Similar to art — it is a way to express certain views but always depends on the style of writing.

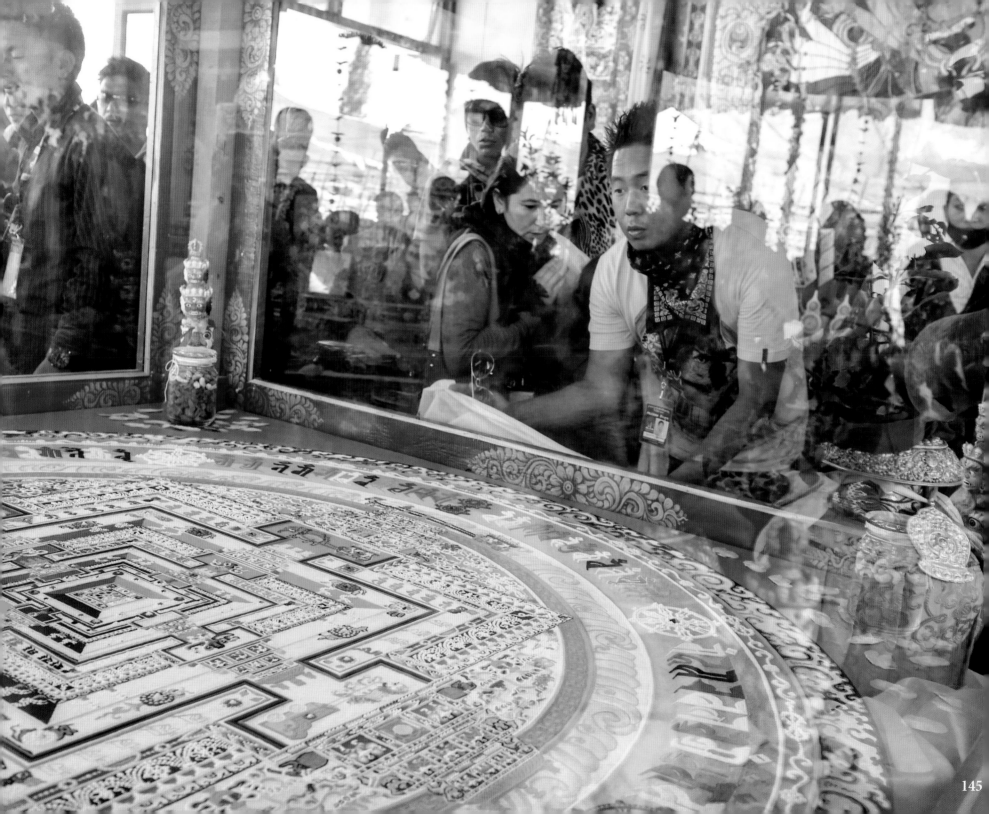

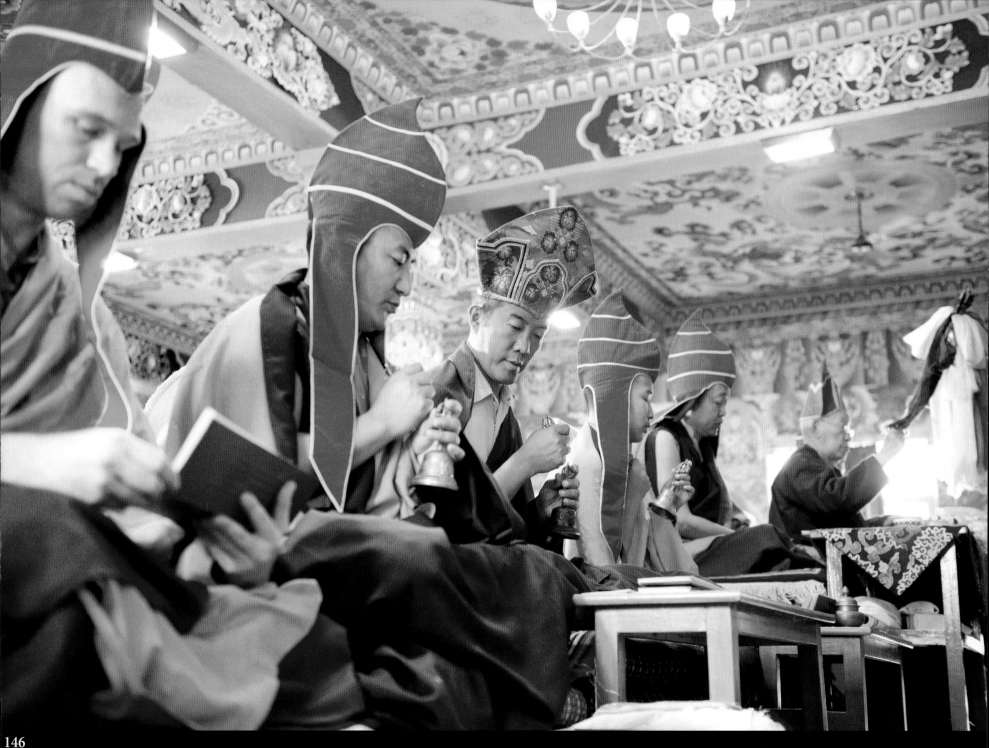

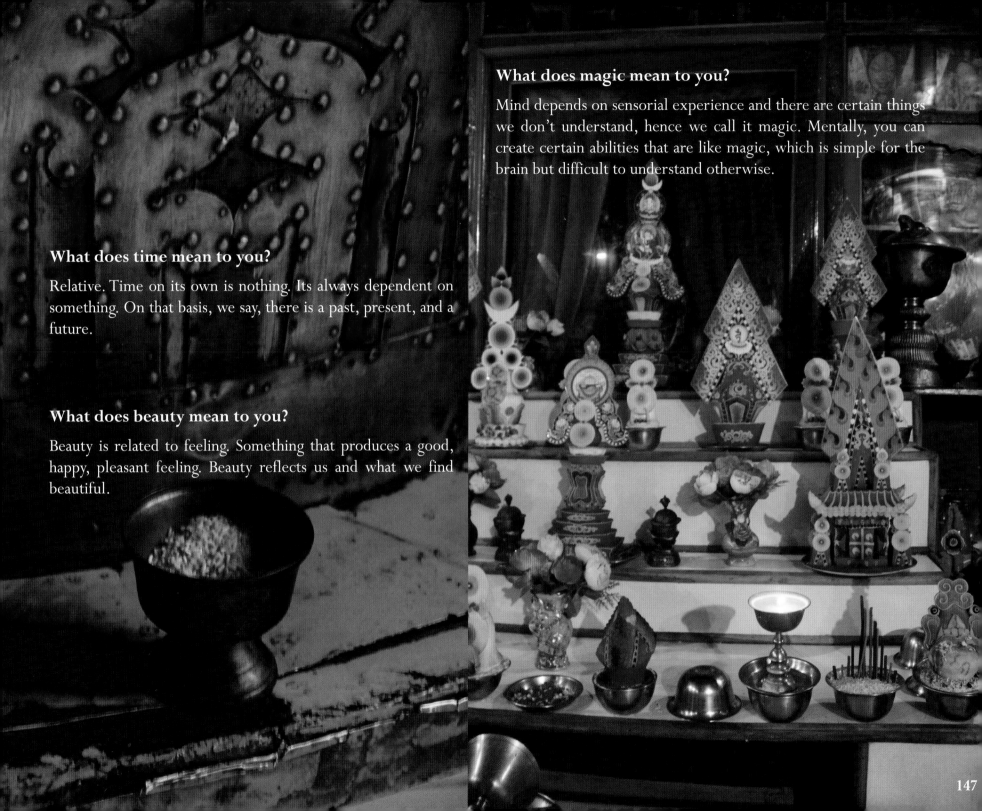

What does magic mean to you?

Mind depends on sensorial experience and there are certain things we don't understand, hence we call it magic. Mentally, you can create certain abilities that are like magic, which is simple for the brain but difficult to understand otherwise.

What does time mean to you?

Relative. Time on its own is nothing. Its always dependent on something. On that basis, we say, there is a past, present, and a future.

What does beauty mean to you?

Beauty is related to feeling. Something that produces a good, happy, pleasant feeling. Beauty reflects us and what we find beautiful.

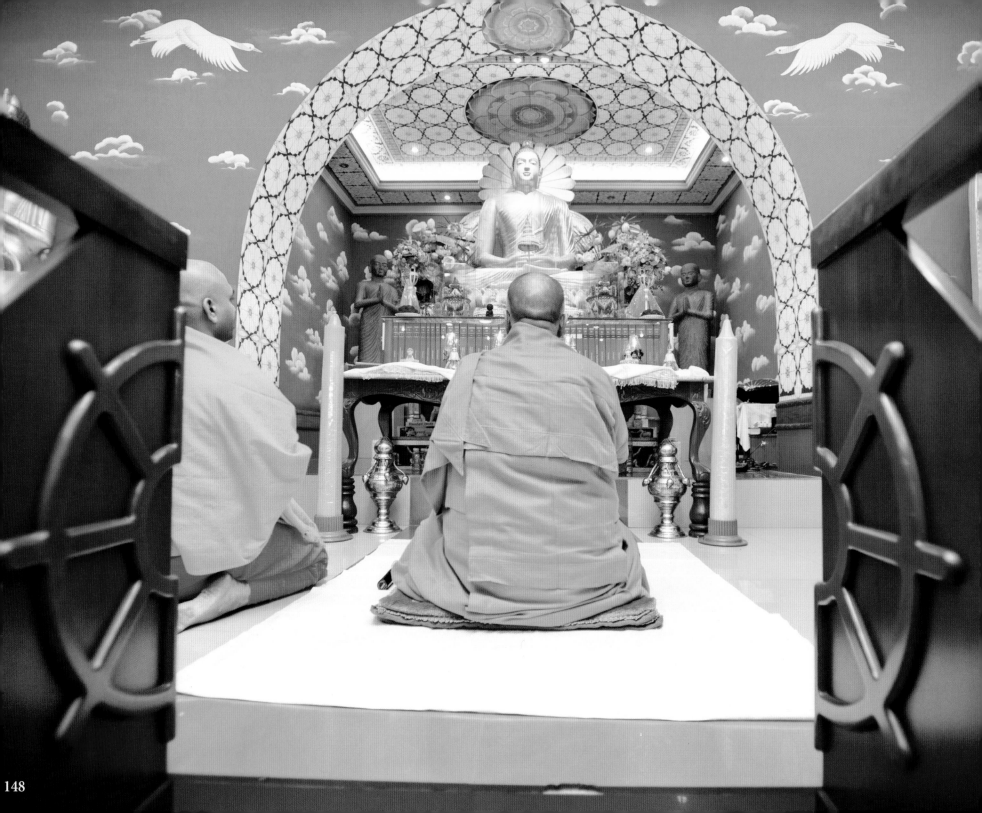

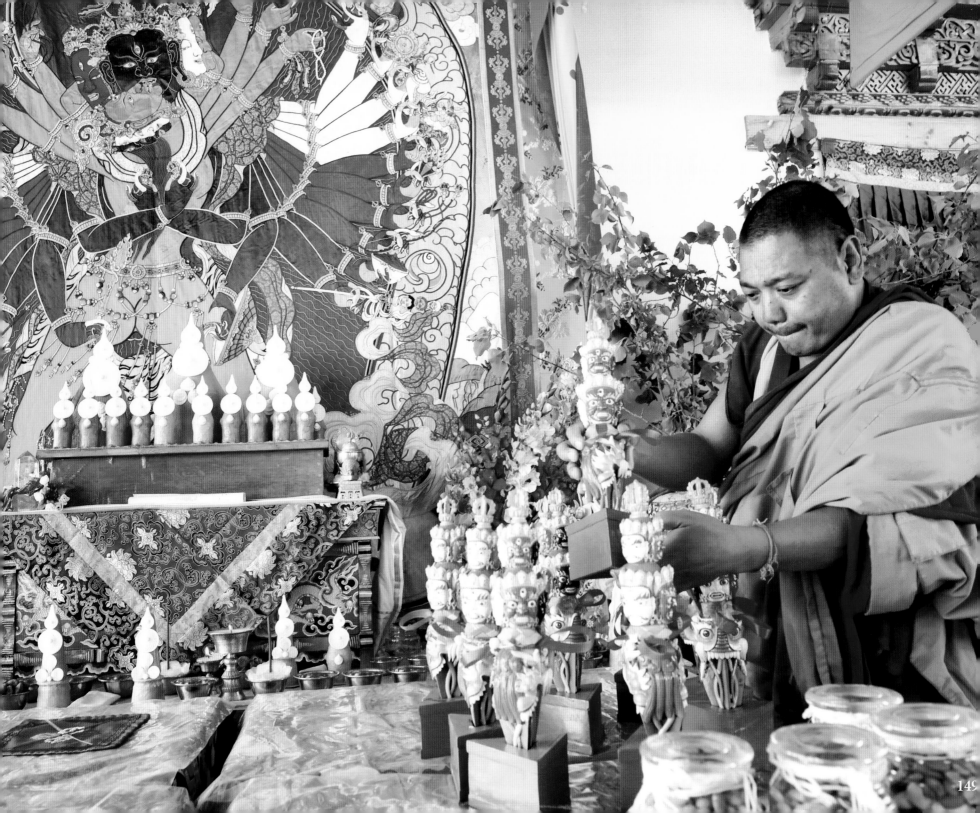

Do you believe in Santa Claus?

Everyone has magic inside them.

What moves your spirit?

Love.

Is hunger good or bad?

Bad. Our life depends on a healthy body and a healthy body needs food and water.

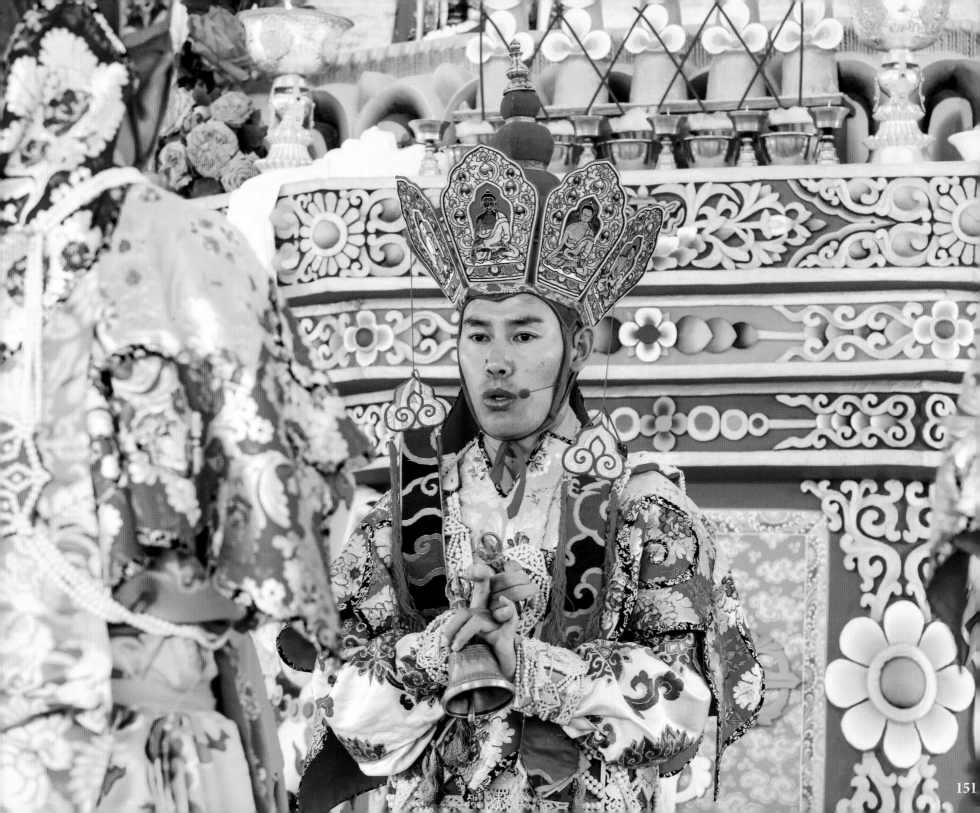

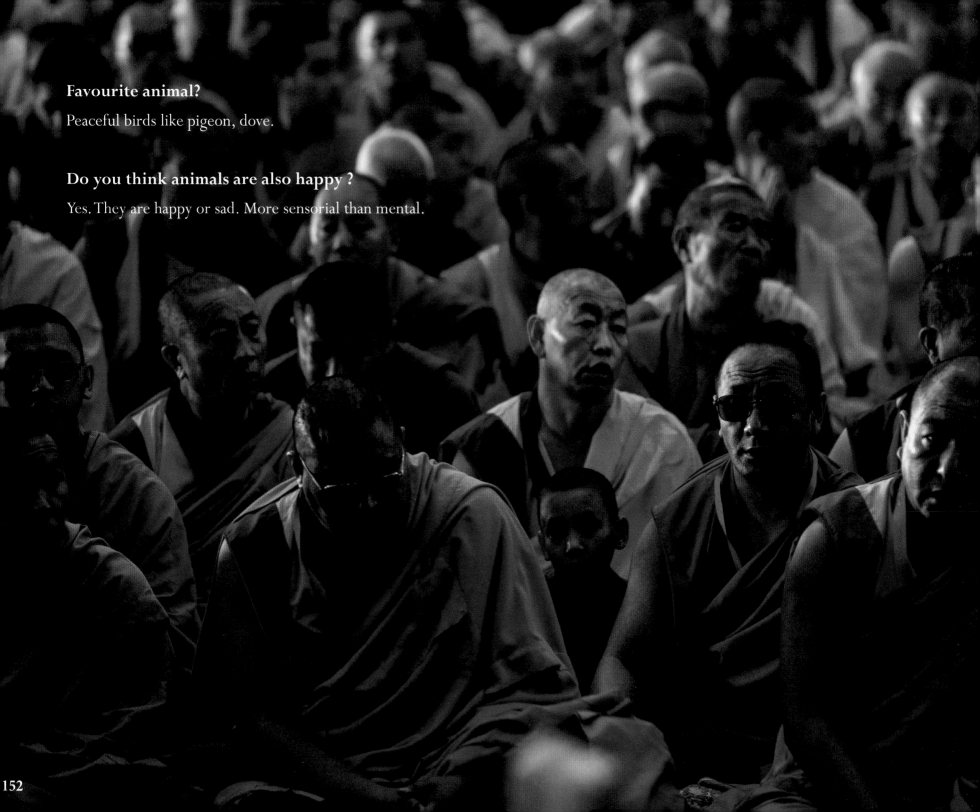

Favourite animal?

Peaceful birds like pigeon, dove.

Do you think animals are also happy ?

Yes. They are happy or sad. More sensorial than mental.

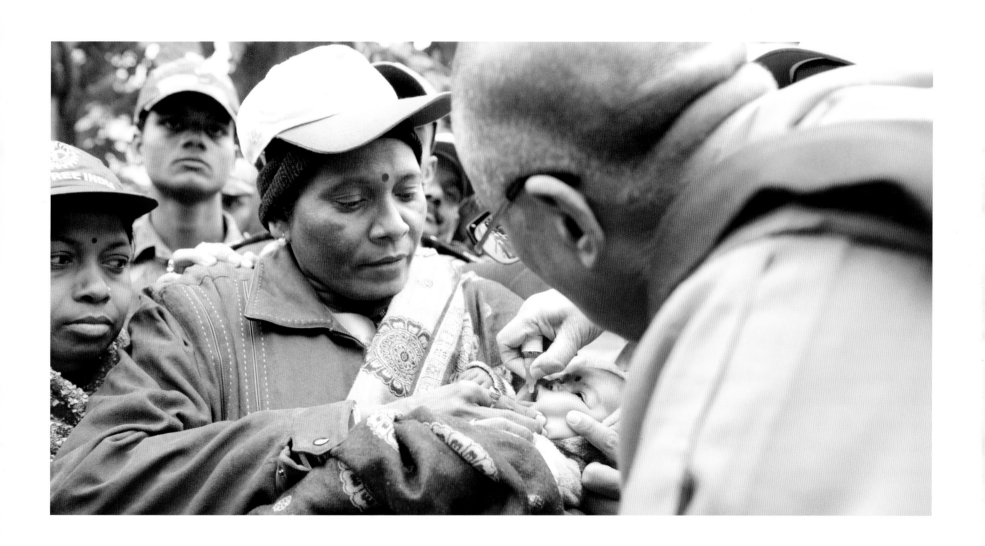

What is the one permanent thing in life?

I am a Buddhist. Ultimate reality is permanent but then what is ultimate reality?

Different interpretations for different people.

What does courage mean?

For something good, it means confidence, it means determination, will power, but if it is harming others, then its bad.

What does sacrifice mean to you?

For good purpose and beneficial to others, then its good.

Favourite city in the world?

Bangalore in the 60s and 70s was fantastic climatically and was very clean.

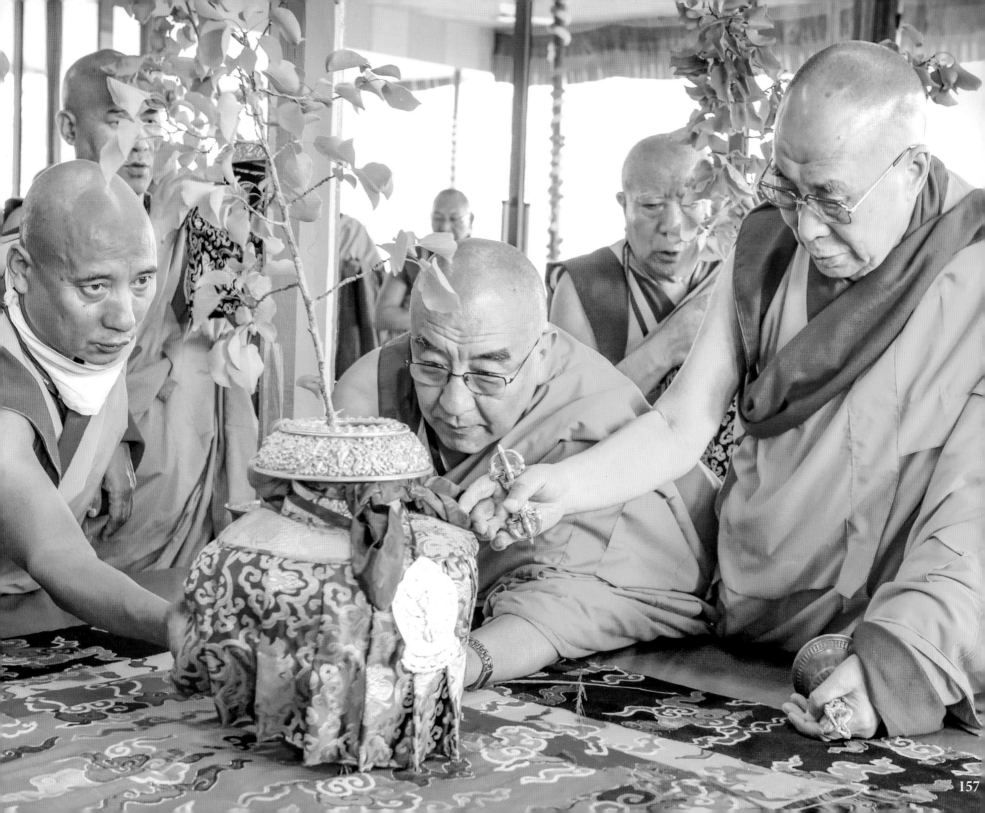

Favourite memory?

In March 1959, when I reached the Indian borders and met Indian officials including some of my friends, and I realized that there is no danger now – it was the feeling of being safe.

What does happiness mean to you?

Complete relaxation, complete satisfaction.

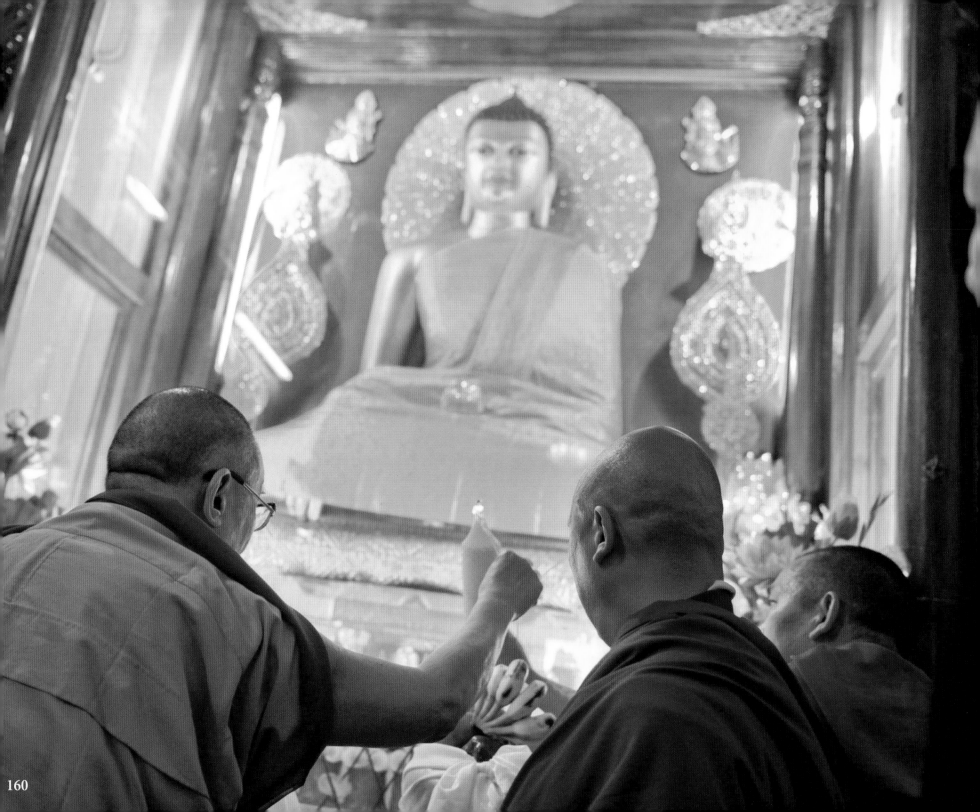

What makes you happy?

When your life becomes useful for others, you feel this life and body get a fulfillment of purpose. That's what makes me happy.

What is the one thing in the world that you would like to change?

A peaceful world – a world without violence, no war – that is the one thing that will be wondrous for me. It is not wishful thinking, it can happen. You can make that attempt and for that attempt, you need courage, education and vision.

Do you believe in destiny?

Yes and no. In the short term, yes, but in the long term, no.

In the long term, everything is in your hands but in the short term, it is tough.

Most important person in a human's life?

Our mother. One – because she gives us this life, and two – gives us value of affection and love.

How will you describe mother?

My mother was a real teacher of affection and love. The seed of this affection and my ability, my capacity, was sown by my mother. Frankly, all people have the same potential and compassion, since we all get it from our mothers.

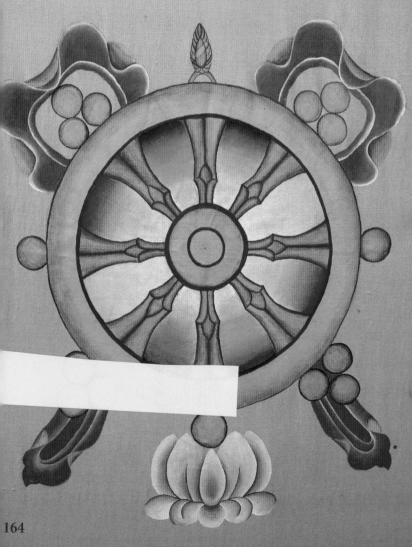

When you hold a small child in your hand, what do you think?

A small child means new life, new beginnings. This young human being has every right to have a happy life but needs a lot of care and affection.

Did your mother scold you when you were a child?

No. My father always scolded me.

166

Were you a naughty child?

Yes. My mother used to carry me on her shoulders when working in the fields or taking care of the cattle. I would sit on her shoulders and hold her ears. If I needed her to do something, I would trust her ears change the direction where we were going. My elder brother was two years older to me and he would never fight but I used to invariably scratch his cheeks.

What do you think of heritage and legacy?

I am a Buddhist monk and I should not think about my name or legacy. However, when I think about my life and what my small contributions have been towards science and spirituality, I hope I have made some significant contribution there.

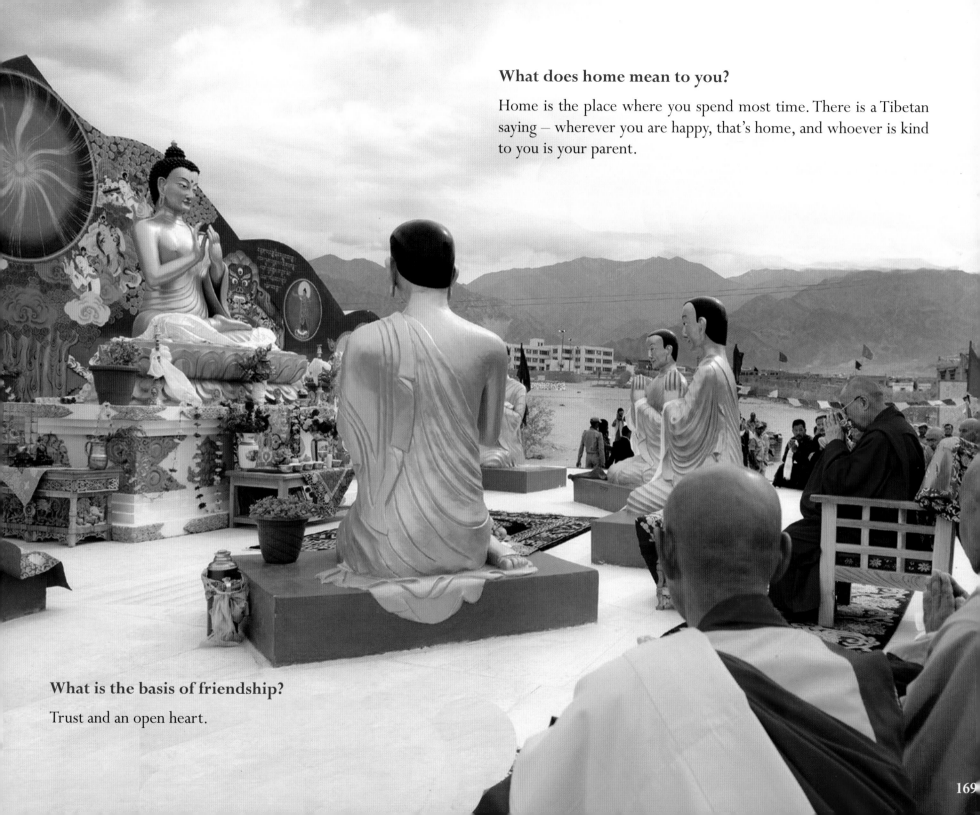

What does home mean to you?

Home is the place where you spend most time. There is a Tibetan saying – wherever you are happy, that's home, and whoever is kind to you is your parent.

What is the basis of friendship?

Trust and an open heart.

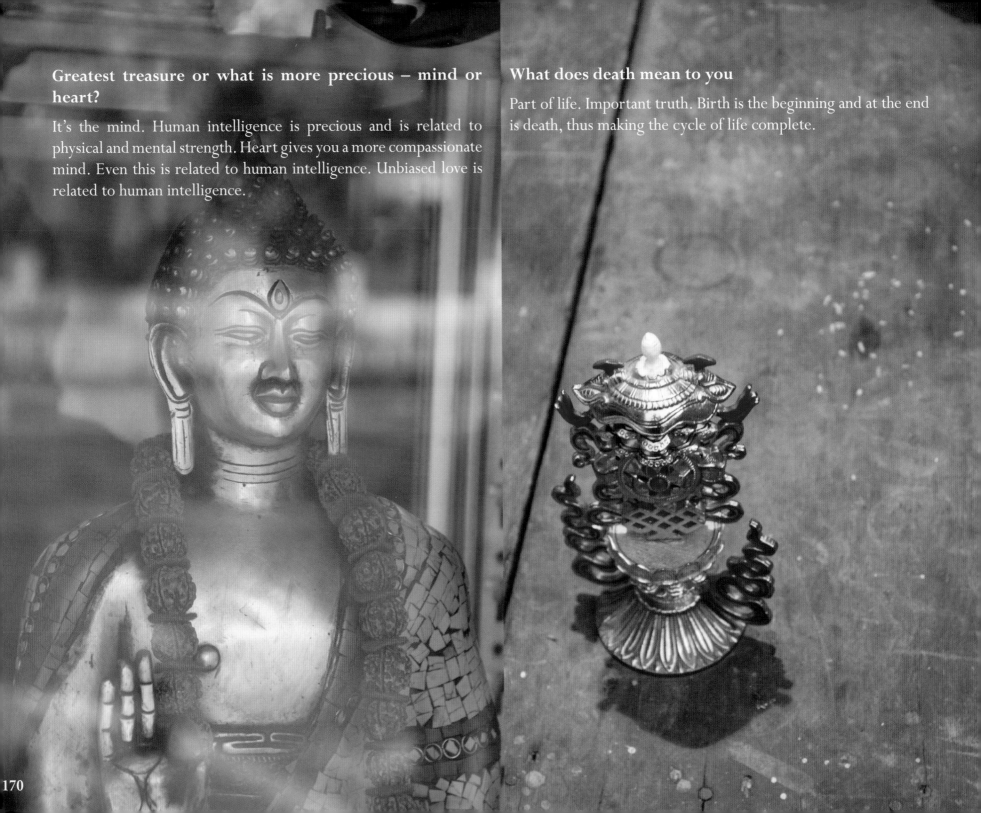

Greatest treasure or what is more precious – mind or heart?

It's the mind. Human intelligence is precious and is related to physical and mental strength. Heart gives you a more compassionate mind. Even this is related to human intelligence. Unbiased love is related to human intelligence.

What does death mean to you

Part of life. Important truth. Birth is the beginning and at the end is death, thus making the cycle of life complete.

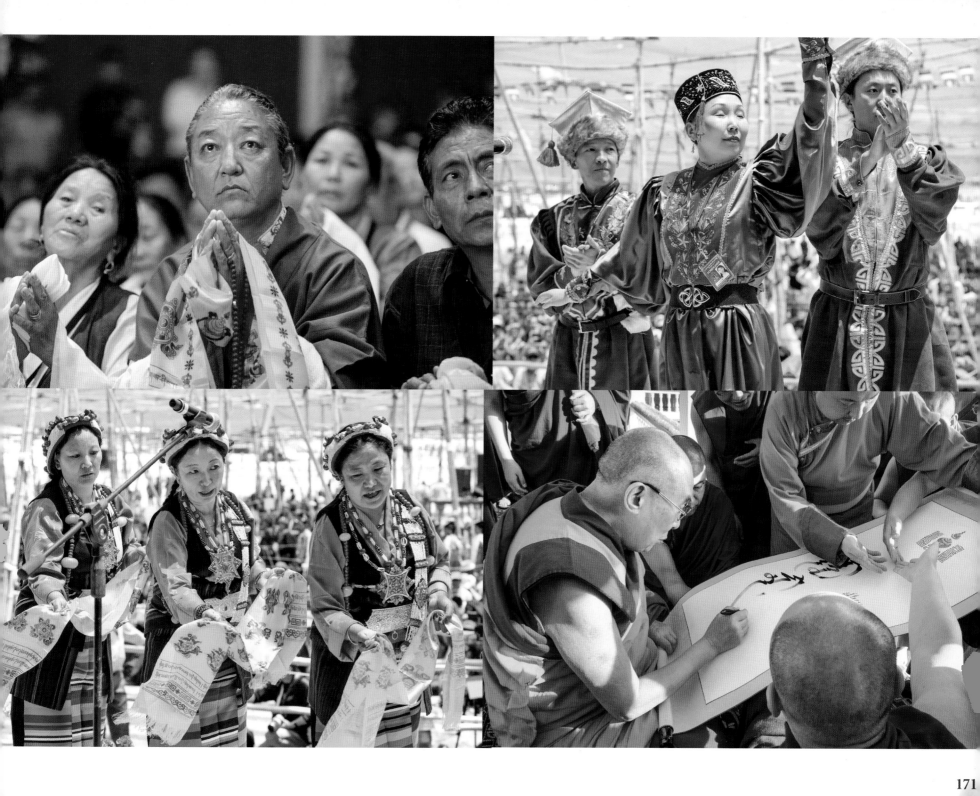

What do you think of pain?

Uncomfortable. There are two kinds of pain. There is physical pain, which is manageable, and then there is mental pain, which is more serious than physical pain.

What does family mean to you?

Family is the root of your compassion, your beliefs, and support.

How can we teach children about compassion?

Children look up to their parents and grow up to be a reflection of their behaviour. As parents, we must always react in a way that we want our children to learn from.

Favourite fruit?

Mango.

Favourite vegetable?

Cabbage.

Favourite colour?

Usually green. All vegetables are green. All living things are green.

Green is the protection of nature.

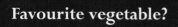

Do you know how to ride a bicycle?

Yes, I rode in Tibet. But these days, I can't.

Do you have a driver's license?

No. But I can drive. I would drive inside the compound in Tibet, away from the public eye.

Can you swim?

I can't swim. I get very scared when in a flight they tell you what to do if your plane crashes in water!

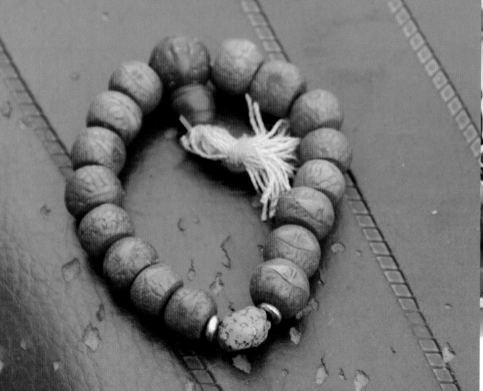

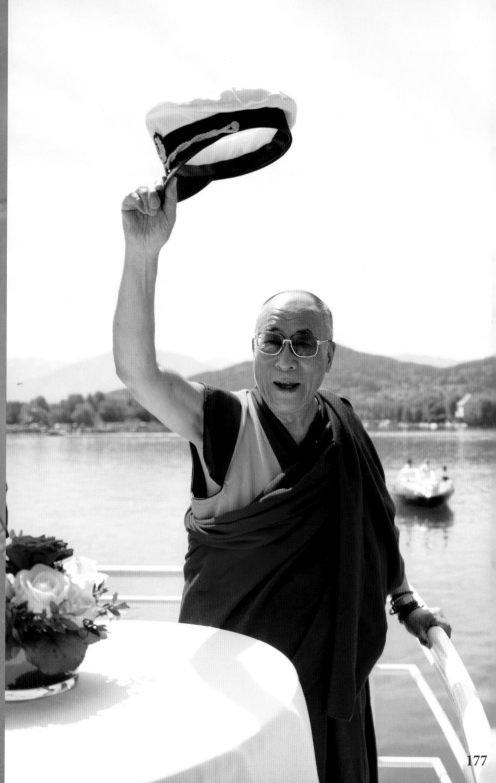

177

Do you wear jeans?

No, but I wore trousers when I escaped from Tibet in disguise on 17 March 1959.

Do you get angry?

Yes, quite often. I scold my team on and off.

How do you stay calm?

I try to look at everything more realistically. In reality, everything is inter-related. If there are problems, we need to look at them from a wider perspective.

There are good things and bad things. Achieving a balance is necessary.

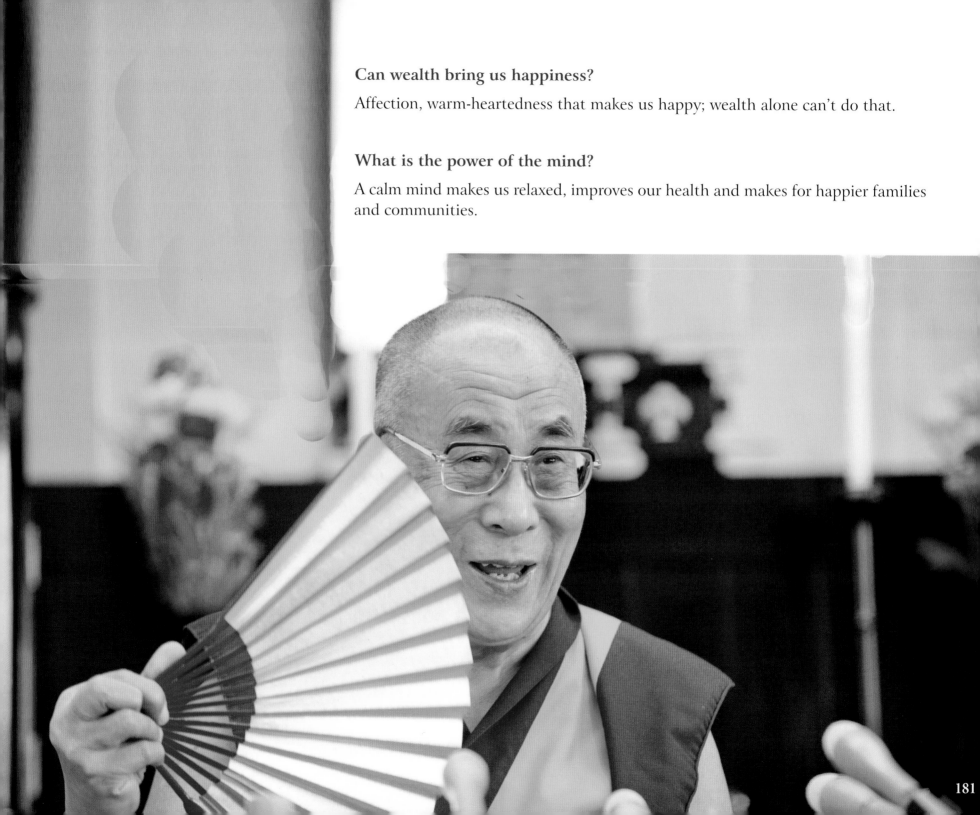

Can wealth bring us happiness?

Affection, warm-heartedness that makes us happy; wealth alone can't do that.

What is the power of the mind?

A calm mind makes us relaxed, improves our health and makes for happier families and communities.

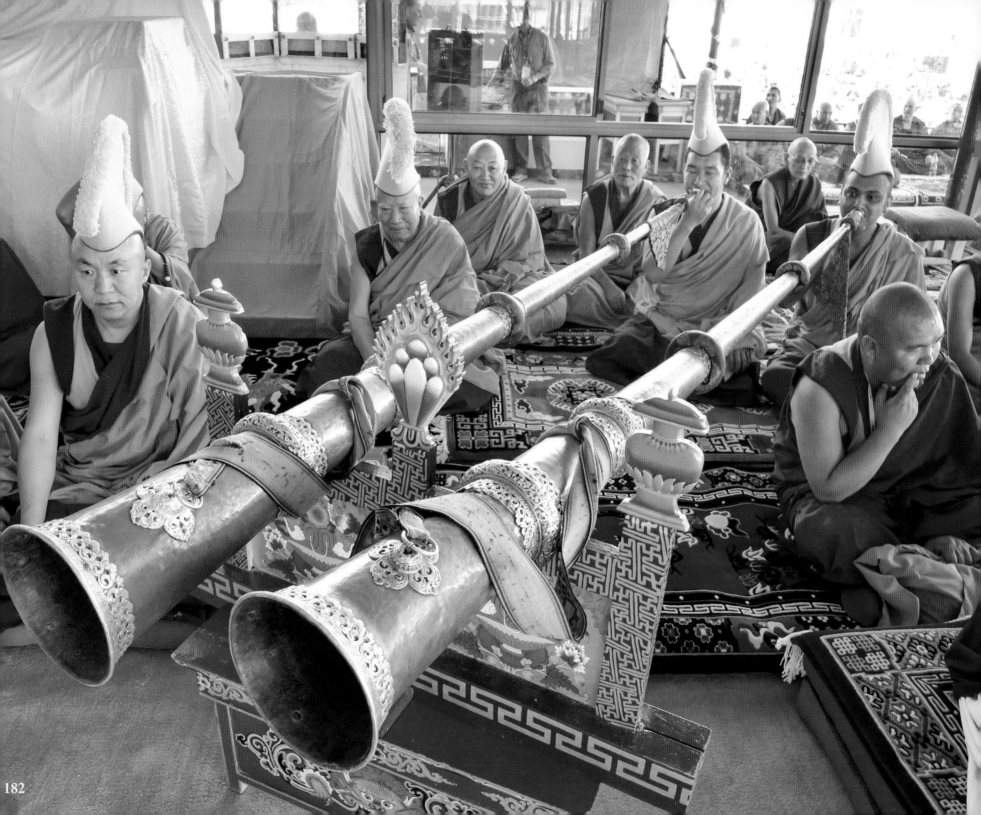

How are we all connected?

If you make others happy, you'll be happy. If you make others unhappy, you'll be miserable.

What guides intelligence?

Our intelligence needs to be guided by warm-heartedness.

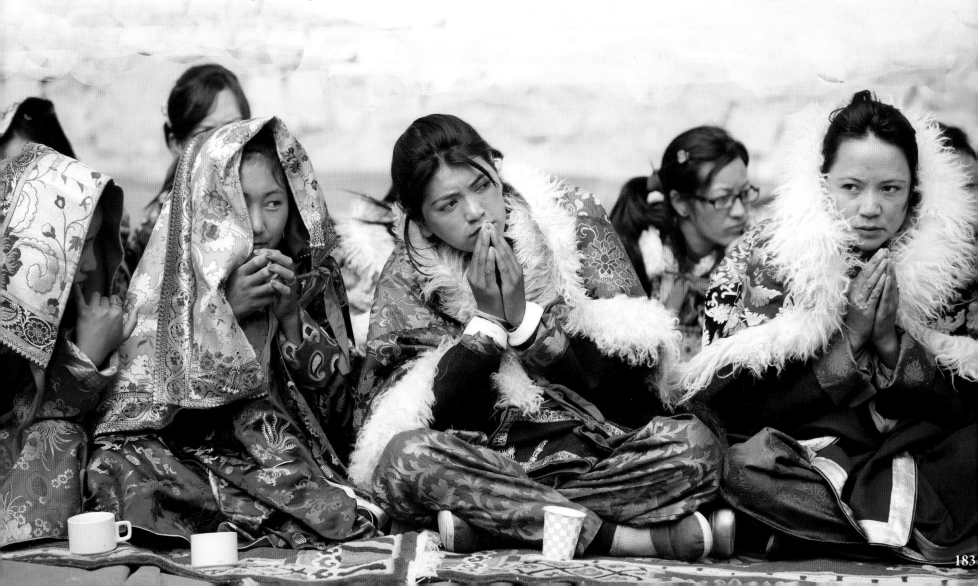

What does truth mean to you?

The power of truth never declines. Force and violence may be effective in the short term, but in the long run it's truth that prevails.

What is essential for success?

No matter what our motivation may be, if we are not realistic we will not fulfil our goal.

What is most important to exercise creativity?

In order to exercise creativity, freedom of thought is essential.

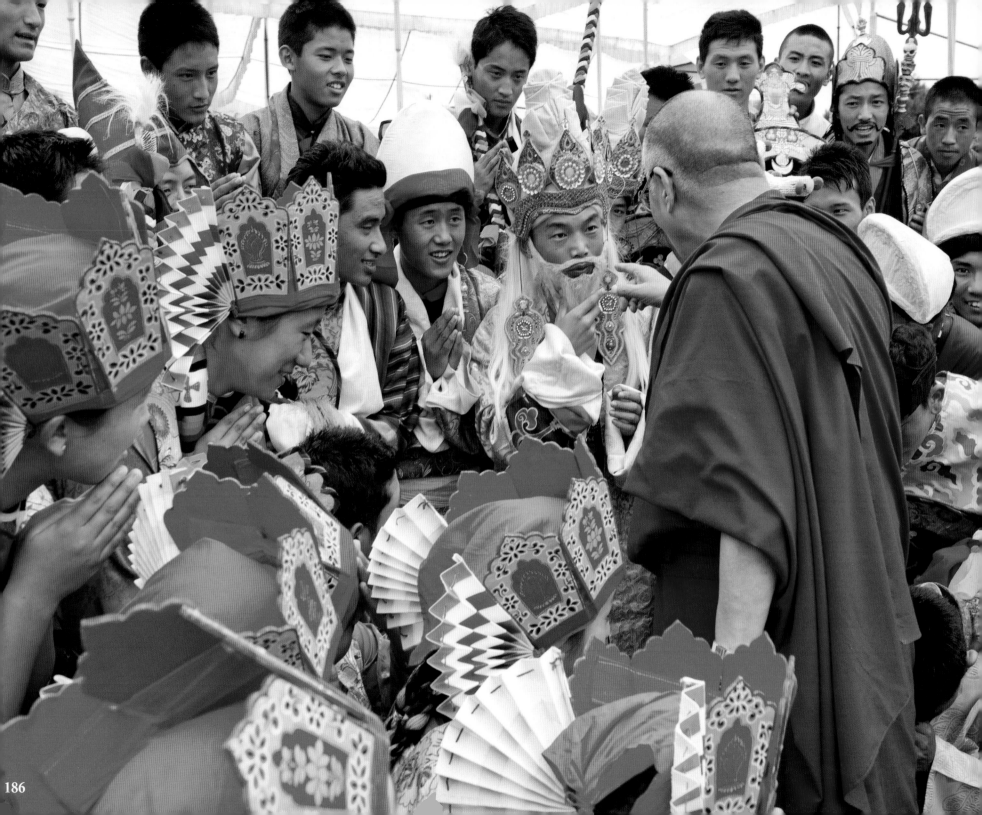

What do you think of technology?

You need to be human to use technology. To even operate a machine and to understand it, you have to have a human mind.

Favourite gadget?

A screw driver.

Favourite spice?

Not too hot, not too sour. You need a combination. When you are hungry, everything is very good.

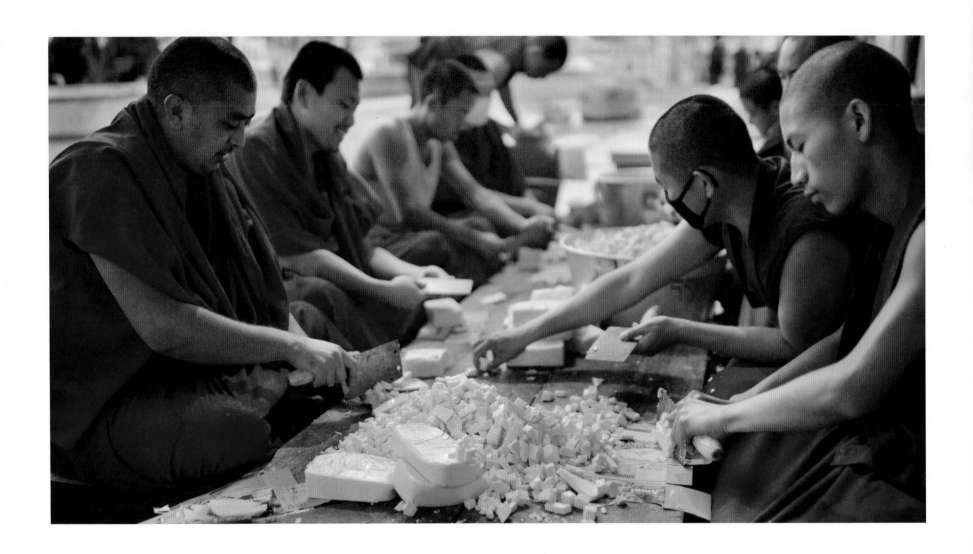

Favorite mealtime prayer?

When you are hungry, no prayer.

Nagarjuna's favourite prayer –

Eating this food, not for physical nourishment but to sustain my life
in order to bring benefits to others.
I consume this food which is a sacrifice of life.
May I be worthy of this sacrifice.
May my unwholesome qualities turn wholesome by consuming this food.
May I take this meal considering it as medicine and depend on it without attachment.

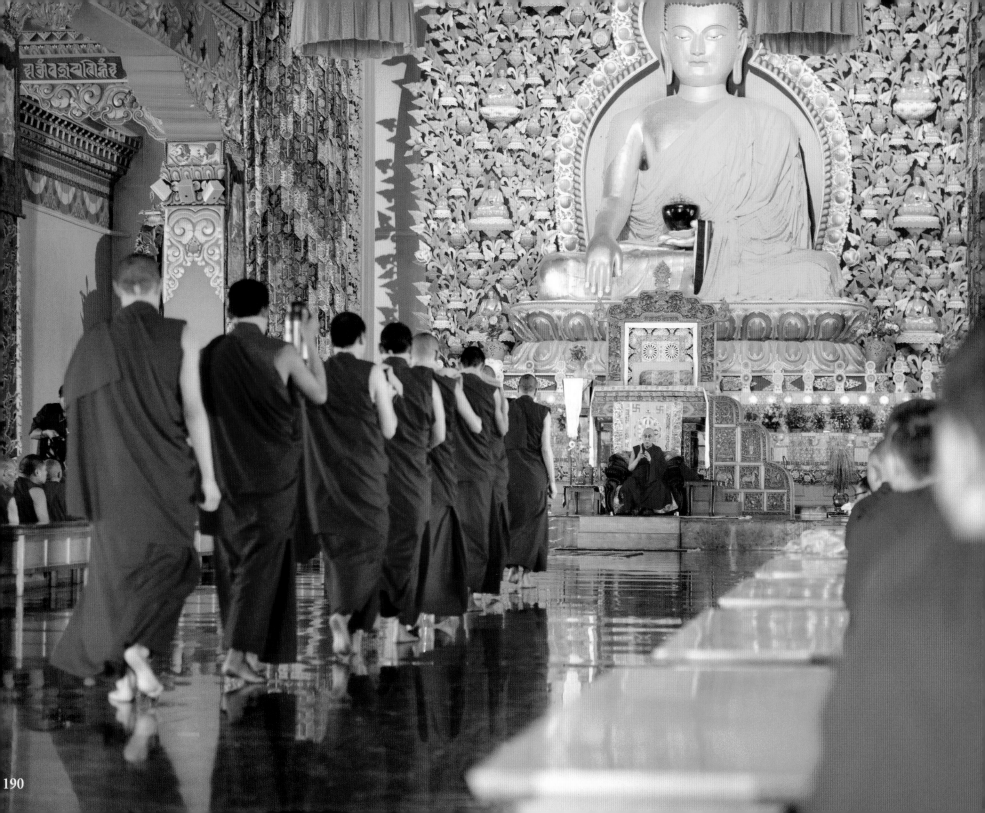

Favourite dish?

Noodles, Amdo bread.

Favourite drink?

Ginger ale.

Do you know how to cook?

I have helped to cook on a few occasions when I was young. If there is need, I can.

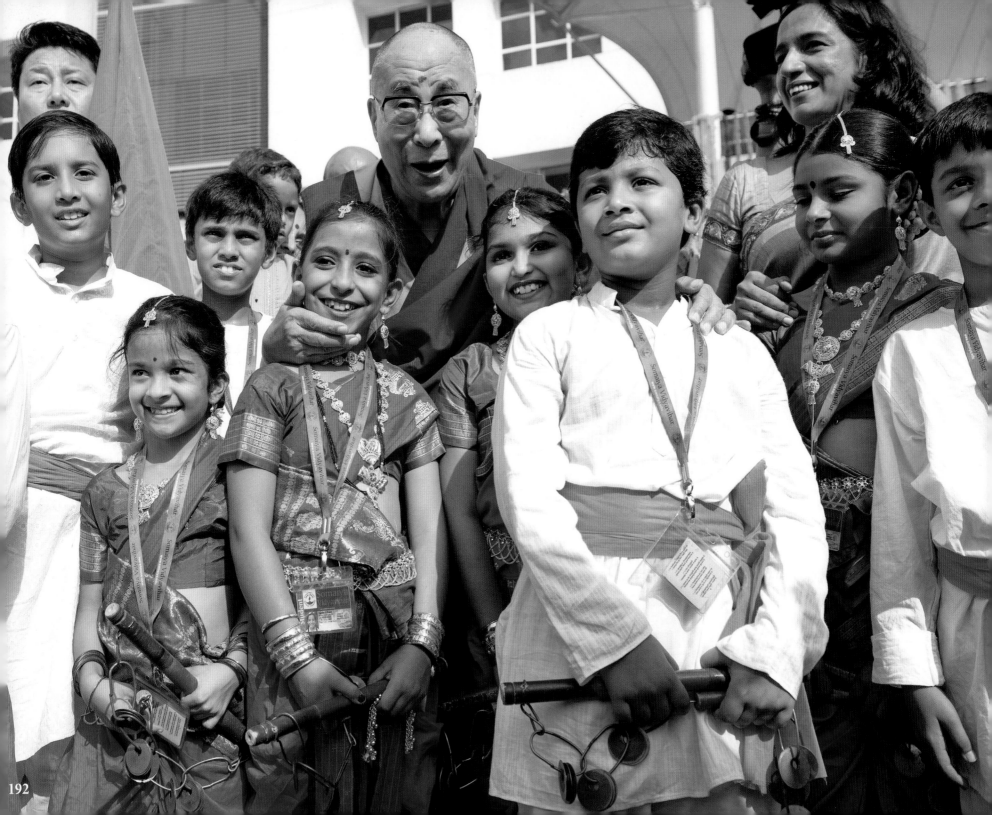

Greatest meal ever had?

When you are hungry, all food is good. In 1954, I went to Peking by road. The bridge collapsed and we had to wait for hours. The meal after that was great. Or, even when I travelled from Srinagar–Leh, which is a very long drive and I was accompanied by a doctor who said that when you are hungry, even a stone is delicious.

Favourite non-vegetarian food?

Chinese.

Favourite vegetarian food?

Indian.

Would you like to cook with Vikas?

I don't cook very often, but I would like to be there to help you.

Let me tell you a story. There was a Tibetan monk whose cook made food.

The monk tasted the food and there was not much salt and liquid/water.

Cook came and threw a handful of salt and then lots of water and told the monk to have the food....

The food was terrible to eat!

Favourite sound of nature?
Rain.

Favourite season?
Spring.

Favourite superhero?

Gandhi, Nelson Mandela – they are bigger than super heroes.

Do you think you have had a successful life?

That's very relative, because a life is a combination of failures and successes.

Respecting others is....?

Showing respect for others' rights and views is not only the source of reconciliation, but it's also an aspect of compassion.

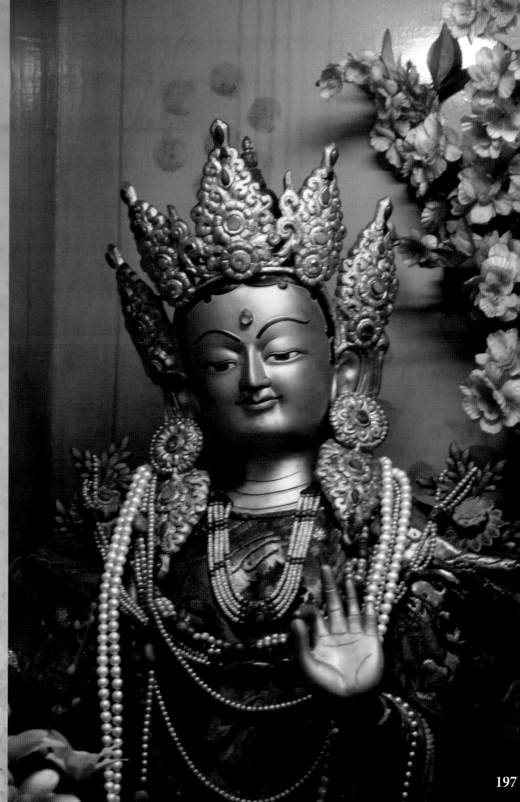

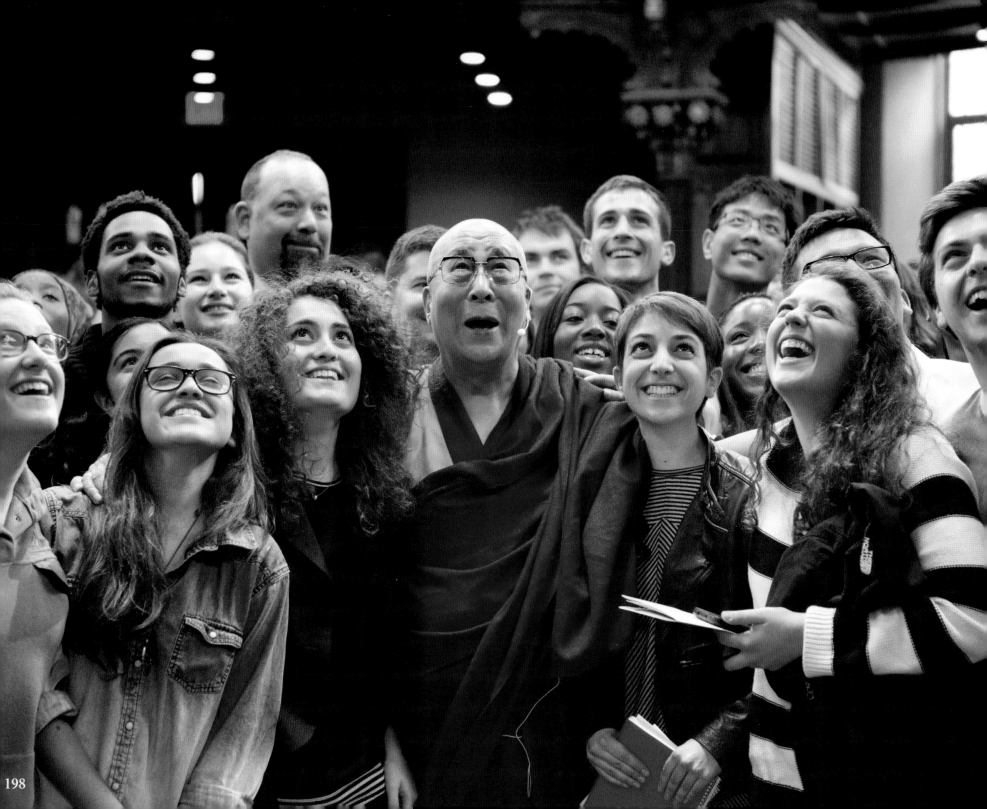

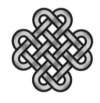

His Holiness

The 14th Dalai Lama of Tibet

Quotations

"Tolerance is always important,
it helps us overcome difficulties.
Without it, small things irritate us and
we overreact."

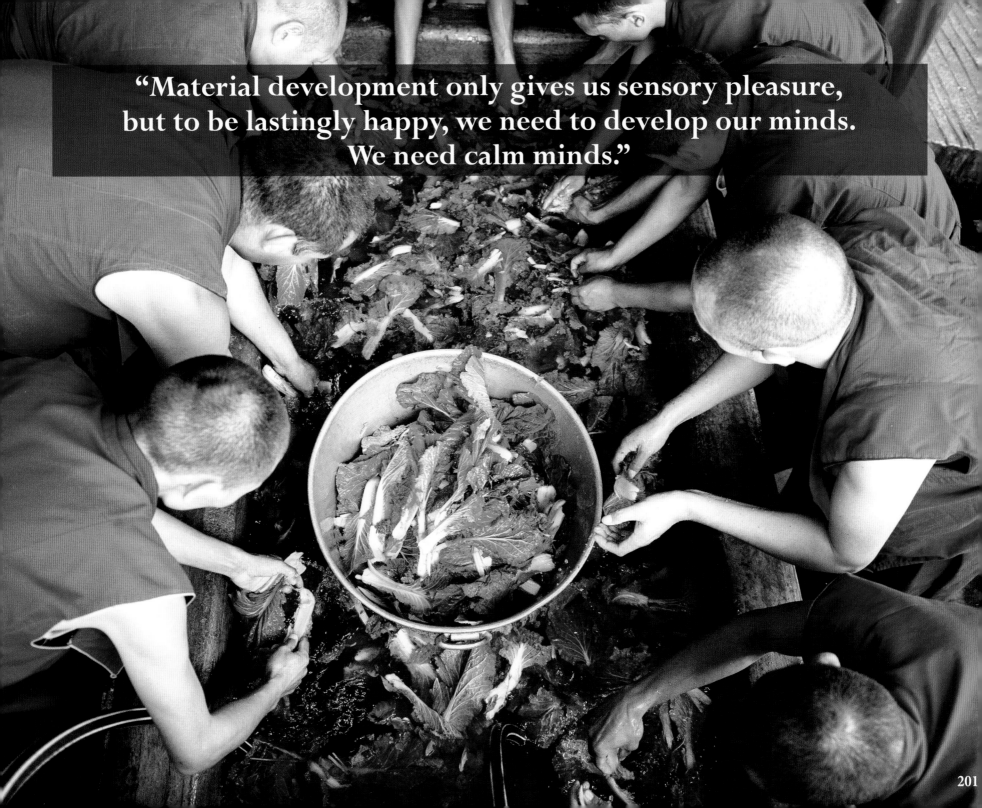

"Material development only gives us sensory pleasure,
but to be lastingly happy, we need to develop our minds.
We need calm minds."

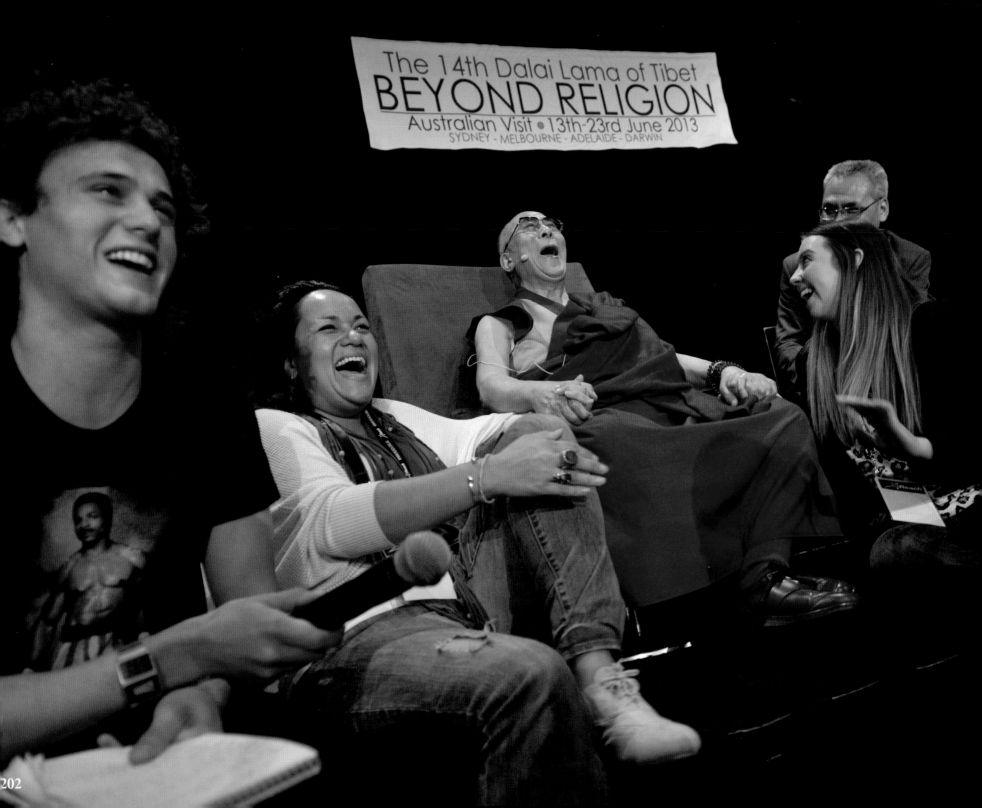

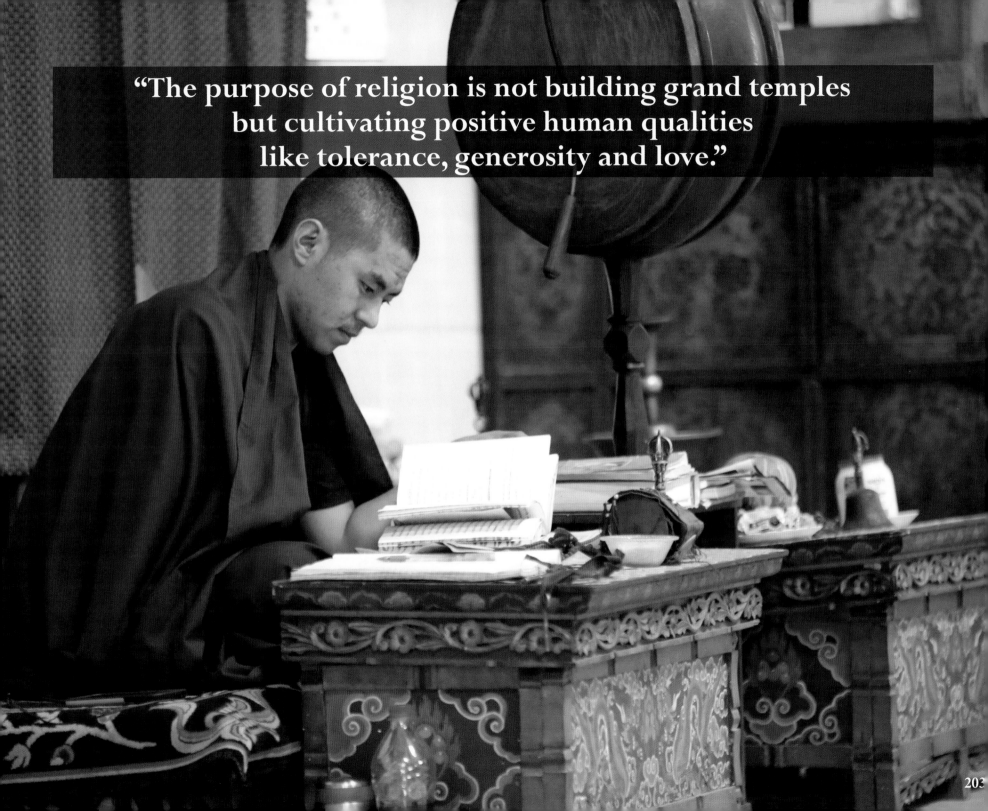

"The purpose of religion is not building grand temples
but cultivating positive human qualities
like tolerance, generosity and love."

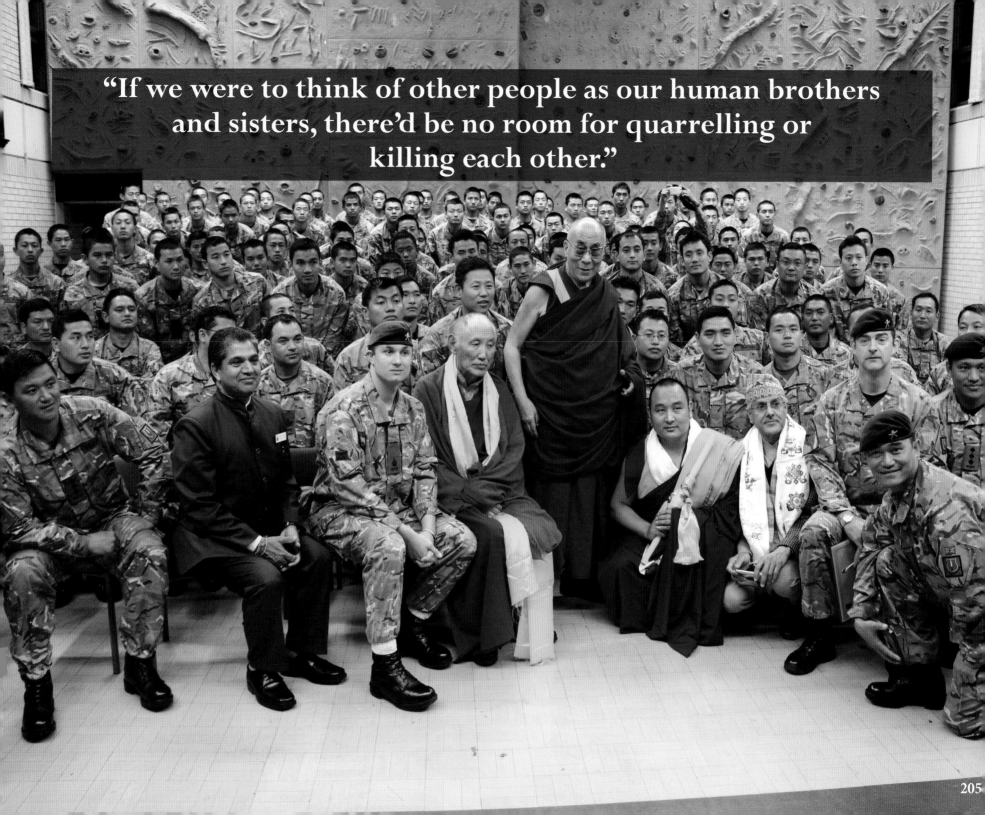

"If we were to think of other people as our human brothers and sisters, there'd be no room for quarrelling or killing each other."

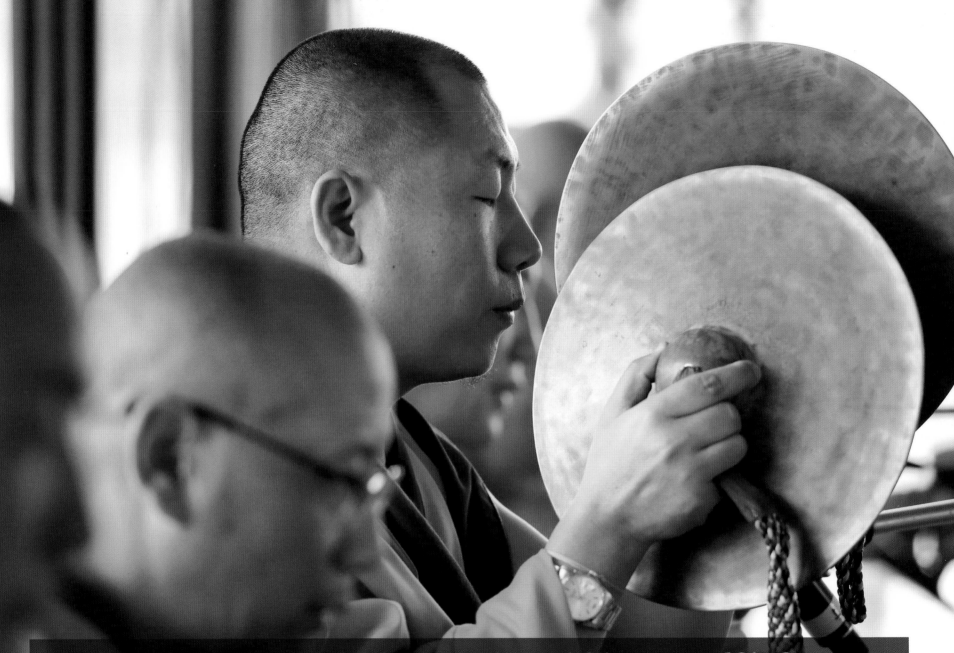

"Being aware of a single shortcoming within yourself is far more useful than being aware of a thousand in someone else."

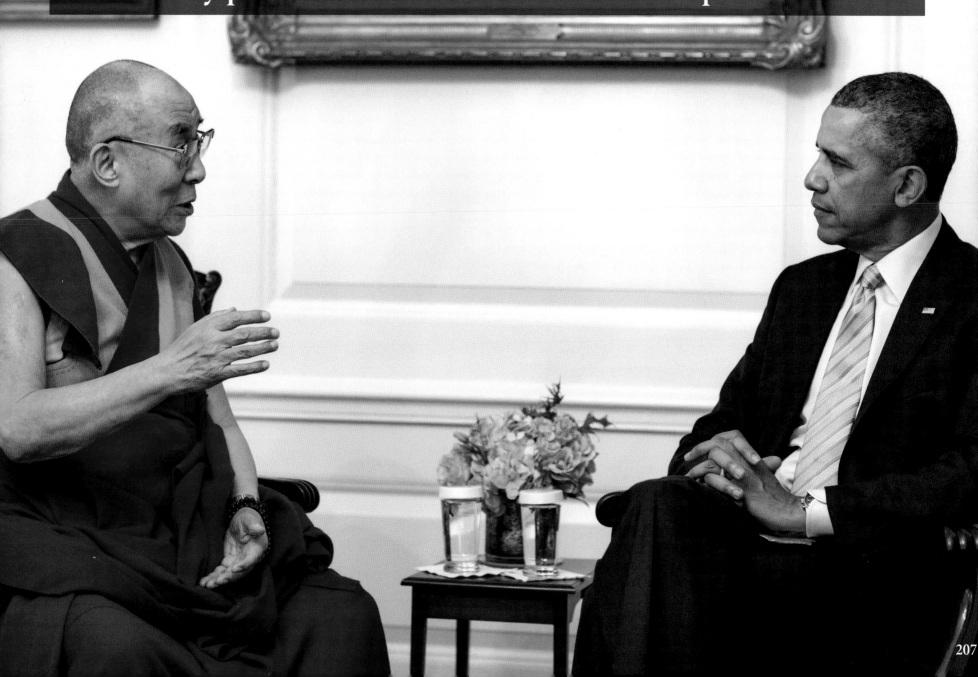

"We can develop patience and change our attitudes through steady practice – the human mind has such potential."

"Concern yourselves more with the needs of others, with the needs of all humanity, and you'll have peace of mind."

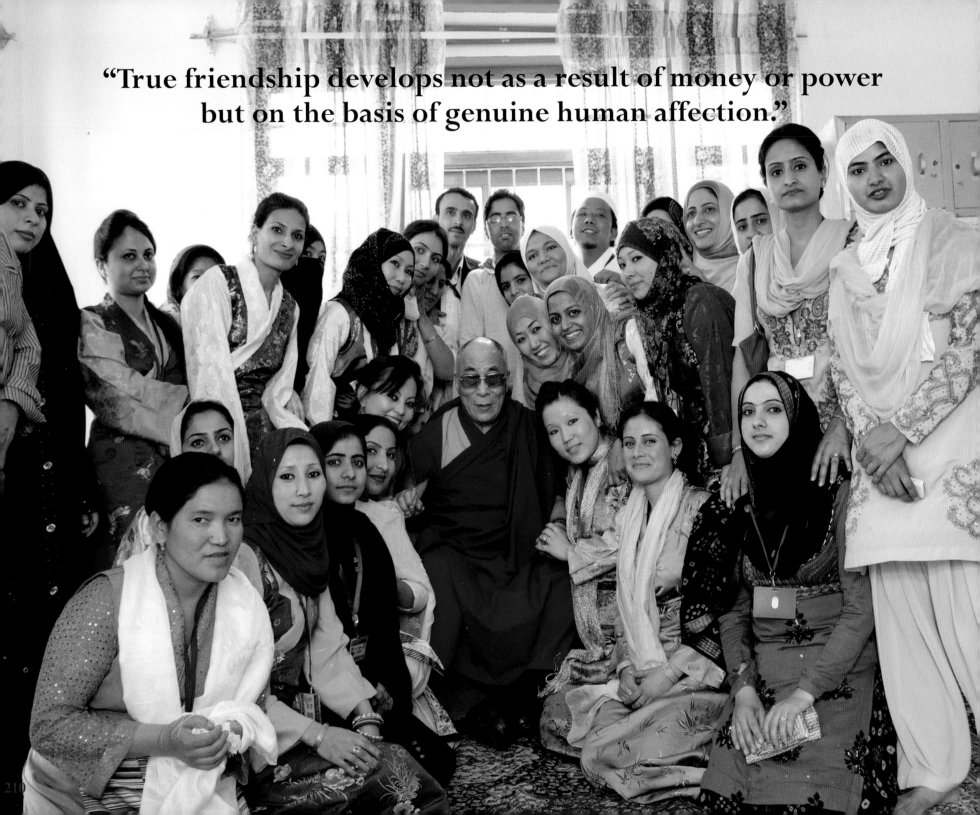

"True friendship develops not as a result of money or power but on the basis of genuine human affection."

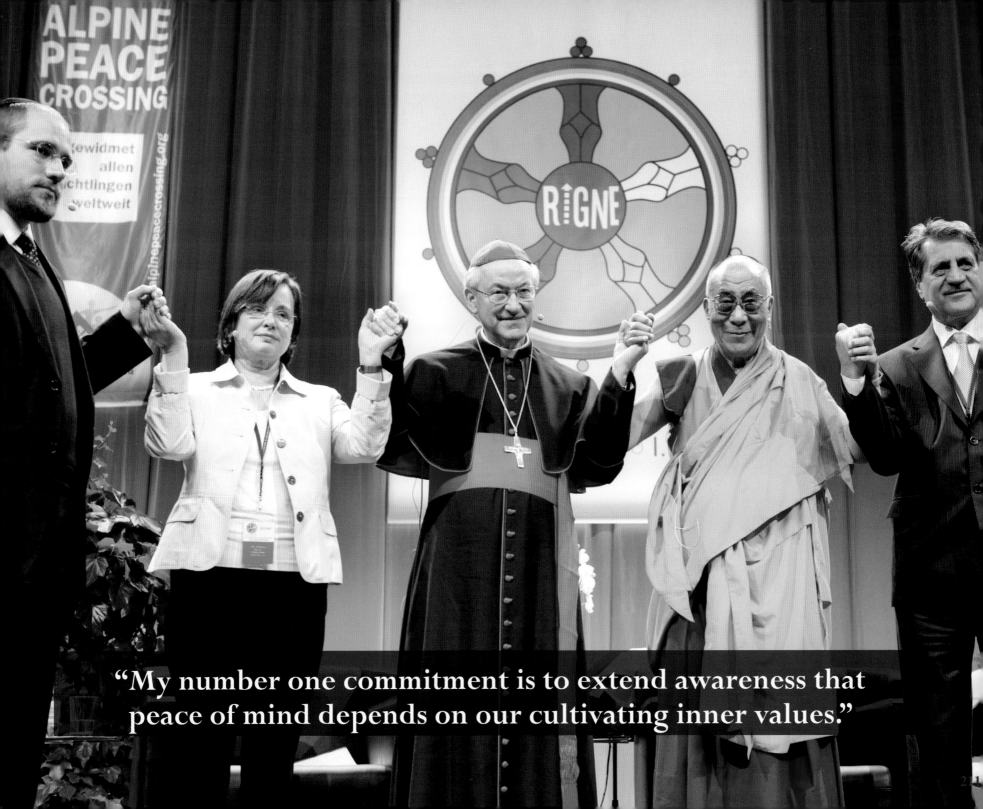

"My number one commitment is to extend awareness that peace of mind depends on our cultivating inner values."

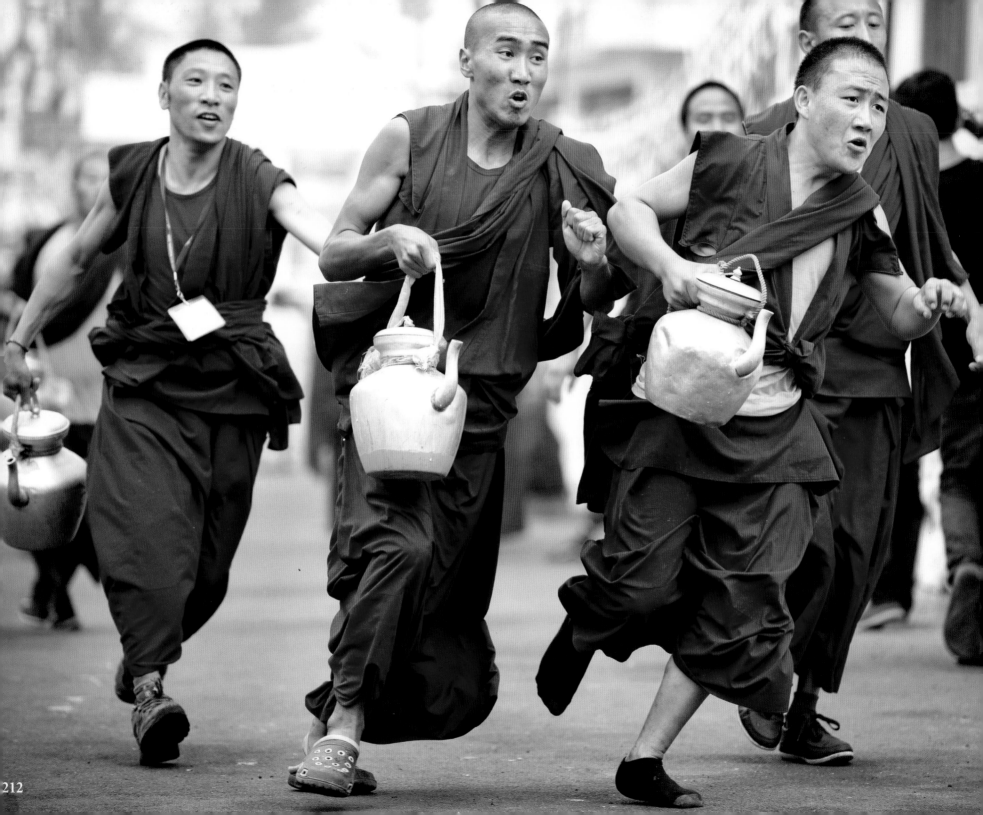

"Love and kindness are the very basis of society. If we lose these positive emotions, society will face tremendous difficulties."

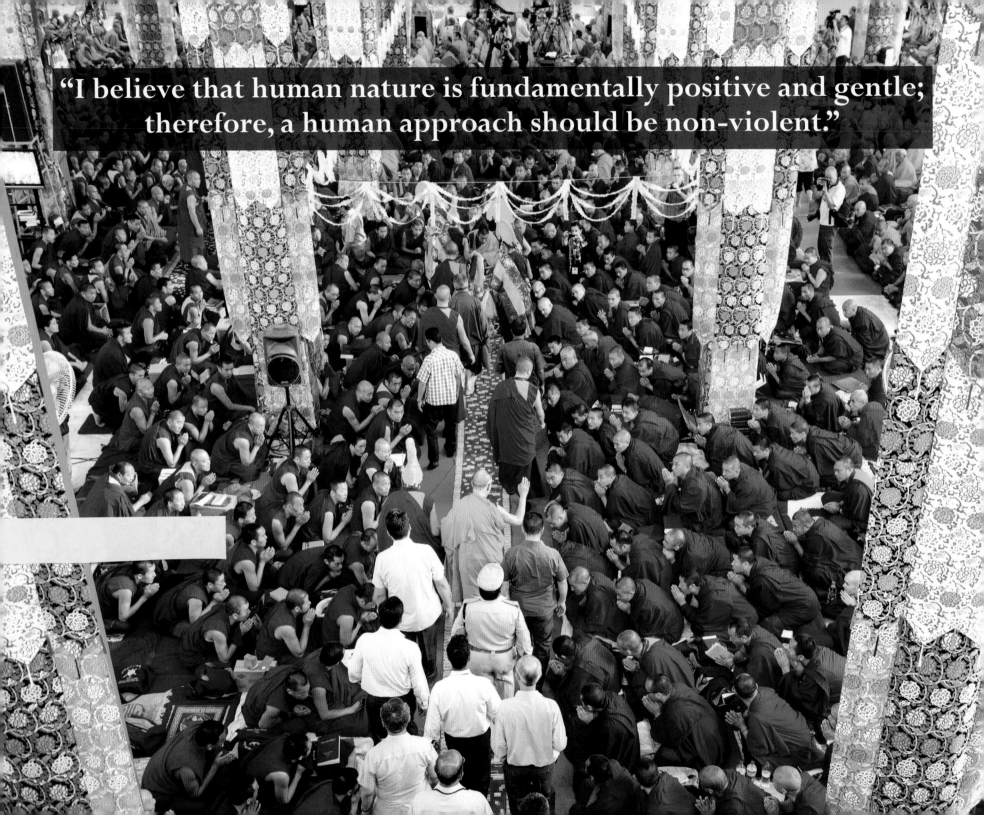

"I believe that human nature is fundamentally positive and gentle; therefore, a human approach should be non-violent."

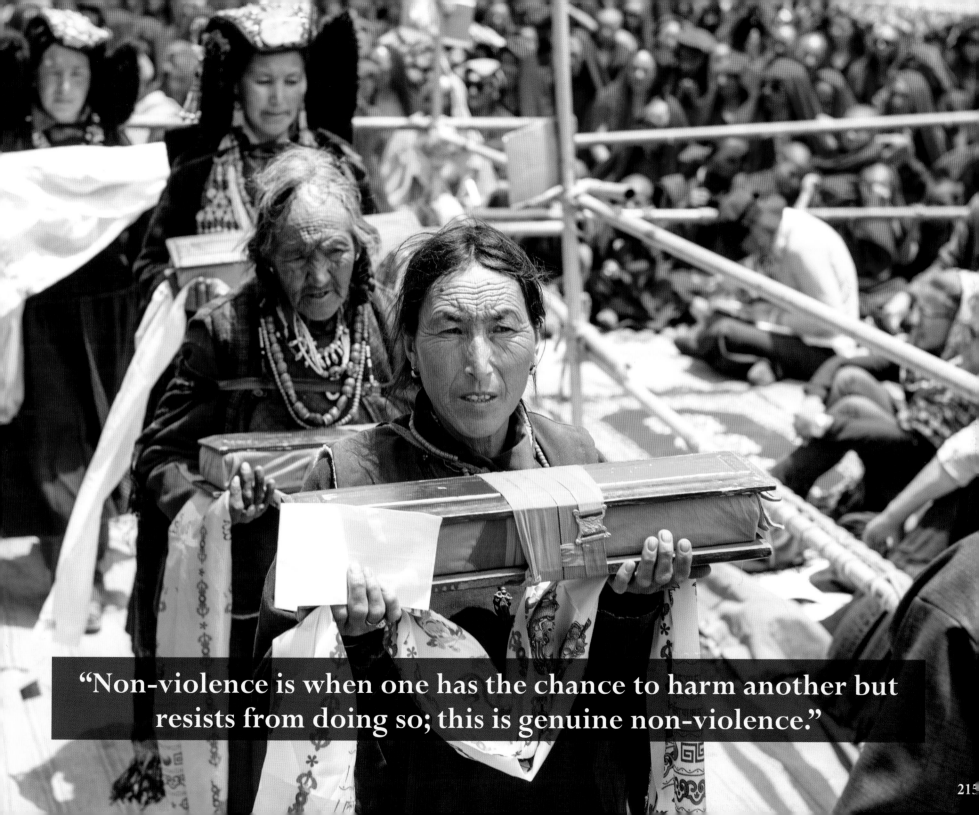

"Non-violence is when one has the chance to harm another but resists from doing so; this is genuine non-violence."

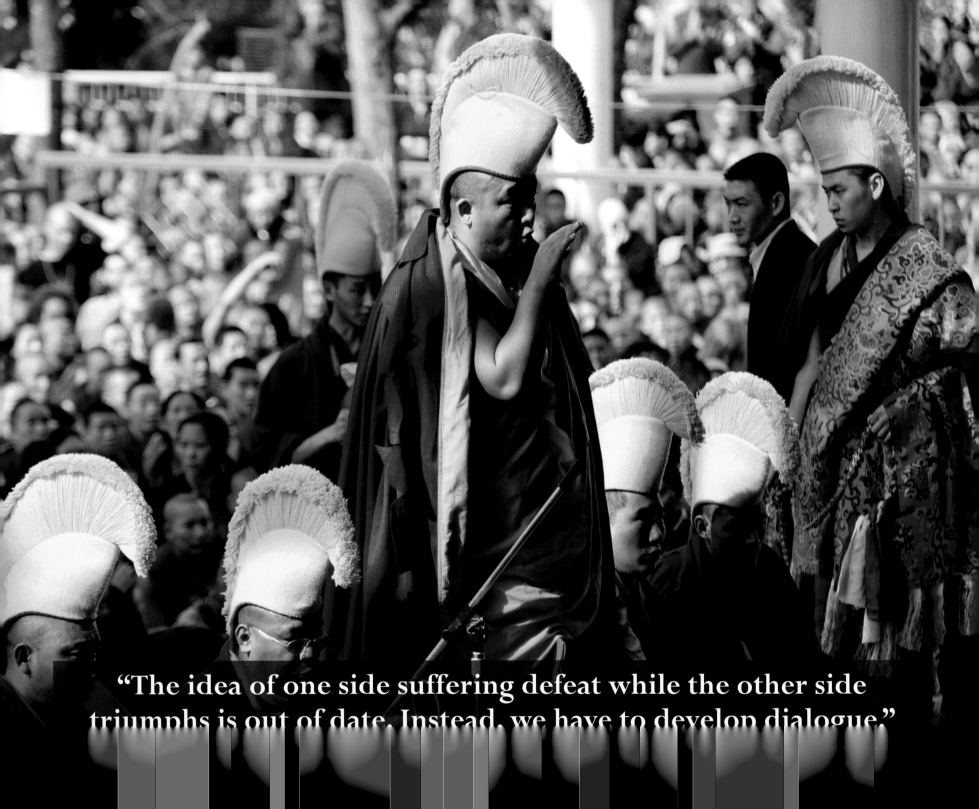

"The idea of one side suffering defeat while the other side triumphs is out of date. Instead, we have to develop dialogue."

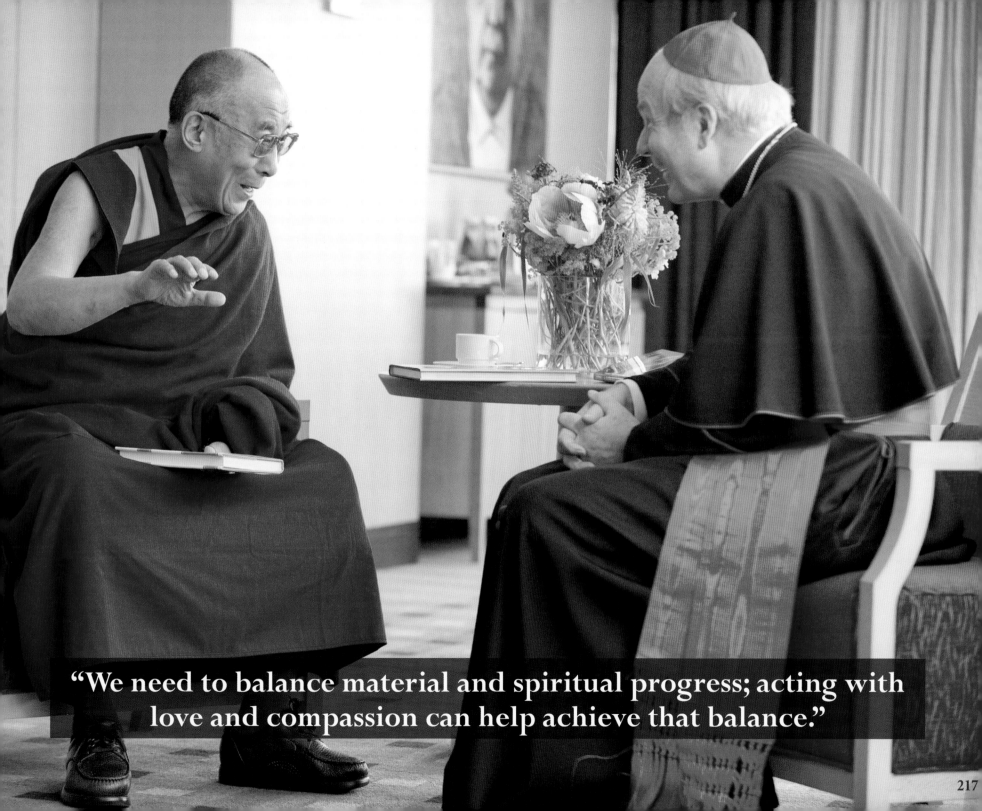

"We need to balance material and spiritual progress; acting with love and compassion can help achieve that balance."

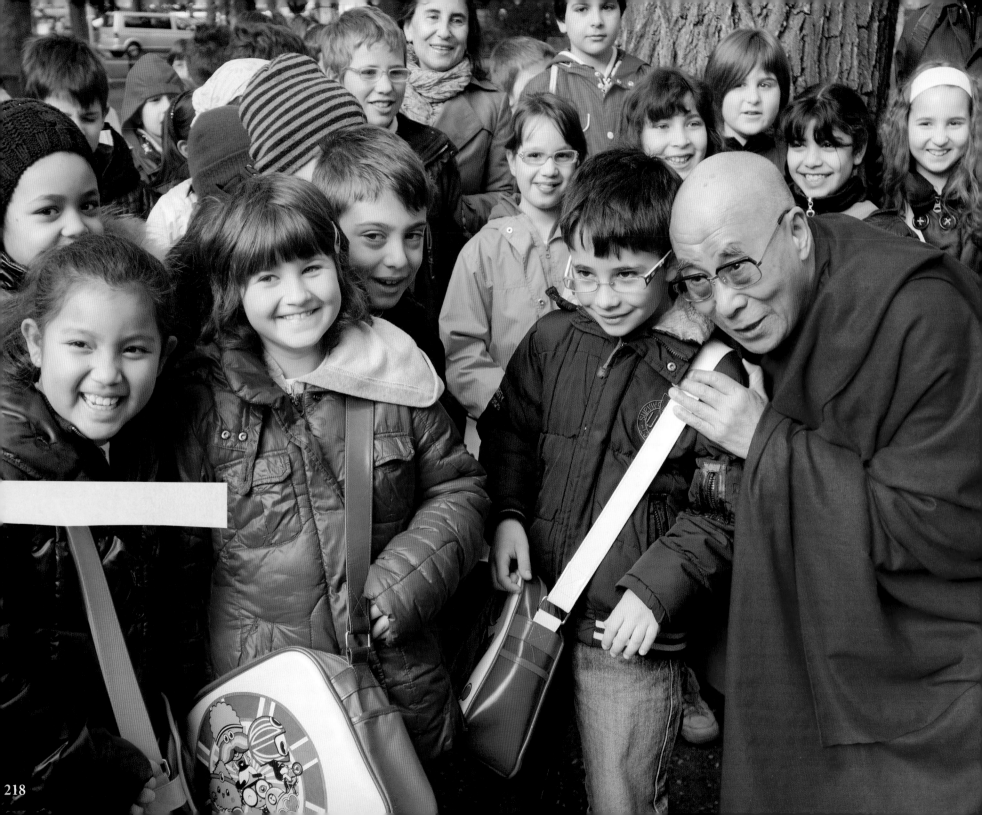

"To meet this century's challenges, human beings need a greater sense of universal responsibility."

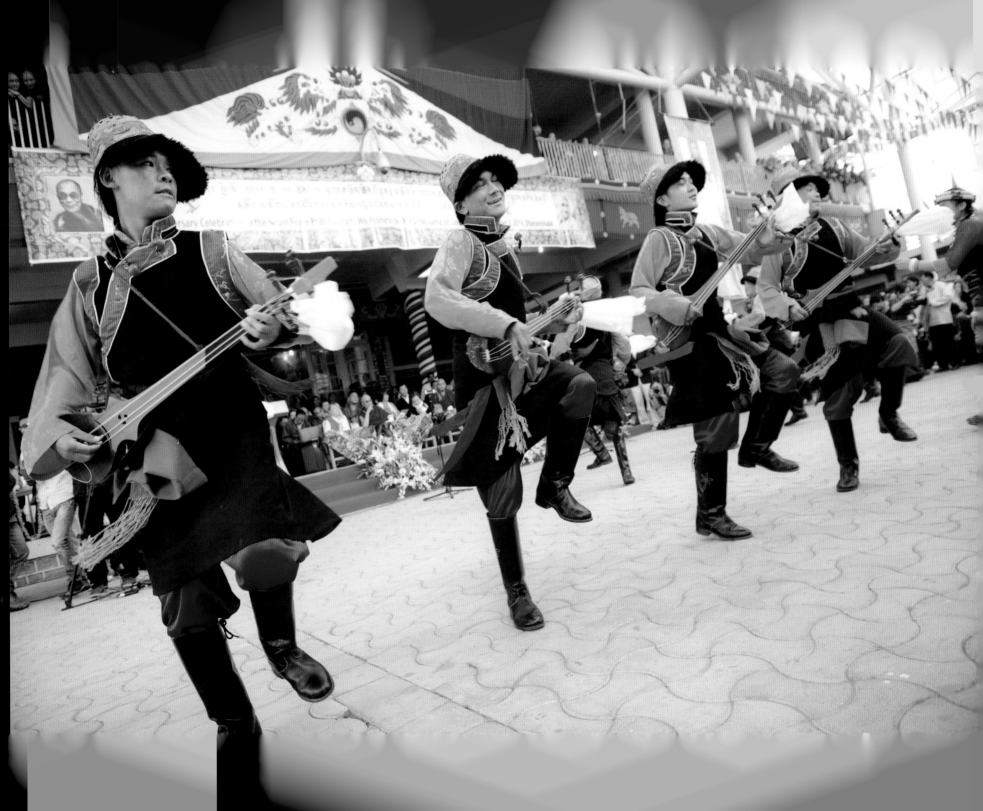

"Without technology humanity has no future, but we have to be careful that we don't become so mechanised, that we lose our human feelings."

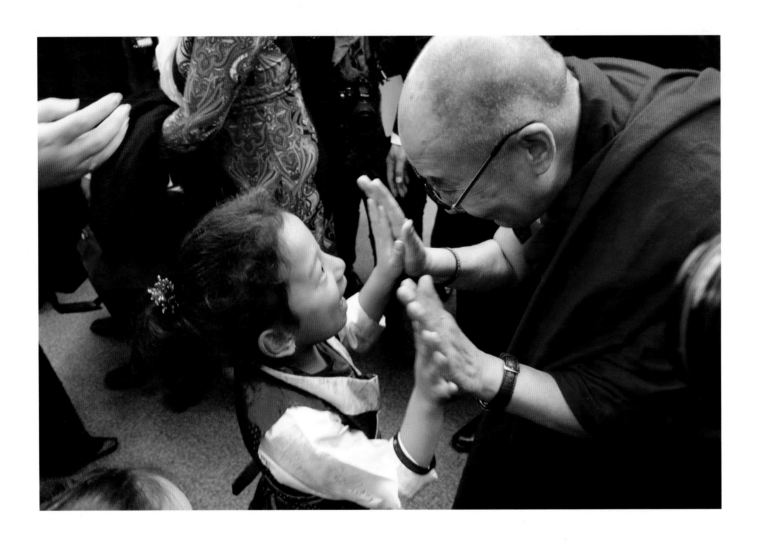

"Only tolerance and patience can protect us from the destructive effects of anger and hatred."

223

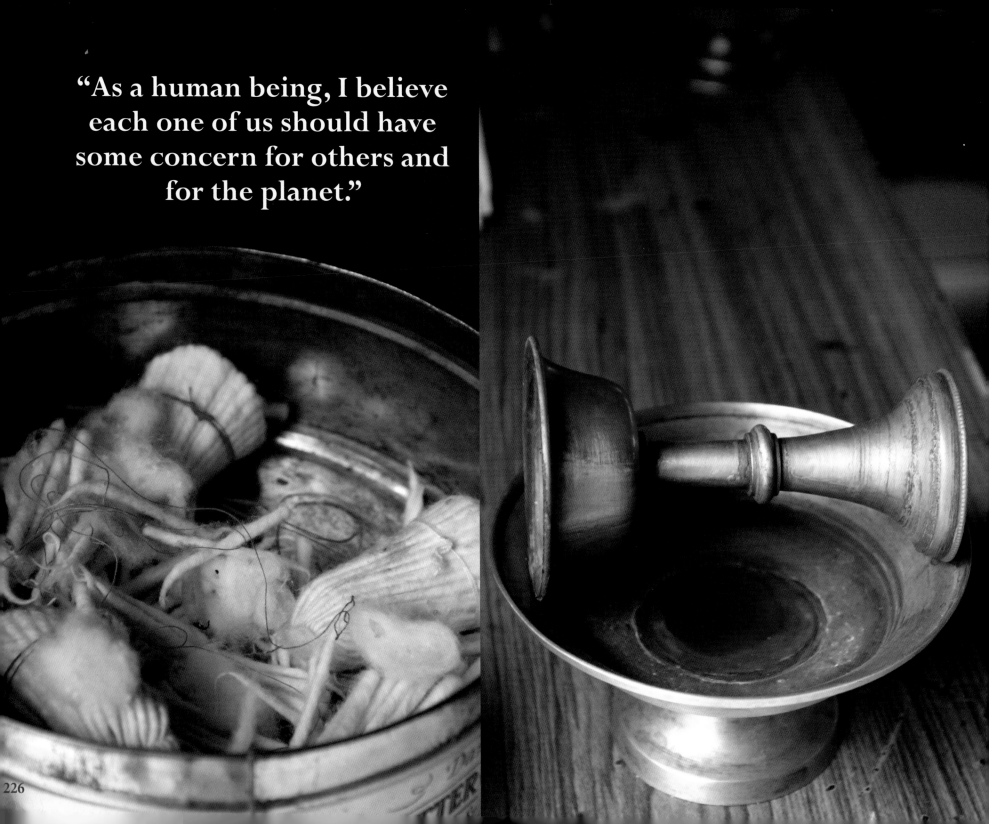

"As a human being, I believe each one of us should have some concern for others and for the planet."

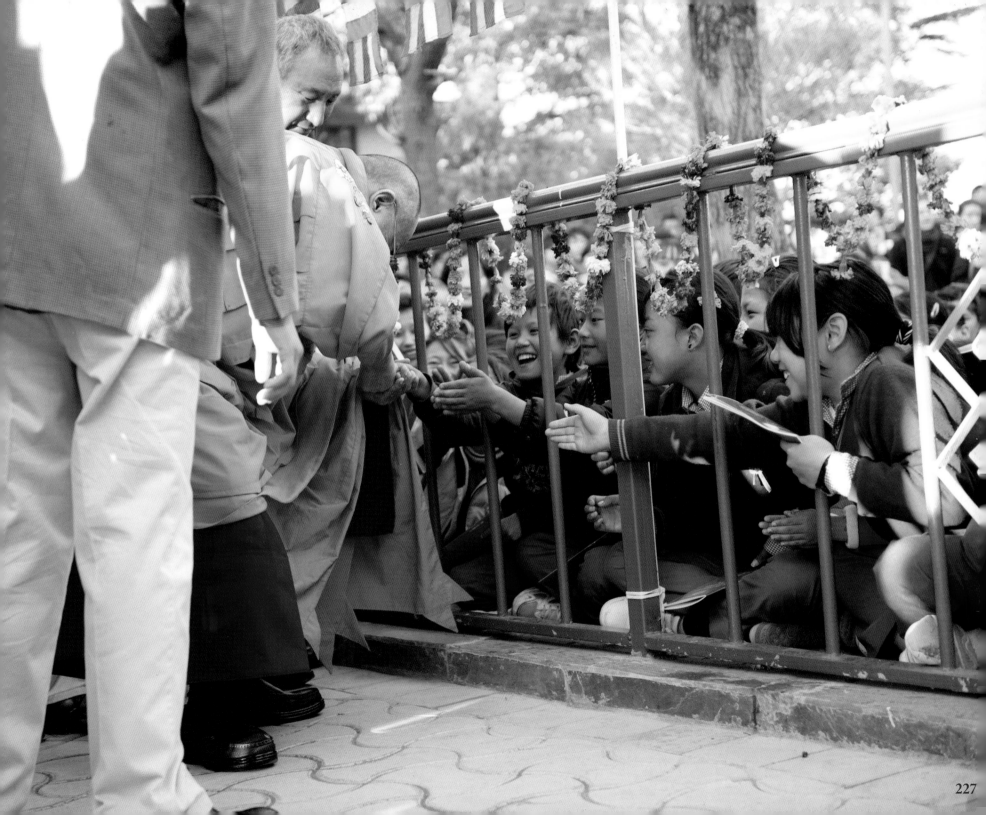

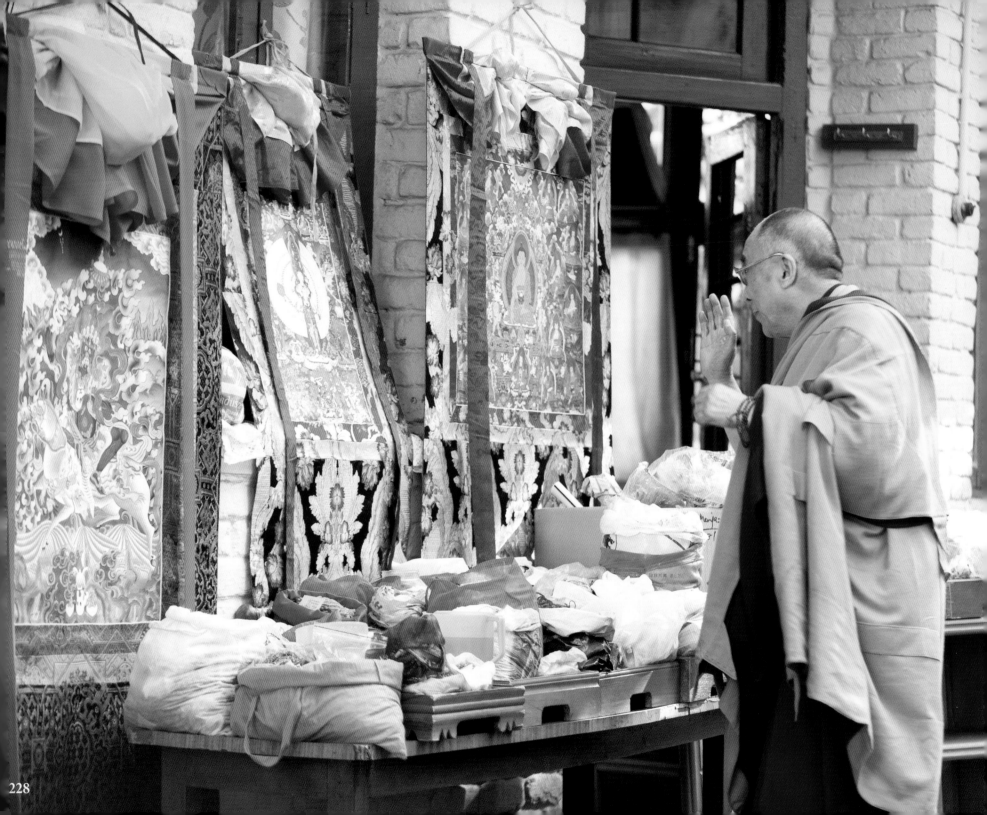

Acknowledgements and Dedication

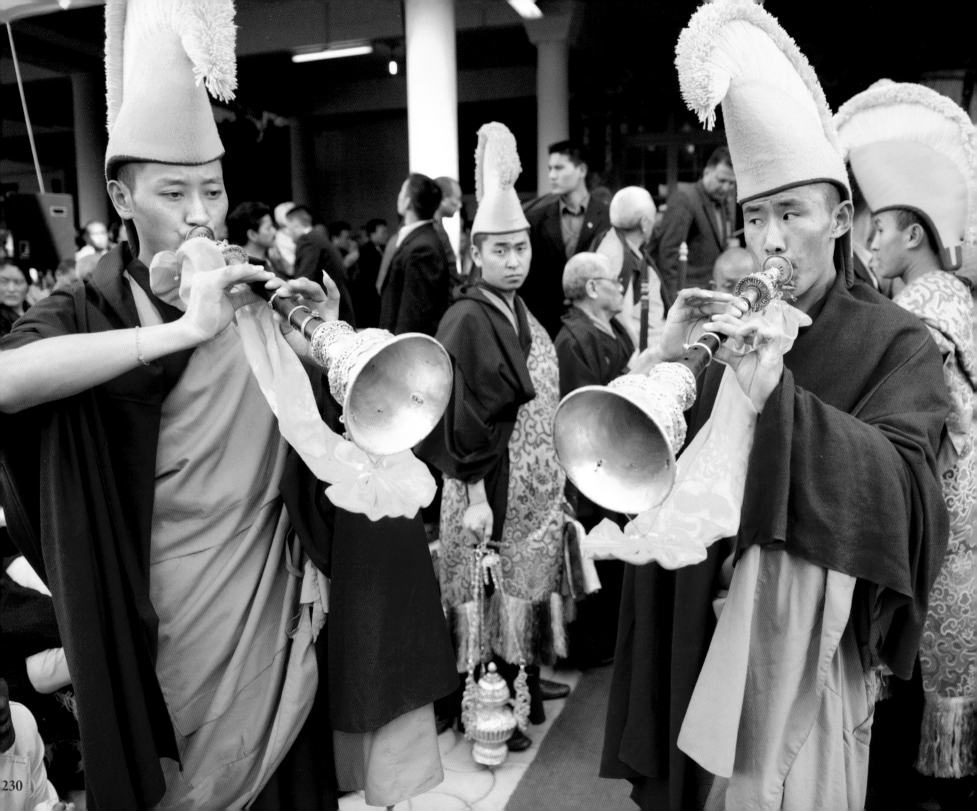

Thousands of candles can be lighted from a single candle, and the life of the candle will not be shortened. Happiness never decreases by being shared.

— Buddha

I still remember the sound of the singing bowl and the calming vibration that ran through me like a harmonic symphony, when I heard it for the first time in Nepal. This was back in 1992, during my training at the Hotel Soaltee Oberoi in Kathmandu. This was my first introduction to Buddhist tradition.

Over the years, like other kids in my school, I too heard stories of the great prince Siddhartha, who gave up all material comforts and riches to become one of the greatest teachers this world has ever seen. The Buddha's story left one of the greatest symbolic impressions on my mind. When I first visited Bodhgaya for the Kalachakra in 2011, and was given the opportunity to cook thousands of balep's for the pilgrims, I couldn't have asked for a more gratifying experience, as everyone peacefully chanted Buddhist hymns, around me.

I was sitting on the stage hearing His Holiness speak, and in the backdrop a group of tranquil Lamas created magnificent sand mandalas. This was where I decided to craft a tribute to the traditions of peace, love and harmony that Buddhism brings to our lives. I stood there watching, as the coloured sands were used to create the mandalas with stunning intricacy and detail.

Certain mandalas like the Kalachakra Mandala contain 722 deities, and are portrayed in perfect geometrical designs. A short while later, I witnessed the most important part of the ceremony – the dismantling of the mandala, and the rituals to celebrate the completion of the creation of the mandala. For me, this entire experience symbolized and upheld the Buddhist doctrinal belief in the transitory nature of material life. At the time it made me feel, that at least once in my lifetime, I had to celebrate this great legacy of Buddhist Lamas, with the man I have followed and revered for a very long time – His Holiness the Dalai Lama.

A big thanks to His Holiness for his time, love, energy and support that he has bestowed upon me over the last few years. Mr Lobsang Nyandak, for always supporting my work and forever being my spiritual guide. Mr Chhime R. Chhoekyapa, for all your support and time, and your patience and blessings, while I was completing this book. My dearest friend Tashi Chodron – the heavenly Momo Queen with a Tibetan heart. Thank you, Tenzin Choejor, for creating such beautiful and unforgettable images through your lens. I can never thank Priyanka Sabharwal enough for encouraging me as a chef and a poet. She was the mind behind shortlisting all the amazing questions we asked His Holiness. Thank you too, Poonam Kaul for always being there and lending me your father's sweater for luck and warmth during my meeting with His Holiness. Karan Sandhu for keeping safe and guarding with your life the Buddhist stone gifted as a blessing by His Holiness in Bodhgaya. My heartfelt gratitude to late Mr Suresh Gopal Ji for being my champion and blossoming my creativity with his love and support and the Bloomsbury team for always believing in me.

I dedicate this book to His Holiness and the lineage of the Lamas, who make us believe everyday, and for keeping the spirit of compassion alive in this world. Thank you for lighting billions of candles of hope in us all.

Index

As the prayer flags blow in the wind, the blessings of love and compassion will be carried to all beings throughout the Universe.

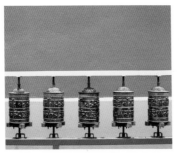

Prayer wheels in Buddhist monastery.

A young monk running with a kettle of tea, before a ceremony.

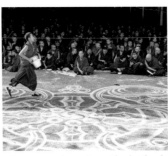

His Holiness with his birthday cake.

A monk carrying a traditional rice dish to offer His Holiness the Dalai Lama during his visit to Tsechen Do Ngag Choeling Sakya Monastery in Mundgod, Karnataka, India.

Tea being prepared to serve over 6,000 people attending His Holiness the Dalai Lama's teaching in Sarnath, Uttar Pradesh, India.

Young monks holding ceremonial scarves listening to His Holiness speak during his visit to Tsechen Do Ngag Choeling Sakya Monastery in Mundgod, Karnataka, India.

A statue of Buddha inspires serenity and peace.

Students in traditional dress lined up to welcome His Holiness as he arrives at the teaching ground at Tibetan Childrens' Village School in Upper Dharamsala, Himachal Pradesh, India.

Young performers waiting for His Holiness to arrive at the Polo Ground in Shillong, Meghalaya, India.

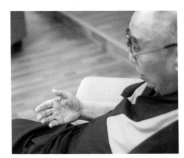

The lines on his palm look so calm and peaceful as I was shooting his pictures during our conversation.

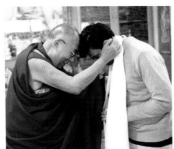

His Holiness blesses me for my book projects *Timeless Legacy* and *Utsav*.

A view of some of the several thousand students and local residents attending His Holiness the Dalai Lama's teaching at Tibetan Childrens' Village School in Upper Dharamsala, Himachal Pradesh, India.

Thousands gathered at the Main Tibetan Temple to attend His Holiness the Dalai Lama's teachings in Dharamsala, India.

A stupa in Tibet with the majestic Mount Kailash in the backdrop.

Students waiting to greet His Holiness at the Tibetan Public School in Srinagar, Jammu and Kashmir, India.

At the "Thank You India" Event at the Waldorf Astoria, New York in 2009.

Mass at St Stephen's Cathedral in Vienna, Austria.

Prayer includes objects that symbolize important concepts in Buddhism.

Butter lamps burning silently in a monastery near Ladakh.

Holding my hand as I showed him *Return to the Rivers*, the book that changed my life.

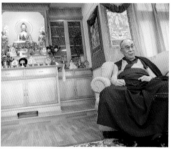

The greatest gift of life is life. "A life without any bullying."

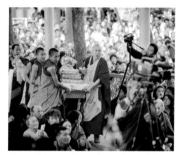

A special statue being borne by monks as part of offerings during Long Life Prayers for His Holiness at the Main Tibetan Temple in Dharamsala, HP, India.

His Holiness the Dalai Lama performing preparatory rituals before conferring the Avalokiteshvera Empowerment at Tibetan Childrens' Village School in Upper Dharamsala, HP, India.

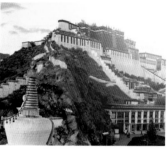

The Potala Palace in Lhasa, was the chief residence of His Holiness the Dalai Lama.

Young Tibetan students waiting for His Holiness to arrive at Tibetan Children's Village School in Upper Dharamsala, HP, India.

Well-wishers waiting for His Holiness after his visit to the newly-reconstructed Tibetan Parilament-in-Exile building in Dharamsala, HP, India.

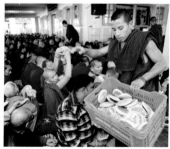

Monks passing out bread to the crowd at the Main Tibetan Temple in Dharamsala, HP, India.

Young Tibetans awaiting their turn to perform at ceremonies organized to mark 25 years since His Holiness the Dalai Lama received the Nobel Peace Prize at the Main Tibetan Temple in Dharamsala, HP, India.

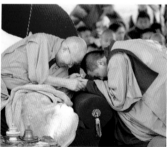

Dilgo Khentse Rinpoche greeting His Holiness at the start of prayer offerings in front of the stupa in Sankisa, UP, India.

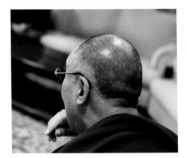
Watching him speak and sometimes finding the correct English word is very endearing.

Members of the Tibetan Institute of Performing Arts singing the song 'Thank You India' at the Closing Ceremony of the Meeting of Diverse Spiritual Traditions in New Delhi, India.

Local Indian monks preparing to distribute offerings to the crowds in Sankisa, UP, India.

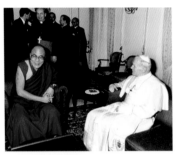
With H.H. Pope John Paul II, Vatican City.

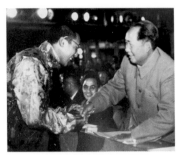
With Mao Tse-Tung, Chairman of CPC, Peking.

With Dr. Arthur M. Ramsey, Archbishop of Canterbury, London.

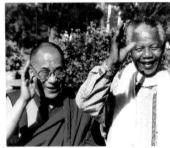
With Nelson Mandela, President of South Africa, Johannesburg.

His Holiness the Dalai Lama placing sand swept up by monks into an urn during the dismantling of the Kalachakra Sand Mandala as part of the 33rd Kalachakara Empowerment in Leh, Ladakh.

Members of the Tibetan community offering His Holiness a traditional welcome on his arrival in Washington, DC, at the start of a three day visit.

His Holiness browsing through a copy of *Return to the Rivers* for which he wrote a Foreword.

His Holiness with Tibetan singers and musicians who performed at the start of his public talk in Basel, Switzerland.

With Mrs. Indira Gandhi, Prime Minister of India.

With Lal Bahadur Shastri, Prime Minister of India, New Delhi.

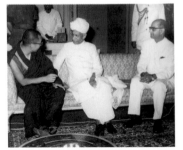
His Holiness meeting with Dr. S. Radhakrishnan, Vice President of India, New Delhi.

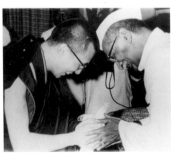
Greeting Dr. Rajendra Prasad, President of India, New Delhi.

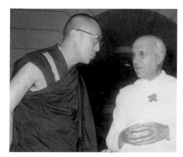

With Jawaharlal Nehru, Prime Minister of India, New Delhi.

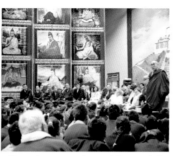

His Holiness introducing fellow Nobel Laureates Jody Williams and Shirin Ebadi to students at the Assembly Hall at the Tibetan Children's Village School in Upper Dharamsala, HP, India.

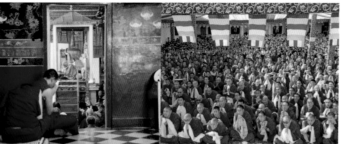

Monks at the Long Life Offering ceremony for His Holiness at Drepung Monastery in Mundgod, Karnataka, India.

Tibetan monks and local residents listening to His Holiness during the inauguration ceremony at Zabsang Choekhorling Monastery in Chauntra, HP, India.

Students offer their artwork to His Holiness during his visit to the Tibetan Children's Village School in Selaquie near Dehradun, India.

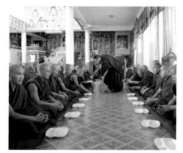

Newly-ordained Bhikshus being offered lunch.

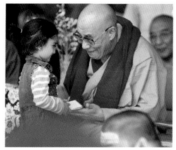

A young girl with His Holiness after he signed an autograph for her.

A traditional Tibetan welcome at Mussoorie Tibetan Homes School in Mussoorie, near Dehradun, India.

Traditional offerings are presented to His Holiness during his visit to Mindrolling Monastery in Clement Town, India.

His Holiness greeting students in traditional dress who performed on his arrival at the Dalhousie Public School, HP, India.

Dancers from Sakti performing during the Kalachakra Ritual Offering Dance on the afternoon of the seventh day of the 33rd Kalachakra Empowerment in Leh, Ladakh.

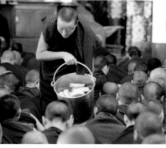

Bread is offered at the beginning of the teachings.

His Holiness participating in a agni puja.

A moment for reflection during a visit to St. Stephen's Cathedral in Vienna, Austria.

His Holinessposes for a photo with the volunteers who helped during his visit to Basel, Switzerland.

237

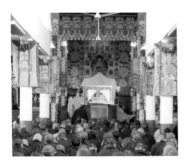
Tibetan monastics at a three-day teaching assembly in Kalachakra Temple, Dharamsala, HP, India.

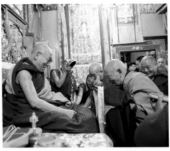
A senior monk making traditional offerings at the start of the Long Life Prayer for His Holiness at Nechung Monastery in Dharamsala, HP, India.

Monks reading scriptures during daily prayers.

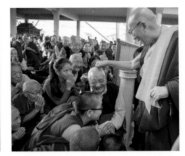
His Holiness playfully greeting an elderly Tibetan on his arrival at the Main Tibetan Temple in Dharamsala, HP India.

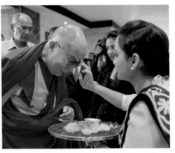
A warm welcome at 'A Meeting of Diverse Spiritual Traditions in India' in New Delhi, India.

The Nechung Oracle blessing offerings during the Long Life Prayer for His Holiness the Dalai Lama at Nechung Monastery in Dharamsala, HP, India.

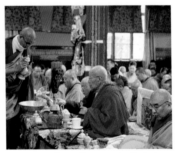
Senior monks performing rituals during the Long Life Prayer for His Holiness at the Nechung Monastery in Dharamsala, HP, India.

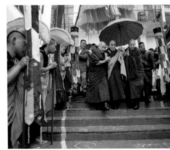
His Holiness arriving at Nechung Monastery in Dharamsala, HP, India.

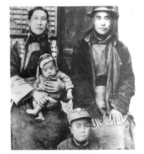
His Holiness as a baby with his mother Dekyi Tsering, father Choekyong Tsering and elder brother Gyalo Thondup taken in Taktser, Amdo Tibet.
(Circa 1935-36)

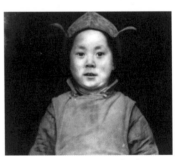
His Holiness posing soon after he was discovered by the search party in 1939, Kumbum, Amdo, Tibet.

His Holiness being received at Nathu-la Pass on his way from Tibet to India to attend the 2500th birth anniversary of the Lord Buddha, 1956.

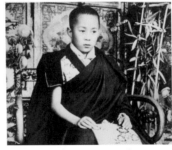
His Holiness as a young boy.

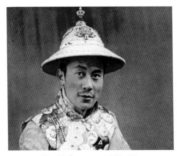
His Holiness in 1954-55.

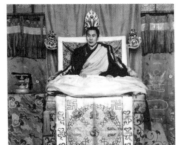
His Holiness in 1956-57.

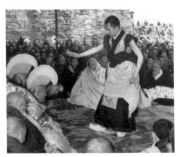
His Holiness during his final Geshe Lharampa examinations in Lhasa, Tibet which took place from the summer of 1958 to February 1959.

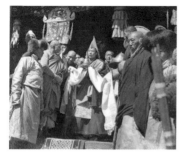

His Holiness in Dromo,1951.

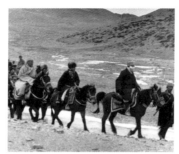

His Holiness in Dromo,1951.

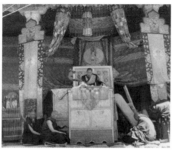

Escape from Tibet,1959.

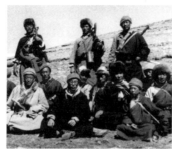

Escape from Tibet,1959.

Escape from Tibet,1959.

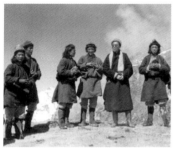

Escape from Tibet,1959.

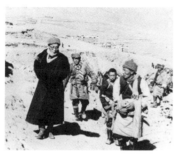

Escape from Tibet,1959.

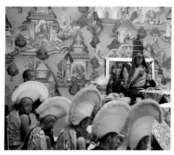

Escape from Tibet,1959.

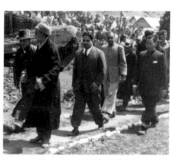

His Holiness performing the consecration of the Tathagata Tsal Buddha statue inside the statue complex, Ravangla, Sikkim, India.

Escape into Exile, 1959.

Escape into Exile, 1959.

Escape into Exile, 1959.

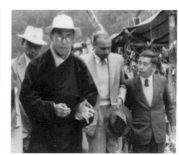

Escape into Exile, 1959.

Escape into Exile, 1959.

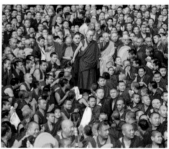

His Holiness poses for photos on the steps of Drepung Loseling Monastery in Mundgod, Karnataka, India.

Beautiful colours and craftsmanship are the hallmark of traditional Tibetan thangkas.

With Mikhail Gorbachev, Former Premier of the Soviet Union, in Rome

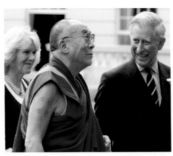

With TRH Charles, Prince of Wales and Camilla, Duchess of Cornwall in London.

An elephant ride with Jawaharlal Nehru, Prime Minister of India in New Delhi.

With Chogyal of Sikkim, Indira Gandhi, His Holiness, Prime Minister Jawaharlal Nehru and Panchen Rinpoche at a State banquet, New Delhi, 1957.

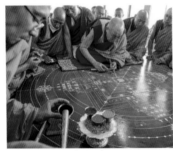

Placing the first grains of coloured sand at the start of the Kalachakra Sand Mandala construction as part of the Kalachakra Empowerment in Leh, Ladakh.

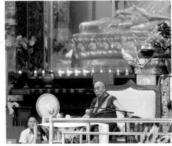

His Holiness the Dalai Lama speaking during his visit to Drepung Loseling Monastery in Mundgod, Karnataka, India.

Members of the audience greeting His Holiness as he arrives at Ganden Jangtse Monastery Temple in Mundgod, Karnataka, India.

Joking with members of a traditional Carinthian brass band which performed on his arrival in Klagenfurt, Austria.

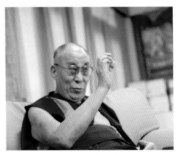

Nature is an example of precision.

Inaugurating the new assembly hall at Likir Monastery in Likir, Ladakh.

A Tibetan monk rushing to serve tea to members of the audience at the Ganden Jangtse Monastery in Mundgod, Karnataka, India.

Superior General of the Order, Sister Mary Prema Pierick, and the Archbishop of Kolkata Thomas D'Souza thanking His Holiness the Dalai Lama after his talk at Mother Teresa's House in Kolkata, West Bengal, India.

People from the Dagyab Kham region pass by with offerings during the Long Life Offering Ceremony for His Holiness the Dalai Lama at the Ganden Jangtse Monastery in Mundgod, Karnataka, India.

Members of the audience braving the rainy weather at Norling Park, Dekyiling Tibetan Settlement near Dehradun, India.

Namgyal Monastery Monks performing the Kalachakra Earth Ritual Dance during the second day of the eleven day Kalachakra Empowerment in Leh, Ladakh.

Monks preparing tea to serve to the over 25,000 people at the Ganden Jangtse Monastery in Mundgod, Karnataka, India.

A view of the temple at the Ganden Jangtse Monastery in Mundgod, Karnataka, India.

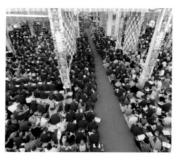

Thousands of Monks listen to the teachings of His Holiness.

Performers dressed in traditional costume listening to speakers during the Nobel Peace Prize Day ceremonies marking the 25th anniversary of His Holiness the Dalai Lama receiving the Nobel Peace Prize in Mundgod, Karnataka, India.

A Tibetan band welcomes His Holiness at the Ganden Jantse Monastery in Mundgod, Karnataka, India.

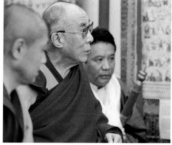

His Holiness looking at thangka's depicting aspects of Tibetan medicine during ceremonies celebrating the 50th anniversary of the Tibetan Medical and Astrological Institute in Dharamsala, HP, India.

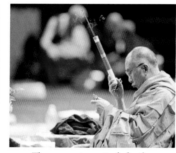

The preparatory rituals for the Avalokiteshvara empowerment in Milan, Italy.

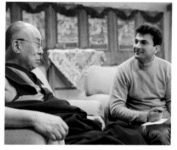

Sometimes we got emotional during our conversations. I simply loved every moment of it.

Monks serving tea during a break in Dharamsala, HP, India.

Intricately carved brass door handle on a monastery door.

Planting a sapling from the Bodhi tree in Bodh Gaya at Dagpo Shedrupling Monastery in Kais, near Manali, HP, India.

Colourful carvings give an auspicious and attractive aura to a Buddist home.

Members of the Tibetan monastic community at the Jataka Tale teachings in Dharamsala, HP, India.

Lotus is one of the main symbols of peace and balance in Buddhism.

A group of children perform in front of the Klagenfurt City Hall in Austria.

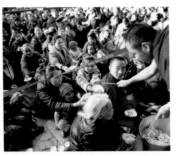

Special Tibetan traditional sweet rice being offered during Jataka Tale teachings at the Main Tibetan Temple in Dharamsala, HP, India.

Butter lamps guide the way to enlightenment and illumination of the mind.

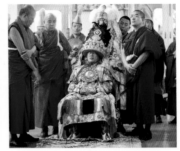

The Nechung Oracle prepares for meeting His Holiness during the Long Life Ceremony offered by the Central Tibetan Administration in Dharamsala, India.

Prayer flags at Majnu-Ka-Tilla, a Tibetan colony, established around 1960 in Delhi.

Incense sticks in a bowl of rice is considered very sacred.

The Wheel of Dharma.

A beautiful ornate door is the entrance to the peaceful setting where monks attend teachings of His Holiness.

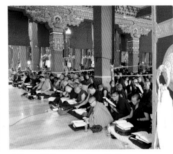

A serene statue of Goddess Tara.

In Tibetan culture, zodiac signs are taken very seriously and considered sacred.

A small section of the huge crowds who had come to view the Kalachakra Sand Mandala in Leh, Ladakh.

Senior monks from Chime Gatsal Ling during a Long Life Offering for His Holiness held in Sidhbari, HP, India.

Rice has an important place in Tibetan rituals and ceremonies.

For over 400 years, Tibetan monks have been using Yak butter to create intricate sculptures inspired by the life of Buddha.

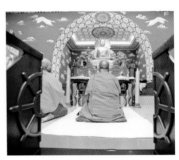

His Holiness offers prayers in front of a Buddha statue at the Mahabodhi Society Temple.

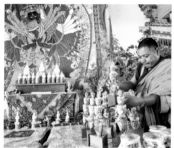

Some of the assorted ritual items to be placed around the completed Kalachakra Sand Mandala on the sixth day of the 33rd Kalachakra Empowerment in Leh, Ladakh.

A Buddhist religious pole atop a monastery.

Namgyal Monastery Monks performing the Kalachakra Earth Ritual Dance during the eleven day Kalachakra Empowerment in Leh, Ladakh.

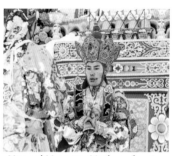

A section of the over 25,000 monks who attended the teachings at the Ganden Jangtse Monastery Temple in Mundgod, Karnataka, India.

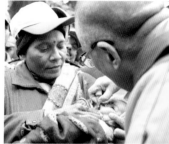

His Holiness the Dalai Lama administers the polio vaccine to an infant at the Mahabodhi Temple in Bodh Gaya, 2010.

A spoon used for religious ceremonies.

Buddhist prayer beads with 108 beads, to recite the mantras.

Monks following the texts during the third day of teachings at the Ganden Jangtse Monastery in Mundgod, Karnataka, India.

Namgyal Monastery monks preparing offerings decorated with butter sculptures at the 33rd Kalachakra Empowerment in Leh, Ladakh.

The treasure vase symbolizes an endless reign of long life, wealth and prosperity.

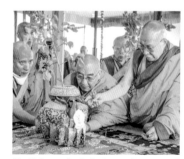

His Holiness the Dalai Lama placing ritual vases as part of the prayers to prepare and consecrate the venue on the second day of his eleven day Kalachakra Empowerment in Leh, Ladakh, J&K, India.

A member of the audience following the text during His Holiness the Dalai Lama's final day of teaching in Sankisa, UP, India.

I absolutely love the sound of the Prayer wheels turning as they spread the prayers and wishes of the devotees.

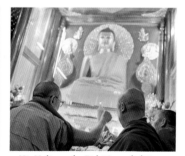

His Holiness the Dalai Lama lighting a candle in front of the main Buddha statue in the Mahabodhi Temple in Bodh Gaya.

The holy texts contain the sacred words of Buddha and his teachings.

A prayer wheel filled with mani mantras, carries the spirit of Tibetan customs and rituals.

Monks in prayer with His Holiness.

Rice is a symbol of life and prosperity.

Prayer beads are a revered ornament of Tibetan devotees.

The eight-spoked wheel, The Dharma Chakra represents the noble eight-fold path of Buddhism.

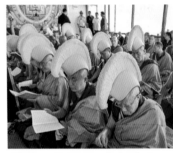

Monks reciting prayers during the Long Life Offering Ceremony on the final day of the 33rd Kalachakra in Leh, Ladakh.

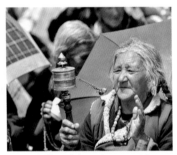

A member of the audience with her prayer wheel during the final session of the actual empowerment at the 33rd Kalachakra Empowerment in Leh, Ladakh.

A monk from Namgyal Monastery playing the cymbals during the final session of the actual empowerment at the 33rd Kalachakra Empowerment in Leh, Ladakh.

The sound and vibrations of the singing bowl, represents the sounds of the Universe.

Intricately carved idols of Buddha in sandalwood.

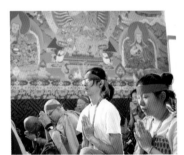

Some of the many overseas visitors who came to the teachings at Chime Gatsal Ling in Sidhbari, HP, India.

Well-wishers greeting His Holiness the Dalai Lama as he returns from lunch to continue the fifth day of his teachings at the Ganden Jangtse Monastery in Mundgod, Karnataka, India.

His Holiness consecrating statues of the Buddha and his five disciples during his visit to the the Central Institute of Buddhist Studies in Choglamsar near Leh, Ladakh.

A beautiful statue of a meditating Buddha as seen through a glass window.

In Buddhism, these are some of the important symbols of prayer.

Members of the Tibetan community in Surat, Gujarat, India.

Dancers from Mongolia performing during the Kalachakra Ritual Offering Dance on the afternoon of the seventh day of the 33rd Kalachakra Empowerment in Leh, Ladakh.

Dancers from the Toepa region of Tibet perform during the Kalachakra Ritual Offering Dance at the 33rd Kalachakra Empowerment in Leh, Ladakh.

Signing a special proclamation during the inauguration of the new hostel for students from Mongolian regions at Drepung Gomang Monastery in Mundgod, Karnataka, India.

Dusk settles peacefully around a gently lit Buddhist shrine.

Young monks debating Buddhist philosophy before the second day of His Holiness the Dalai Lama's teachings in Padum, Zanskar, J&K, India.

Young children dressed in traditional Tibetan costumes performing during celebrations honouring His Holiness the Dalai Lama's 77th birthday at the Main Tibetan Temple in Dharamsala, HP, India.

Young children dressed in traditional Tibetan dress performing during celebrations honoring His Holiness the Dalai Lama's 77th birthday at the Main Tibetan Temple in Dharamsala, HP, India.

A serene butter lamp represents a wish in a monastery.

Some of the over 25,000 people waiting to see His Holiness the Dalai Lama as he departs the Ganden Jangtse Monastery at the end of the third day of his teachings in Mundgod, Karnataka, India.

A child looks at his mother lovingly during the final day of His Holiness the Dalai Lama's teachings in Padum, Zanskar, J&K, India.

A hand-crafted prayer wheel at the Majnu-Ka-Tilla monastery in Delhi.

His Holiness looking at a huge thangka of Guru Rinpoche hanging from Sera Jey Monastery as he arrives for the fifth day of his teaching in Bylakuppe, Karnataka, India.

Buddhists take a lot of pride in their rosary beads.

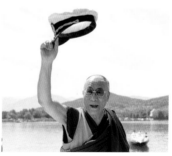

His Holiness waves during a boat trip in Austria.

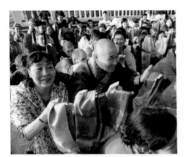

Well-wishers greeting His Holiness on his arrival at the new hostel for students from Mongolian regions at Drepung Gomang Monastery in Mundgod, Karnataka, India.

Close up of the fine detail of the butter sculptures decorating offerings arranged at the 33rd Kalachakra Empowerment in Leh, Ladakh.

Students offering a traditional welcome at the teaching ground at Tibetan Childrens' Village School (TCV) in Upper Dharamsala, HP, India.

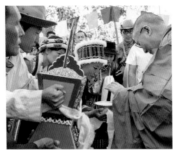

A view of the Ganden Jangtse Monastery during the fourth day of teachings in Mundgod, Karnataka, India.

Butter Lamps represents peace and hope.

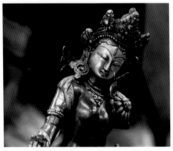

There are different forms of Tara, which in Buddhism represent the different faces of nature.

Crowds eagerly await the arrival of His Holiness for the consecration of the Tathagata Tsal statue, Ravangla, Sikkim, India.

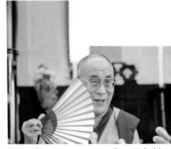

His Holiness at a press conference held at the Zenkoji Temple in Nagano, Japan.

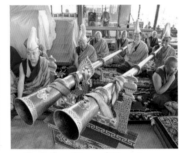

Monks from Namgyal Monastery blowing Tibetan horns during ritual prayers conducted on the afternoon of the seventh day of the 33rd Kalachakra Empowerment in Leh, Ladakh.

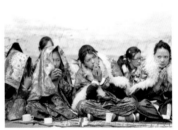

Local Ladakhi women listening to His Holiness during the inauguration of the Seminar on Parchin (Perfection of Wisdom) at Likir Monastery in Ladakh.

Turquoise and coral stones are an important element in the design of Tibetan artifacts.

A small cylindrical container which sometimes contain incense sticks and prayers.

Monks preparing tea to serve to over 25,000 people attending the fifth day of teachings at Ganden Jangtse Monastery in Mundgod, Karnataka, India.

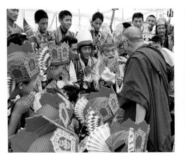

His Holiness greeting some of the students who performed during the Tibetan Homes Foundation Golden Jubilee in Mussoorie, India.

Butter lamps light up the darkness and set the stage for focus and meditation.

A decorative painting of the eight sacred symbols on the steps to bring good luck and prosperity.

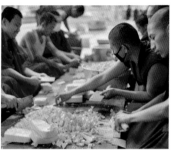

Monks preparing lunch to serve over 25,000 people attending the last day of the teachings at Ganden Jangtse Monastery in Mundgod, Karnataka, India.

The flames are an offering of light and energy.

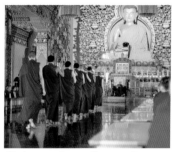

Monks preparing to offer tea at Dzongsar Institute in Chauntra, HP, India.

A bundle of peacock feathers is used to sprinkle sacred water or elixir.

Tibetan incense sticks have been used since ancient times to spread the calming aroma of the rich red sandalwood.

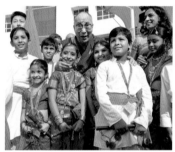

His Holiness with students who welcomed him to Somaiya School in Mumbai, India.

The burning of incense represents the need to get rid of the negative qualities within ourselves to reveal the purity within.

The doors to the monastery are painted in the traditional and beautiful red colour.

"All major religious traditions carry basically the same message, that is love, compassion and forgiveness.
The important thing is they should be part of our daily lives."
– His Holiness the Dalai Lama.

Rows of butter lamps waiting to be lit.

The beautiful sound of the bell helps in meditating by clearing the energy and enhancing the presence of mind.

The lotus flower is a symbol of fortune and purification in Buddhism. The seven bowls of water placed at the Buddhist altar represent the seven limbs of prayer.

Tibetan Nine-spoke Dorje or Vajra represents a thunderbolt, which clears negativity and ignorance.

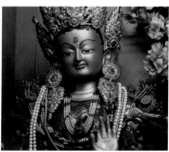

The statue of Goddess Tara represents success in work and achievements.

His Holiness with students after his interactive session at Princeton University's Chancellor Green Library in Princeton, New Jersey.

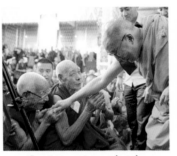

Greeting a senior monk at the conclusion of the third day of his teachings at Ganden Jangtse Monastery in Mundgod, Karnataka.

Monks preparing lunch for the over 30,000 people attending the teachings at Sera Jey Monastery in Bylakuppe, Karnataka, India.

His Holiness shares a hearty laugh.

A monk reading the ancient text and scriptures.

The blue lotus is a symbol of consciousness.

Mudras are sacred hand gestures. It is the mystic gesture of Goddess Tara.

His Holiness poses for a memorable photograph.

A monk playing the cymbals during ritual prayers to prepare and consecrate the venue on the first day of the Kalachakra Empowerment in Leh, Ladakh.

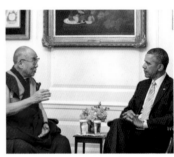

His Holiness with President Barack Obama.

Tingsha or brass cymbals with eight traditional symbols representing victory, purity and endless devotion.

The Tibetan shrine is an integral part of the household.

His Holiness with members of Namgyal Monastery after the Long Life Offering Ceremony at His Holiness's residence in Dharamsala, HP, India.

His Holiness poses for a photograph.

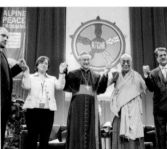

Panelists Rabbi Mag. Schlomo Hofmeister, Mag. Luise Mueller, Archbishop Dr. Alois Kothgasser, His Holiness the Dalai Lama and Dr. Fuat Sanac during an inter-faith dialogue on Harmony in Diversity in Salzburg, Austria.

Monks rushing to serve tea to the over 30,000 people attending the final day of teachings at Sera Jey Monastery in Bylakuppe, Karnataka, India.

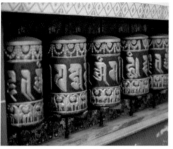

The rows of prayer wheels which the devotees spin as they recite mantras.

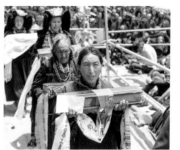

His Holiness arrives at Drepung Loseling Monastery to continue his teachings in Mundgod, Karnataka, India.

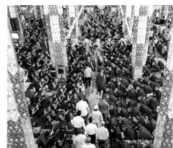

Local residents with offerings during Long Life Offering Prayers on the final day of teachings in Padum, Zanskar, J&K, India.

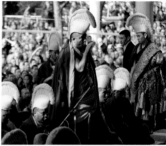

Monks at Jataka Tales Teaching.

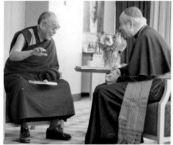

His Holiness the Dalai Lama and Cardinal Christoph Schonborn, Archbishop of Vienna, during their meeting in Vienna, Austria.

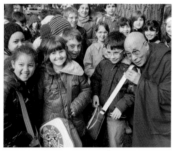

His Holiness stops to talk to a group of school children on his way to the Provincial Offices in Bolzano, South Tyrol, Italy.

Butter lamp holders just before they are filed with Yak butter and lit for the prayers.

An ancient Tibetan copper artifact.

Tibetan musicians performing traditional songs during ceremonies to mark 25 years since His Holiness the Dalai Lama received the Nobel Peace Prize at the Main Tibetan Temple in Dharamsala, HP, India.

A beautiful stone studded statue of Lord Buddha against the back drop of a thankgka.

Tibetans value the power of stones, especially Tibetan turquoise as it is a symbol for the sky.

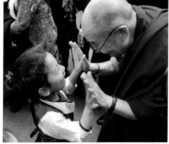

His Holiness greeting a young girl as he departs from John Oliver School in Vancouver, Canada.

Light from butter lamp symbolizes the wisdom of the awakened mind.

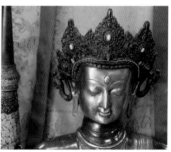

The rare statue of a coronated Prince Siddhartha.

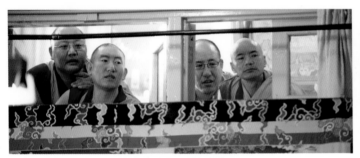

Monks listening to His Holiness.

Bundles of cotton wicks which will be lit in butter lamps by the devotees.

Butter lamps offered daily on devotees shrine or household altar.

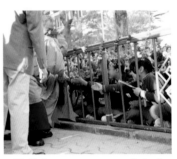

His Holiness greets a group of school children on his way to the prayers.

His Holiness blessing religious objects on his way to the Main Tibetan Temple at the start of the second day of teachings in Dharamsala, HP, India.

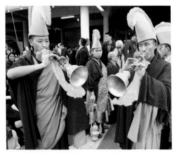

Celebrations at Jataka Tales Teaching.

A couple of children stuggling to turn a large prayer wheel outside a monastery.